THE METROPOLITAN MUSEUM OF ART NEW YORK · THE METROPOLITAN MUSEUM OF ART NEW YORK · THE METROPOLITAN MUSEUM OF ART NEW YORK · THE METROPOLITAN MUSEUM OF ART NEW YORK · THE METROPOLITAN MUSEUM OF ART NEW YORK · THE METROPOLITAN MUSEUM OF ART NEW YORK · THE METROPOLITAN MUSEUM OF ART NEW YORK · THE METROPOLITAN MUSEUM OF ART NEW YORK · THE METROPOLITAN MUSEUM OF ART NEW YORK · THE METROPOLITAN MUSEUM OF ART NEW YORK · THE METROPOLITAN MUSEUM OF ART NEW YORK · THE METROPOLITAN MUSEUM OF ART NEW YORK · THE METROPOLITAN MUSEUM OF ART NEW YORK · THE METROPOLITAN MUSEUM OF ART NEW YORK · THE METROPOLITAN MUSEUM OF ART NEW YORK · THE METROPOLITAN MUSEUM OF ART NEW YORK · THE METROPOLITAN MUSEUM OF ART NEW YORK · THE METROPOLITAN MUSEUM OF ART NEW YORK · THE METROPOLITAN MUSEUM OF ART NEW YORK · THE METROPOLITAN MUSE

THE METROPOLITAN MUSEUM OF ART

Egypt and the Ancient Near East

THE METROPOLITAN

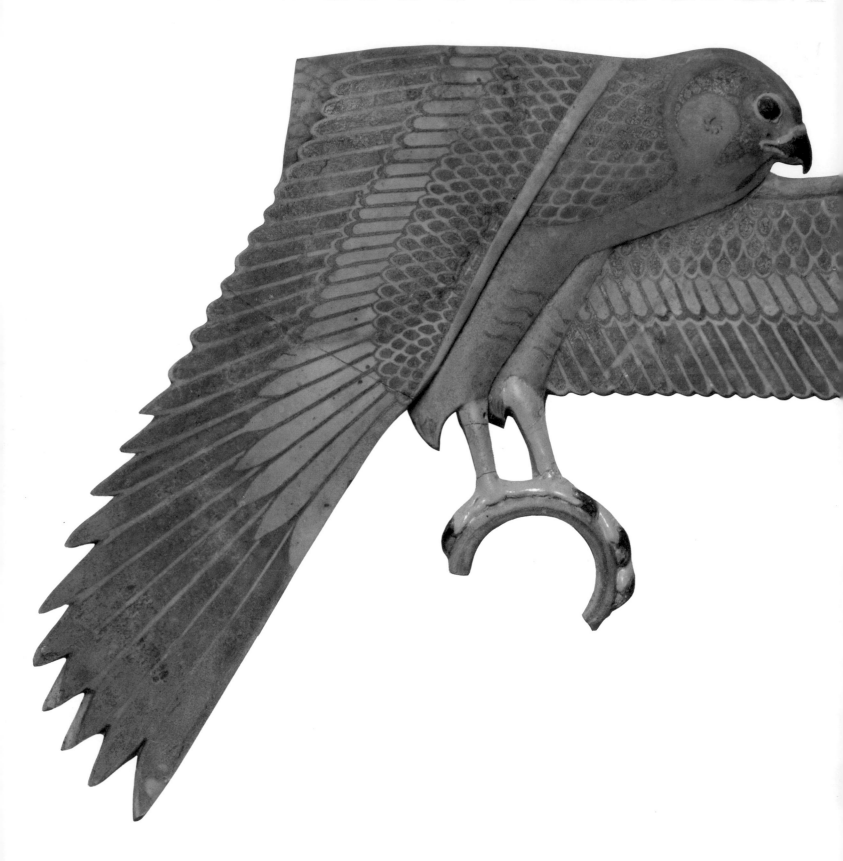

MUSEUM OF ART
Egypt and the Ancient Near East

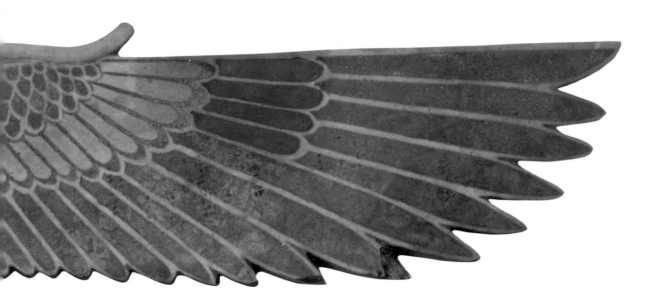

INTRODUCTIONS

BY

Peter F. Dorman
ASSISTANT CURATOR, DEPARTMENT OF EGYPTIAN ART

AND

Prudence Oliver Harper
CURATOR, DEPARTMENT OF ANCIENT NEAR EASTERN ART

Holly Pittman
ASSOCIATE CURATOR, DEPARTMENT OF ANCIENT NEAR EASTERN ART

THE METROPOLITAN MUSEUM OF ART, NEW YORK

PUBLISHED BY

THE METROPOLITAN MUSEUM OF ART
New York

PUBLISHER
Bradford D. Kelleher

EDITOR IN CHIEF
John P. O'Neill

EXECUTIVE EDITOR
Mark D. Greenberg

EDITORIAL STAFF
Sarah C. McPhee

Josephine Novak

Lucy A. O'Brien

Robert McD. Parker

Michael A. Wolohojian

DESIGNER
Mary Ann Joulwan

———

Commentaries written by the editorial staff.

Photography commissioned from Schecter Lee, assisted by Lesley Heathcote: Plates 8–10, 27, 29, 42, 44, 49, 51, 52, 55, 68, 70a-c, 75, 81, 84, 87–89, 100, 101, 104, 105, 111, 112. All other photographs by The Photograph Studio, The Metropolitan Museum of Art.

Maps and time chart designed by Wilhelmina Reyinga-'Amrhein.

Drawing on page 121 by C. Koken.

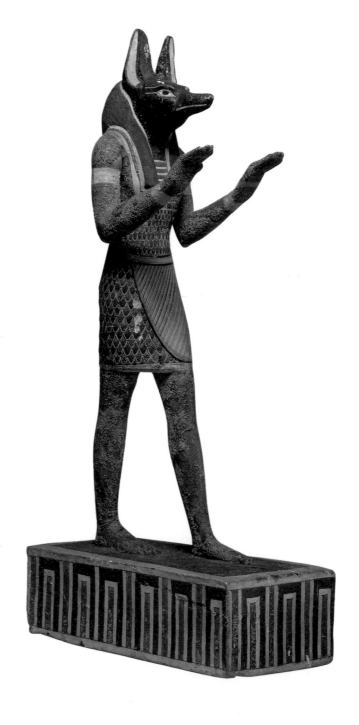

TITLE PAGE

Plaque with Faience Inlays
Egyptian, Macedonian-Ptolemaic Period,
ca. 332–30 B.C.
Polychrome faience; L. 11⅜ in. (28.9 cm.)
Purchase, Edward S. Harkness Gift, 1926 (26.7.991)

THIS PAGE

Annubis
Egyptian, Ptolemaic Period, ca. 332–30 B.C.
Gessoed and painted wood; H. 16½ in. (42 cm.)
Gift of Mrs. Myron C. Taylor, 1938 (38.5)

Library of Congress Cataloging-in-Publication Data

The Metropolitan Museum of Art (New York, N.Y.)
 Egypt and the Ancient Near East.

 1. Art, Ancient—Egypt. 2. Art, Egyptian.
3. Art, Ancient—Near East. 4. Art—Near East.
I. Metropolitan Museum of Art (New York, N.Y.)
N5345.E34 1987 709'.39'4 85-3010
ISBN 0-87099-413-1 ISBN 0-87099-415-8 (pbk.)

Printed and bound by Dai Nippon Printing Co., Ltd., Tokyo.

This series was conceived and originated jointly by The Metropolitan Museum of Art and Fukutake Publishing Co., Ltd. DNP (America) assisted in coordinating this project.

This volume, devoted to the collections of the Egyptian and Ancient Near Eastern departments, is the first publication in a series of twelve volumes that, collectively, will represent the scope of the Metropolitan Museum's holdings while selectively presenting the very finest objects from each of its curatorial departments.

This ambitious publication program was conceived as a way of presenting the collections of The Metropolitan Museum of Art to the widest possible audience. More detailed than a museum guide and broader in scope than the Museum's scholarly publications, this series presents paintings, drawings, prints, and photographs; sculpture, furniture, and decorative arts; costumes, arms, and armor—all integrated in such a way as to offer a unified and coherent view of the periods and cultures represented by the Museum's collections. The objects that have been selected for inclusion in the series constitute a small portion of the Metropolitan's holdings, but they admirably represent the range and excellence of the various curatorial departments. The texts relate each of the objects to the cultural milieu and period from which it derives and incorporate the fruits of recent scholarship. The accompanying photographs, in many instances specially commissioned for this series, offer a splendid and detailed tour of the Museum.

We are particularly grateful to the late Mr. Tetsuhiko Fukutake, who, while president of Fukutake Publishing Company, Ltd., Japan, encouraged and supported this project. His dedication to the publication of this series contributed immeasurably to its success.

The Department of Egyptian Art, founded in 1906, is responsible for the care and exhibition of one of the largest collections of Egyptian art outside the Cairo Museum. Virtually all of its approximately 40,000 objects have been on permanent display since the reinstallation of the galleries in 1983. The holdings of the department have grown through a variety of means: underwriting of non-Museum excavations, gifts, purchases, and most important, through its own extensive program of excavations, which began in 1906 and ended in 1936. Now, after a hiatus of nearly fifty years, the department is once more excavating in Egypt.

For the purpose of scholarly research, it is significant that much of the collection was acquired in the course of controlled excavations. But the department is also fortunate to have inherited important private collections, most notably those of Lord Carnarvon, the Reverend Chauncey Murch, and Theodore Davis. Individual benefactors such as Edward Harkness, J. Pierpont Morgan, and Lila Acheson Wallace have enriched the collection still further by their gifts. In the latter part of the nineteenth century the Museum received many works in return for its financial support of the Egypt Exploration Society. It also purchased a number of monuments from the Egyptian government. Most recently, the Museum was chosen to house the Temple of Dendur, which was given to the people of the United States in appreciation of their support of the campaign to save the monuments of Nubia.

The Museum's holdings of ancient Near Eastern art represent cultures from western Turkey east to the valley of the Indus River and from the Caucasus Mountains as far south as the Gulf of Aden. From this enormous geographic area come works of art from the late Neolithic Period of the seventh millennium B.C. up to the Islamic conquest in the middle of the seventh century A.D.

Until 1956, works of ancient Near Eastern art were part of the collection of the Department of Near Eastern Art. When that department was created in 1932, its collection already included antiquities from all parts of the Near East. Indeed, seals and tablets from William Hayes Ward and the Wolfe Expedition to Babylonia had entered the Museum's collection as early as the 1880s. In the first decades of this century, the Museum benefitted handsomely from the gifts of its many generous patrons—among them, J. Pierpont Morgan and John D. Rockefeller, Jr.—and the Museum's participation in archaeological excavations in the Near East has been rewarded by a division of objects among supporting institutions. Other works of art have been acquired through purchase or exchange with other museums. Most recently, the generosity of Norbert Schimmel has greatly enhanced both the quality and breadth of the collection.

We are especially grateful for the invaluable assistance of Prudence Harper and Holly Pittman of the Department of Ancient Near Eastern Art and of Peter Dorman of the Department of Egyptian Art in the preparation of this volume. In addition to composing the introductions, they spent much time reviewing all maps, photographs, and texts.

Philippe de Montebello
Director

EGYPT

Even to the uninitiated viewer, who is more often familiar with the rather different traditions of Western or Oriental civilizations, the qualities that infuse the art of ancient Egypt are nevertheless instantly recognizable. In sculpture they are manifest in the formality of theme and rigidity of pose; in relief they can be seen in the combination of contradictory perspectives used to portray the human figure.

Astonishingly, these qualities remained consistent for the greater part of Egyptian history, finding their origin in the Predynastic Period (ca. 4300–3000 B.C.) before the emergence of a unified country, and exerting a powerful influence long after the conquest of Egypt, first by Persia, then by Macedonia, and finally by Rome. The student of modern civilizations, more accustomed to tracing the appearance, development, and passage of aesthetic ideas within the span of centuries, generations, or even a single lifetime, will be struck by the uniformity of the artistic approach of the ancient Egyptians over three millennia. There are, of course, significant differences that appear from period to period, but the reasons why a monolithic aesthetic endured for some three thousand years lie in the Egyptian conceptions of time and space, conceptions that can ultimately be traced to a single source, to the physical setting that gave birth to one of the most splendid civilizations of the ancient world: the Nile valley.

Running its course from the highland lakes of central Africa toward the waters of the Mediterranean Sea, the Nile flows across the arid expanse of the Sahara, slicing through the limestone plateaus of the Sudan and Egypt without receiving a drop of tributary water during its last fifteen hundred miles. In the midst of unimaginable desolation, today as in ancient times, the Nile sustains abundant life in a narrow band of cultivation on either side of the river. Permanent settlement of the valley was made possible only by a natural phenomenon that prevented salinization and the gradual loss of soil fertility: the annual inundation, which covered the land in late summer and deposited rich alluvial silt brought down by torrential rains falling in the distant Ethiopian mountains. The onset of the inundation was heralded in the heavens by the heliacal rising of Sirius, the Dog Star, on the eastern horizon in late July. The appearance of the star signaled the renewal of life, the beginning of another agricultural year, and the affirmation of a natural order whose effects were visible but whose causes could not be fully comprehended. The flat alluvial soil was neatly bounded on either side by the desert highlands; the cardinal points were prescribed by the northerly flow of the Nile and the westerly journey of the sun.

The annual cycle of the agricultural seasons, linked to the slow progression of stars and constellations, was punctuated by the movements of the sun and moon. The sun offered the most obvious measure of recurrent change, with alternating periods of blazing days and black nights. The moon and its predictable phases allowed the measurement of longer spans of time; the lunar month became the basis of the agricultural calendar and its concordant festivals. Every observance of nature—and as an agricultural civilization Egypt was subject to nature's rules and vagaries—confirmed the belief that life was cyclical, that time moved in a never-ending, ever-renewing circle.

The conception of divine kingship, based on the myth of Osiris, served as another important counterpart to these recurrent natural patterns. According to myth, Osiris, the primeval ruler of Egypt, was murdered by his brother, Seth, and was given sway over the land of the dead; after a period of titanic conflict, his son, Horus, rightfully succeeded to the throne of his father and restored order. Every king of Egypt, as the "living Horus," which his title proclaimed him to be, was the mythic successor of Osiris; at death he himself became an Osiris, to be worshiped by posterity. The throne then passed to his heir, the next living Horus. As the coronation of each king symbolized the reestablishment of order upon earth, the succession to the throne represented yet another cycle of time, which was reflected quite literally in the reversion in all dated documents to "year 1" at every royal accession.

In such a world, reassurance was to be found in the repetitiveness of life. The unusual or unpredictable innovation tended to introduce a note of chaos into a well-ordered universe. In religion, in art, in politics, and in social behavior, moderation and constancy were the supreme virtues, since these recalled the perfection of the world at "the time of the god," the moment of creation. This perfection, both physical and moral, was called *maat;* it meant "order" or "righteousness," and every human endeavor was supposed to be in accordance with it.

The Egyptian artist was therefore compelled by everything in his social and natural environment to create works that were in perfect balance and harmony with *maat,* and this could be achieved only by means of time-honored principles. It must also be noted that Egyptian aesthetics lies quite outside the Western tradition. Indeed, it preceded and, to some degree, influenced the Western approach. But

the very concept of fine arts, with all its present connotations, was something quite alien to ancient Egypt. Representational art was not made for the delectation of an informed observer, nor was much of it intended to be placed on public view. Rather, it played a crucial religious and mortuary role for both king and commoner. Conversely, while it is inappropriate to speak strictly of practical function in relation to modern works of art, function cannot be separated from the objects that have come to be considered the very pinnacle of Egyptian creativity; in fact, the purposes served by Egyptian art represent the primary reason for its remarkable resistance to innovation. These purposes pertained to two realms: the present life and the afterlife.

In the present world, the divine cult played a central role in propitiating the gods and assuring their lasting favor. The focus of the daily rituals was the feeding and clothing of the god's statue, which was imbued with the essence of the deity but otherwise seems to have had very much the same physical needs as an ordinary mortal. Divine statues (see Plate 53) were created as a means through which the gods might receive sustenance during the celebration of their cult rituals. Beginning with the Middle Kingdom, statues of nonroyal personages could be placed alongside royal sculpture in sacred precincts, to permit those who were depicted to share in the divine bounty so liberally dispensed during the temple services.

With regard to Egyptian beliefs concerning the afterlife, the preservation of the mummy was of paramount concern, for it was considered to be the abode of the soul (see Plate 21). The original purpose of private tomb sculpture was to provide an alternative refuge for the soul of the deceased, lest the more perishable mummy suffer the ravages of time. And, as with the representations of gods, statues of deceased mortals could therefore assist in maintaining the perpetual presence of the individual in the land of the living.

Two-dimensional representations served much the same purpose as sculpture in the round. Reliefs and paintings that decorated temples and tombs served not only to illustrate the daily temple rites or the amusements of the present life, they also ensured, in a very literal way, that those activities would continue far beyond the physical capabilities of the participants to perpetuate them.

The relation of art to religion is made explicit by the Egyptians themselves, in a creation myth that accords a primeval existence to Ptah, the patron god of Memphis and of all artisans. According to the Memphite cosmogony, Ptah was the creator god who breathed life into all things simply by uttering their names, and the high priest of Ptah at Memphis bore the title "greatest of craftsmen." Through the practice of his skills, the artist was endowed with the latent power of creation itself, for creation and existence were virtually synonymous. To fashion a thing or to speak its name was to lend it effectiveness and viability in the present world. The artist promoted this magical potency in his creations by conforming to the accepted norms; this left very little room for individualistic approaches, or innovative ways of interpreting the world.

Even before the beginning of the Dynastic Period (ca. 3100 B.C.), the rise of an organized state led to the primary use of sculpture and relief for the commemoration of royal power. Artistic standards originating in the Predynastic Period were perfected in the centralized royal workshops (see Plates 1 and 2), and for the next three thousand years they were used to express conservative religious and political truths concerning the immutability of the natural order. It is illuminating to note that temple reliefs normally consist of a series of rather repetitious scenes—the pharaoh making offerings to various gods—each bounded by familiar hieroglyphs: the flat land sign below; the heaven hieroglyph above, often dotted with stars; and a scepter signifying dominion on either side, representing the "four supports of heaven." Hence each scene is a small cosmos in which perfect order reigns. Just as monumental art was a portrayal of an ideal world, it became a reflection of that world as well, wherein progressive change was unwelcome—and therefore art itself acquired unchanging norms.

Those norms are most easily visible in relief and painting, where the Egyptian artist had to force a three-dimensional world into two dimensions. The composition of scenes was organized by registers that divided subjects into convenient compartments, while size was used to indicate the relative importance of the people and activities portrayed. These two conventions ruled out the development of perspective in Egyptian art through the use of diminishing scale or isometric views. Objects or people depicted in rows one over the other are frequently to be understood as being next to each other, or massed together in a great crowd.

The Egyptian rendering of the human figure in two dimensions was based on mathematical relationships. Drawn according to a strict canon of proportions, each part of the body was illustrated, as a rule, from its most characteristic viewpoint, so as to reflect its truest aspect. Thus the face was rendered in profile, with the protruding nose, lips, and chin easily portrayed; but the eye was drawn as if seen from the front, staring directly outward. The shoulders were not foreshortened, as a side view would dictate, but were also depicted from the front, while the arms, hips, and legs were in profile once again. The formalized convention of earlier periods simplified such minor considerations as right and left hands; both feet were portrayed as if viewed from the instep and thus each had, impossibly, one visible toe (see Plate 5).

Special cases were handled by means of special conventions. Foreigners were, of course, identifiable by their distinctive clothing and hair styles (see Plate 48), but occasionally the artists would take the opportunity to emphasize their barbarity through comic or grotesque facial features. Old age was signified by a wrinkled face and baggy eyes; childhood by nakedness and a forefinger held to the mouth. Obesity or unsightly folds around the stomach did not necessarily mean an individual was fat; these were conventions for indicating prosperity and success. Depending on the context, the same person might be represented in several ways, none of which would necessarily approximate his physical aspect or reveal features of his personality in the

7

manner of true portraiture. These standards were followed not because they were inherently excellent, or because they accurately depicted the visible world; it was simply that they embodied certain ideals that were universally accepted.

With a consistent striving toward a specified set of norms, experimentation and deviation were either unwelcome or produced results that would have been judged undesirable or chaotic. Artists as individual creative forces were non-existent; they did not advocate divergent avenues of exploration, nor did they form schools of artistic thought. As a consequence, there are virtually no signed works of art from ancient Egypt.

This reluctance to identify an object with its creator sprang not from a low regard of the artist, or from the attitude that his handiwork was not worthy of bearing his name. It arose from the fundamental Egyptian belief, manifest in the Memphite cosmogony, in the animation of inanimate forms through the use of words, both spoken and written. Language was as potent, if less tangible, a force as art, and hence in representational art—sculpture as well as relief—the name to appear must naturally be that of the subject portrayed, rather than that of the artist. Since statues or reliefs were not intended solely to imitate unique personal features or suggest character (see Plate 5), the subject's name was an essential part of the work. Correspondingly, attacks against the memory of an individual usually consisted of erasing his name rather than his physiognomy, which could, after all, represent almost anyone. A pharaoh wishing to claim an earlier king's work as his own simply carved his cartouche over the earlier one; such usurpation was technically defensible, since the present ruler was merely the last manifestation of the "living Horus."

The relationship between Egyptian art and language, then, is yet another aspect to be explored. To the untutored eye, the hieroglyphic script hardly looks as if it could have been intended as a medium for communication. The birds, insects, ritual emblems, and animal-headed figures that people its script look bizarre to the modern beholder, and even the ancient Greeks believed that the Egyptian priesthood had access to profound truths through the arcane script. Whatever message the hieroglyphs carry—and it is usually prosaic—they have a simple and immediate fascination for both novice and initiate: They are pictorial; they are art in miniature. Hence the influence of hieroglyphic writing on Egyptian art is as understandable as it is pervasive.

At the heart of any writing system lies a sense of orientation: The individual signs must indicate the direction in which the words are to be read. Although most languages are confined to a single directional flow, the purely pictorial nature of hieroglyphs allows them to be written from right to left or vice versa, either in horizontal lines or in vertical columns (see Plate 19). The majority of signs, especially those that depict human figures or animals in miniature, possess an inherent orientation because, being rendered in profile, they look either to the right or the left. It is hardly surprising, then, that a sense of orientation and balance lies

at the very heart of the conventions for carved relief and wall painting. With rare exceptions, the human figure is rendered in profile, and the accompanying name, formulaic speech, or descriptive caption is written in the same direction. Frequently, little distinction is made between a human figure in a wall relief and the hieroglyphs around it; the full-size representation can serve as the determinative sign for the individual's name. Less often, a hieroglyph was treated as the object or animate being it actually portrays; thus, signs depicting certain birds or reptiles believed to be potentially inimical were on occasion purposely mutilated (see Plate 34). The sense of direction, which derives ultimately from writing, is carried through into architecture as well. The walls of every monument were decorated so that the individual scenes would face consistently inward toward the focus of the building, or outward toward its entrance.

In sculpture, which is theoretically free of the tyranny of orientation that exists in the two-dimensional context, the relentless influence of Egyptian script can be traced in the striding stance, in which the left leg is customarily flung forward. Statues are seen in entirety only from the right side, when viewing the right profile, and it is surely no coincidence that in cursive writing an orientation toward the right is the rule.

Egyptian art, then, both reflected and helped to maintain the attitudes of the Egyptians toward their physical and spiritual environment, and was intimately related to the hieroglyphic system of writing, with which it developed at an early period. First impressions of Egyptian art, however, are often colored by its overriding application as material for the tomb. The predominance of funerary objects often fosters the misapprehension that the ancient Egyptians were forever preparing for their burial and for the preservation of their bodies. This circumstance derives less from a morbid concern with the afterlife than with the nature of archaeological preservation, and this, too, is largely an accident of the geography of the land. As an agricultural society drastically limited in its arable resources, the Egyptians built their towns near the great river that annually renewed their fields, but they erected their funerary monuments on the edges of the desert cliffs, away from land needed so badly for the cultivation of produce for human and animal consumption. The Nile has made slight changes in its course over the millennia, but it has nonetheless been confined to a rather narrow flood plain because of the limiting cliffs on either side. Town sites that have not been entirely lost due to erosion by the great river are locations that are still inhabited today, or are unsuitable for the preservation of organic material because of their proximity to ground water. The desert, on the other hand, provides an ideal climate for the preservation of artifacts.

Furthermore, not only have funerary monuments and their contents had a far better chance of surviving the depredations of time, but the ancient cemeteries have been conspicuous and convenient targets for tomb robbers, amateur antiquarians, and professional excavators for the last two hundred years. Most collections of Egyptian art inevitably have a sufficiency—if not an excess—of coffins, mummies,

servant figurines, canopic equipment, and funerary papyri; and private statuary, relief, and painting frequently derive from tomb chapels. By happy coincidence, the Egyptians included much of their domestic paraphernalia in the grave as well, for material possessions were thought to be almost as necessary for the deceased as the preservation of the mummy. Consequently there is a rich representation of furniture, cosmetic objects, jewelry, amulets, clothing, games, and food. It is these mundane items that help to give an accurate view of Egyptian life as it was lived and enjoyed.

In the few domestic sites preserved in Egypt, one can get rare and startling glimpses of the human side of the ancient civilization of the Nile valley. At the village of Deir el Medina, home of the workmen who built the royal tombs in the Valley of the Kings in western Thebes, thousands of painted limestone fragments have been found that detail the organization of work gangs, records of petty work transactions, oracular answers delivered by various gods, excerpts from favorite literary quotes of the day, and complaints against an accused adulterer. Limestone flakes, picked at random and used as doodling pads in idle moments (see Plate 49), depict kings spearing lions, men adoring gods, or—in a satirical vein—cats waiting on mice. Graffiti discovered on the walls of temples and tombs record the admiration of ancient tourists during their visits to yet more antique monuments. Papyri from the shelves of an abandoned administrative archive record the trial minutes of a gang of tomb robbers, at the same time shedding unexpected light on the rivalry between two high officials of Thebes, three thousand years ago.

And yet, despite all that has been said thus far, Egyptian art is by no means a monolithic tradition. Over the course of three millennia, significant changes can be traced. These changes are largely due to the strict interrelation between art, religion, and the Egyptian conception of the world, since changes occurring in any one of these domains was bound to affect the others. In the case of the artistic realm it was more often a matter of reflective, rather than innovative, change; divergences can be traced in both stylistic devices and in subject matter.

In dealing with countries outside its borders, Egypt had to cope with the effects of foreign influence from its earliest periods. Innovations appear as early as the Gerzean Period (ca. 3600–3200 B.C.), in the form of a suddenly sophisticated mastery of mudbrick architecture, the use of niched facades in buildings, and of certain motifs characteristic of early Mesopotamian civilizations. Some kind of communication with the Tigris-Euphrates valley, perhaps a trade route via the Red Sea around the Arabian Peninsula, may have existed to account for the sudden appearance of cylinder seals—a device ubiquitous in the Levant, used for sealing mud documents, but utterly useless for that purpose in Egypt, where the writing system evolved for use on stone and papyrus rather than soft clay tablets. The political and economic conditions that brought about contact with such a distant land cannot be clearly outlined but are mirrored in the artistic flowering of the Gerzean culture just prior to the unification of Egypt at the beginning of pharaonic history.

Oddly enough, outside influence on Egyptian art was minimal during later historical periods; on the contrary, Egyptian artistic conventions had a far greater impact on other cultures of the ancient Near East.

Significant domestic power shifts are often reflected in art, as during the First Intermediate Period (ca. 2160–2040 B.C.). Centuries of prosperity under the rulers of the Old Kingdom had culminated in an economic crisis and a disintegration of central authority during the ninety-four-year reign of Pepi II. Political control was subsequently exercised by a number of provincial governors scattered along the Nile valley, cut off to a greater or lesser degree from the influence of the old capital of Memphis. Isolated from the royal ateliers schooled in the magnificent traditions of the Pyramid Age, provincial artists were left free—for lack of guidance—to imitate or improvise as best they could. Reliefs and sculpture of the First Intermediate Period are by turn clumsy, charming, humorous, or garish; but they are inventive and constantly fresh to the eye, quite unlike the earlier programmed works of the Old Kingdom.

One of the sudden shifts in royal sculpture occurs in the reign of Senwosret III (ca. 1879–1841 B.C.) of the Twelfth Dynasty (ca. 1991–1786 B.C.), for reasons that are less obvious. The provincial families had retained a measure of independence during the first reigns of the Twelfth Dynasty, but a dramatic reorganization of the administration took place under Senwosret III, who eliminated the local districts and split the land into two or three large departments headed by administrators with no provincial ties, who were loyal only to the crown. The careworn features of this monarch, his spherical eyes sunk deeply into a furrowed face lined with age, are a startling contrast to the placid, idealized faces of his predecessors, and perhaps reflect a changed political reality (see Plates 26 and 27).

The dynasty that founded the New Kingdom (ca. 1559–1085 B.C.) refined the uses of propaganda. When she assumed pharaonic titles in precedence over her nephew, Tuthmosis III (ca. 1504–1450 B.C.), Queen Hatshepsut (ca. 1503–1482 B.C.) asserted divine birth and her selection by the god Amun as future king in a series of reliefs in her temples. Her most astonishing claim, however, was the rulership of Egypt as a male king, a claim affirmed in her mortuary sculpture, in which she is usually depicted with a man's physiognomy and the insignia and costume of a king. Obviously, this was not intended to deceive the public; instead it was a propaganda ploy to legitimize her accession. The conventions of Egyptian art made it easier for her to assert her claim.

Occasionally the urge to emulate the past, and thereby acquire the aspect of legitimacy, was so strong that direct imitation was the result. One archaizing period occurred during the first few reigns of the Twelfth Dynasty, when the new rulers went to great lengths in sculpture, relief, and architecture to recapture the artistic achievements of the Old Kingdom, indicating a desire to emphasize continuity with a glorious past and thereby acquire a reflected luster. Another such period was the early Eighteenth Dynasty (ca. 1570–1320 B.C.), at which time the statuary of the Middle Kingdom

still standing at Deir el Bahri in western Thebes served as models for an active workshop there. Perhaps the most unabashed tendencies to archaize were unleashed during the Saite Period (664–525 B.C.). Motifs from Eighteenth Dynasty tombs, in every detail, found comfortable homes again in tombs built eight hundred years later; stelae from periods as early as the Old Kingdom were faithfully copied for new tomb owners; certain statue types were revived, yet rendered in the Saite mode, with typically elegant and attenuated lines, the faces given bland, masklike expressions and a fine polish.

Changing religious ideas are evident in the appearance of anthropoid coffins at the beginning of the New Kingdom. The tomb was originally conceived as a house of eternity, where the deceased would reside forever. The rectangular sarcophagus, or coffin, in which the mummy lay was decorated as an abode for the dead, often carved with miniature niches or painted elaborately with an architectural motif that imitated a niched facade. A changed conception of the coffin is evidenced by the early anthropoid coffins, which were representations of the deceased as a wrapped body; the earliest examples show the person enshrouded by wings, later criss-crossed with bands of hieroglyphic text representing the bands that form the outermost layer of mummy bandages.

The most significant changes introduced into Egyptian art are to be found in the reign of Akhenaton (ca. 1379–1362 B.C.), whose own hand, either directly or indirectly, indisputably guided those of his artists. The reign of his father, Amenhotpe III (ca. 1417–1379 B.C.), had clearly been a period of experimentation in artistic styles, but it was Akhenaton who devised comprehensive new rules for the portrayal of the human figure: thin, slanted eyes and full, fleshy lips set into an elongated face with prognathous jaw; narrow shoulders and corpulent abdomen, large thighs and spindly limbs. An obsession with realism in detail also made its appearance at this time: wrinkles in the neck, earring holes, right and left feet vividly distinguished. Early depictions of the royal family are often compelling in their ugliness, and it has been suggested that, in accordance with the tendency of all representations to imitate the royal standard, their physiognomy approximates the appearance of Akhenaton himself, perhaps a victim of a deforming medical disorder. But one must keep in mind the perennial Egyptian abhorrence of true portraiture, which was not the purpose of representational art. Furthermore, portrayals of the same family members range from the grotesque to the unusual to the beautiful. While the bust of Nefertiti from Akhenaton's capital at Tell el Amarna is, for the present generation, the epitome of Egyptian beauty, is it more faithful than any other of the queen's portraits?

It is far more likely that this artistic revolution is not a conscious experiment in aesthetics, but a reflection of the equally drastic changes that took place simultaneously in the religious sphere. Akhenaton's most notable achievement was his attempt to impose his personal deity, the Aton, the "disk of the sun," over all other gods in the traditional Egyptian pantheon. In point of fact, the emergence of his idiosyncratic theology can be dated prior to the appearance of the new style in art. Akhenaton may have realized that the religion of the Aton could not be promoted within the framework of a tradition that constantly looked back toward a perfect creation initiated and populated by a multitude of gods—that the cult of the Aton had to be communicated in a new idiom, devoid of reference to a preconceived world order. The art of Akhenaton's reign illustrates, in a manner rarely demonstrated in other historical periods, the intimate correlation between Egyptian art and religion.

The notion that these extraordinary innovations were directed by the personal dictates of Akhenaton is strengthened by the evidence that his death was promptly followed by a return to the old religion and the reassertion of familiar artistic conventions. Certain legacies remained, especially in the realm of realistic detail, but they did not introduce a sustained realistic approach in art. They had originated from a revolutionary religious view, but they survived because, in time, they had simply become part of the artist's repertoire.

Other changes in Egyptian art were due to adaptations to new media or to changing preferences in funerary customs. These phenomena occurred sporadically throughout pharaonic history. The magnificent slate palettes of the Predynastic (ca. 4300–3000 B.C.) and Archaic periods (ca. 3100–2686 B.C.), eloquent witnesses to the skill of early craftsmen, disappeared completely with the development of buildings made or veneered with stone. They were now replaced by these more permanent monuments, for whose decoration they had served as prototype. Similarly, the primary function of Old Kingdom tomb reliefs was the perpetuation of the activities and material supplies thought necessary to a life after death. Desire for greater realism led to the production of three-dimensional portrayals of these activities and provisions: miniature models whose high point is to be found in the brilliantly painted boats and workshops of Mekutra (see Plates 15 and 16). By a later reversal, the fad for large, detailed models died out within a few centuries and was replaced once again by a preference for tomb reliefs.

The brilliant and crowded ornamentation of the coffins of the Third Intermediate Period (ca. 1085–656 B.C.) coincides with certain changes in tomb decoration, perhaps necessitated by an unstable domestic situation following the decline of Egyptian power at the close of the New Kingdom (ca. 1085 B.C.) and a subsequent division of the country between the kings of Tanis and the high priests of Amun at Thebes. The coffins (see Plate 51) were now deposited in roughly hewn burial shafts that were utterly devoid of adornment. But the decoration once confined to the walls of tomb chapels was now applied to the coffins themselves, in the hope that they would better survive the unwelcome attentions of vandals. Thus these later coffins vibrate with color, some so elaborate that the details can hardly be distinguished: painted bouquets, apotropaic pectorals, bands of hieroglyphic texts, and vignettes of the deceased with the gods.

In cultural spheres outside art, the accomplishments of the ancient Egyptians were manifold. By no means the least of their achievements was the survival of a unified political tradition for almost three millennia. It was only the conquest of Egypt by Alexander the Great in 332 B.C. that initiated an unbroken span of foreign domination that continued until this century. For the thirty dynasties (ca. 3100–332 B.C.) listed in the ancient annals as legitimate, each king considered himself the direct political heir of Menes, the first king of a unified Egypt, and the direct spiritual heir of Osiris. The hieroglyphic writing system, unwieldy as it was, continued in use from its origins prior to the unification of the land (ca. 3100 B.C.) at least to the last known text, inscribed in A.D. 394. The spoken language survives to the present day as Coptic, a framework of pharaonic syntax with a partial overlay of Greek vocabulary; it is used as a liturgical language in the Coptic church but is not spoken as a colloquial tongue. Egyptian craftsmen mastered the tools of their trade in every sense. Stone carving, woodworking, and jewelry making reached several points of perfection; certain ancient methods, such as colloidal soldering as a lapidary technique, have only recently been rediscovered. Complete mastery of stone as a building material was achieved within a century of its first appearance. The Great Pyramid of Khufu (ca. 2589–2566 B.C.), the largest stone structure ever built, stands as proof of their prowess.

To Western civilization, the Egyptians left a very mixed legacy, and one that was largely diluted by the introduction of Christianity and by the Islamic conquest. The present Gregorian calendar is based ultimately on the Egyptian civil calendar, which contained an unvarying 365 days—an approximation that was apparently close enough for short-term administrative purposes. The canon of proportions prevalent during the first millennium B.C. was passed on to the Greeks and appeared in the archaic statuary of that culture, although the comparatively rapid developments in Greek sculpture in subsequent centuries illustrates as well as any other criterion the vast difference in intellectual outlook between the two civilizations. In the areas of mathematics, medicine, and philosophy—at least from such examples as are preserved to us in papyri—the Egyptians were vastly outstripped by the Greeks, although, paradoxically, they had a reputation among the Hellenes for a profound wisdom that was hidden in the hieroglyphs, fathomable only by the sacerdotal class. The latest-known hieroglyphic inscription appeared shortly before A.D. 400, after which knowledge of the ancient script was soon lost; even at that date most of the existing monuments, as well as a rich and varied body of literature, were a book closed to the world.

The rediscovery of ancient Egypt is primarily due to the efforts of two Frenchmen, a young general, Napoleon Bonaparte, and a child prodigy, Jean-François Champollion. Napoleon's expedition to Egypt in 1798 had as its goal the control of the Suez trade routes to the riches of India. Along with the army traveled a group of scientists who intended to record the geography, botany, geology, architecture, crafts, and antiquities of Egypt. Although the French occupation of Egypt was a strategic failure, the publication of the *De-scription de l'Egypte*, which began in 1809, aroused an intense and enduring fascination with the ancient civilization of the Nile.

The key to that civilization lay in the decipherment of the hieroglyphs, which were thought to be exclusively ideographic. Through classical records, the myth of the wisdom of the Egyptians had survived into the Renaissance, at which time attempts at divining the Egyptian texts were based on elaborate allegorical interpretations, each sign representing an idea or phrase. By the early 1800s, the quest for decipherment had focused on the trilingual inscription of the Rosetta Stone, which recorded a decree of Ptolemy V in Greek, demotic, and hieroglyphs. The stone itself—later confiscated by the British—had been discovered by one of Napoleon's soldiers, and, in 1822, using the Ptolemaic decree from the Rosetta Stone in combination with other sources, Jean-François Champollion revealed the basic phonetic nature of the hieroglyphic script as well as its direct relation to Coptic, which had become extinct as a colloquial language.

During the next decades, agents of collectors and of foreign consuls laid unofficial claim to antiquities sites and began a systematic removal of large objects for resale to European museums, whose interest in things Egyptian had been newly awakened. The founding of an antiquities organization in 1858 slowed the wholesale export of an irreplaceable national resource; henceforth, permission to excavate was strictly licensed, even though archaeology as a science was in its infancy. The search for art treasures has gradually become a quest for knowledge, for the context of archaeological finds is infinitely more precious than their intrinsic value.

Despite an ever-increasing flow of information, innumerable questions remain to be answered about ancient Egypt; with the solution of old problems, new ones are constantly posed. A fairly coherent chronological framework now allows for the examination of larger social issues, such as the emergence of occupational classes or the political effects of an agrarian economy. Once the rudimentary sense of the language had been discovered, linguists could proceed to explore its tenses and compositional structure, as well as its lost vocalization. Despite the lack of domestic sites, settlement patterns and the relation of towns and their surrounding environments are recent subjects of inquiry. In art a number of avenues are being pursued: the role of the individual artist, the relationship between royal and private sculpture, the commissioning of works of art, the operation of royal workshops, and—despite all that has been said above—the identification of individual artists' styles.

In all these disciplines, the dominant impression is the astonishing interdependence of all aspects of Egyptian civilization, which resulted in a cohesiveness that outlasted centuries of foreign domination. But it is the ancient artist who has left for the modern observer the face of a vanished world, a face that reveals a profound and serene belief in the endurance of the human spirit.

Peter F. Dorman

PREDYNASTIC CARVED IVORIES

Many of the characteristics of the art of pharaonic times are evident very early in Egyptian culture. During the late Predynastic Period—before the kingdoms of Upper and Lower Egypt were united in 3200 B.C. under Menes, the first of the pharaohs—artisans were already decorating utilitarian objects in ways that were to be repeated in Egyptian relief sculpture over the next three thousand years: the division of figures into separate registers, formalized perspective, careful spacing, and rigid orientation.

Two of the earliest pieces in The Metropolitan Museum's Egyptian collection are a carved ivory knife handle (Plate 1) from the collection of Lord Carnarvon—whose expedition discovered Tutankhamun's tomb—and an ivory comb (Plate 2). Both pieces date from about 3600 to 3200 B.C. The carved ivory pieces that were produced during this time are among the most interesting finds of the period. Both pieces are decorated with many of the same animals arranged in roughly the same fashion.

The knife handle, carved from a single piece of elephant tusk, is a magnificent product of the craftsmanship of Predynastic Egypt. In the upper register, a wading bird and a giraffe are followed by more wading birds with long beaks; next, an African elephant, treading on two cobras, leads a file of three lions. At the bottom stand three oxen and another lion.

The delicately carved relief decoration on the ivory comb portrays the same animals as those on the knife, except for the addition of a hyena. The similarity of subject leads us to suspect that the choice of animals was not haphazard: They may represent the emblems of Predynastic clans or districts to which the owners of these objects belonged.

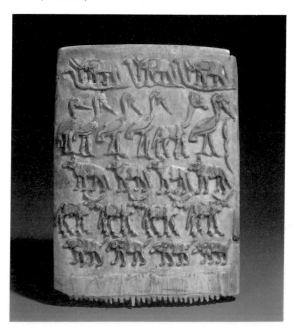

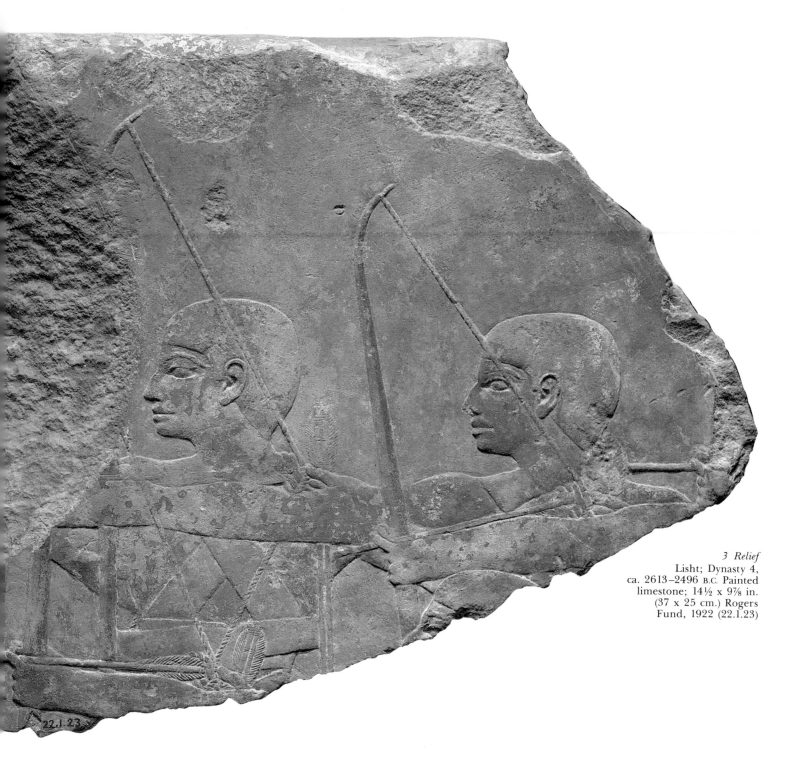

3 Relief
Lisht; Dynasty 4,
ca. 2613–2496 B.C. Painted
limestone; 14½ x 9⅞ in.
(37 x 25 cm.) Rogers
Fund, 1922 (22.1.23)

Painted Limestone Relief

The Fourth Dynasty lasted from about 2613 to 2498 B.C. During this time, the country was united under a highly organized and centralized government that functioned around the divine figure of the king. The massive pyramids at Giza, about eight miles southwest of Cairo, were constructed to enshrine the majesty of the deceased ruler.

Khufu (Cheops), who was the second ruler of the Fourth Dynasty, reigned from around 2589 to 2566 B.C. His tomb, now known as the Great Pyramid, is the largest stone building ever constructed by man. Covering an area of thirteen acres, it has a solid masonry core composed of some 2,300,000 great blocks of coarse yellow limestone, which were once covered by a smooth casing of white limestone. It has been estimated that to build this single monument, one hundred thousand of Khufu's subjects must have worked uninterruptedly for at least twenty years.

Some six centuries later, blocks of limestone reliefs that once adorned the pyramid temple were transported south to Lisht where they were reused by the builders of a Twelfth Dynasty pharaoh, Amenemhat I (ca. 1991–1962 B.C.), as a construction fill for his own tomb. Uncovered by The Metropolitan Museum's archaeological expeditions conducted at Lisht between 1906 and 1934, the reliefs reveal the consummate artistry of the Fourth Dynasty craftsmen.

This fragment, from the core of the North Pyramid, shows portions of five overlapping archers—a composition rare in Egyptian carving of any period. The work is of the highest quality, flat but with subtle modeling; only the ears stand out in a higher relief. The twisted bowstrings and arrow feathering are indicated with fine attention to detail. In style, this work matches the best examples of Fourth Dynasty art.

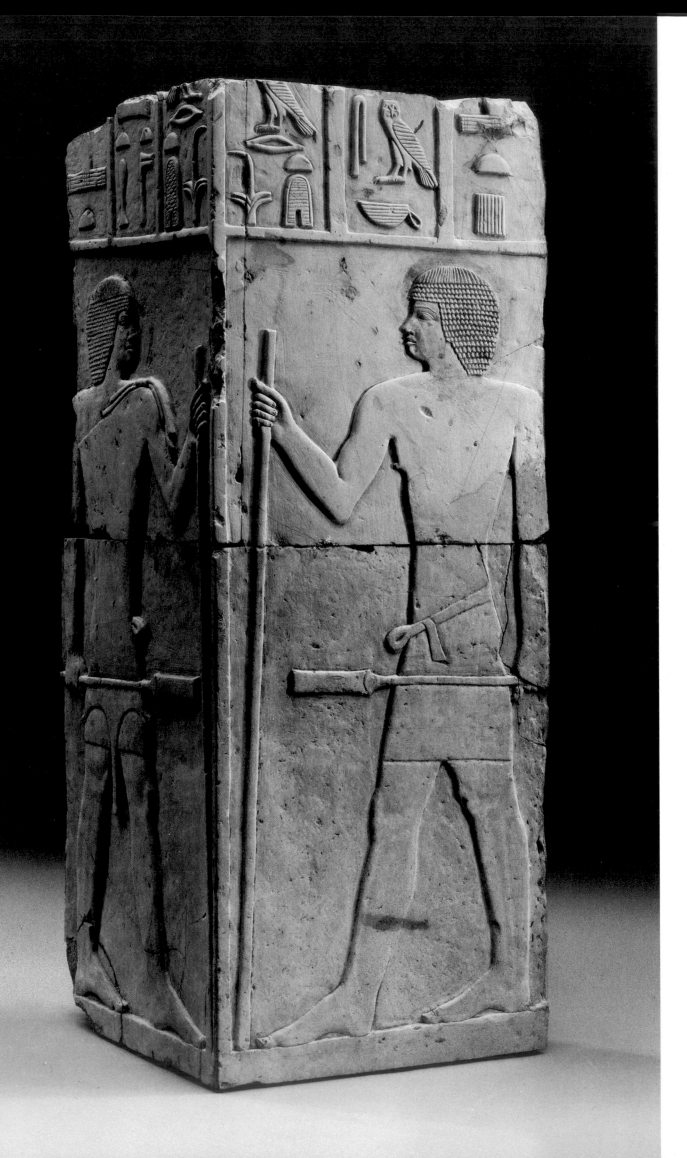

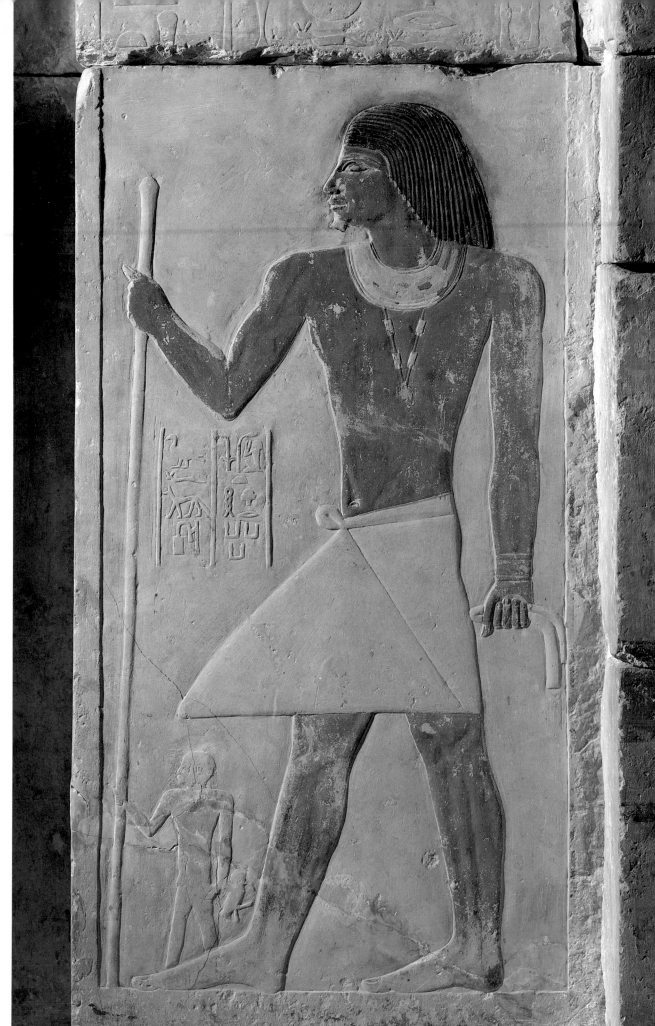

4 Relief
Saqqara; Dynasty 4,
ca. 2613–2498 B.C.
Limestone; H. 38 in.
(96.5 cm.) Funds from
various donors, 1958
(58.123)

Page 16: text

5 Relief
Saqqara; Dynasty 5,
ca. 2498–2345 B.C.
Painted limestone;
H. of main figure 39¾ in.
(100.9 cm.) Rogers Fund,
1908 (08.201.2)

Page 16: text

15

Representations of the tomb owner, with his name and titles, were the most important feature of any decorated Egyptian tomb. They were not only more numerous, but also larger and often more carefully worked than the images of anyone else. These two details, from tombs of the Fourth and Fifth dynasties, illustrate the ways in which the tomb owner was typically portrayed and indicate some of the changes in relief style that occurred during the time of the Old Kingdom (ca. 2686–2160 B.C.).

The earlier example (Plate 4) is the base of a corner from a niched chapel in the Fourth Dynasty tomb of Akhtyhatpu, decorated on two sides with his figure. His costume, like the titles above each figure, has been deliberately varied, to perpetuate the scope and variety of his activities. The relief is high and rather sharply cut, giving a bold but somewhat heavy effect. Little of the internal detail has been carved, but no doubt it was originally provided in paint, since the reliefs would have been fully colored. Their thickness and simplicity make these reliefs look a bit old-fashioned, even for the early years of the Fourth Dynasty; it is possible that the figure of Akhtyhatpu provides an early example of the perennial Egyptian tendency to seek models in the venerated works of the past.

The relief at the right (Plate 5) represents the judge Nykauharu of the Fifth Dynasty facing his false door; it is but a part of a larger section in The Metropolitan Museum's collection from the west wall of his tomb chapel. Nykauharu has permitted one of his sons to join him here. The son's inscription, below his father's elbow, shows that he was named after his father and held several titles, including that of judge. We must assume, therefore, that this diminutive naked child, clutching a hoopoe bird and clinging to his father's staff, was in reality a full-grown man by the time the relief was made. Both the use of the delicate low relief technique and style of dress depicted—the elaborately curled wig, the jewelry, and the stiffened kilt—are typical of art of the Fifth Dynasty.

SAHURA AND A DEITY

Statues and statuettes of kings of the Fifth Dynasty are exceedingly rare. The Metropolitan Museum, however, possesses a fine gneiss group portraying King Sahura (ca. 2487–2473 B.C.) seated upon his throne, accompanied by a male figure personifying Koptos, the fifth nome, or province, of Upper Egypt. Each of the nomes—of which ancient records reveal twenty-two in Upper Egypt and twenty in Lower Egypt—possessed its own loosely defined boundaries, capital town, and local god, whose fetish often served as the emblem of the district itself. Many of these nomes survived as administrative units to the end of ancient Egyptian history.

The king's headdress is the royal *nemes,* a striped wig cover of stiff linen cloth or, possibly, leather. The device that surmounts the *nemes* is the hooded head and serpentine body of the cobra, or uraeus, an emblem of the sun god Ra of Heliopolis that distinguished his earthly representative, the pharaoh. The Fifth Dynasty was fostered by the ancient and powerful priesthood of Ra, who had by then become the state god of all Egypt.

The smaller figure, wearing the archaic wig and long, curved beard of a god, is identified by the standard of the nome of Koptos that surmounts its head: two falcons standing on perches side by side. With his outstretched left hand the nome god presents to Sahura the symbol of life, the *ankh,* and, in his right hand, he holds a symbol that perhaps represents universal dominion. At the edge of the broken surface in front of the feet of this figure we can make out the first words of the speech that the nome is addressing to the pharaoh: "I have given to thee [every] thing [which is in Upper Egypt]."

This statue, purchased in the town of Luxor, may be from the nearby site of ancient Koptos, which was the residence of the god Min and the starting point of the much-used caravan route to the Red Sea.

6 Sahura and a Deity
Dynasty 5, ca. 2487–2473 B.C.
Gneiss; H. 24¾ in. (62.9 cm.)
Rogers Fund, 1918 (18.2.4)

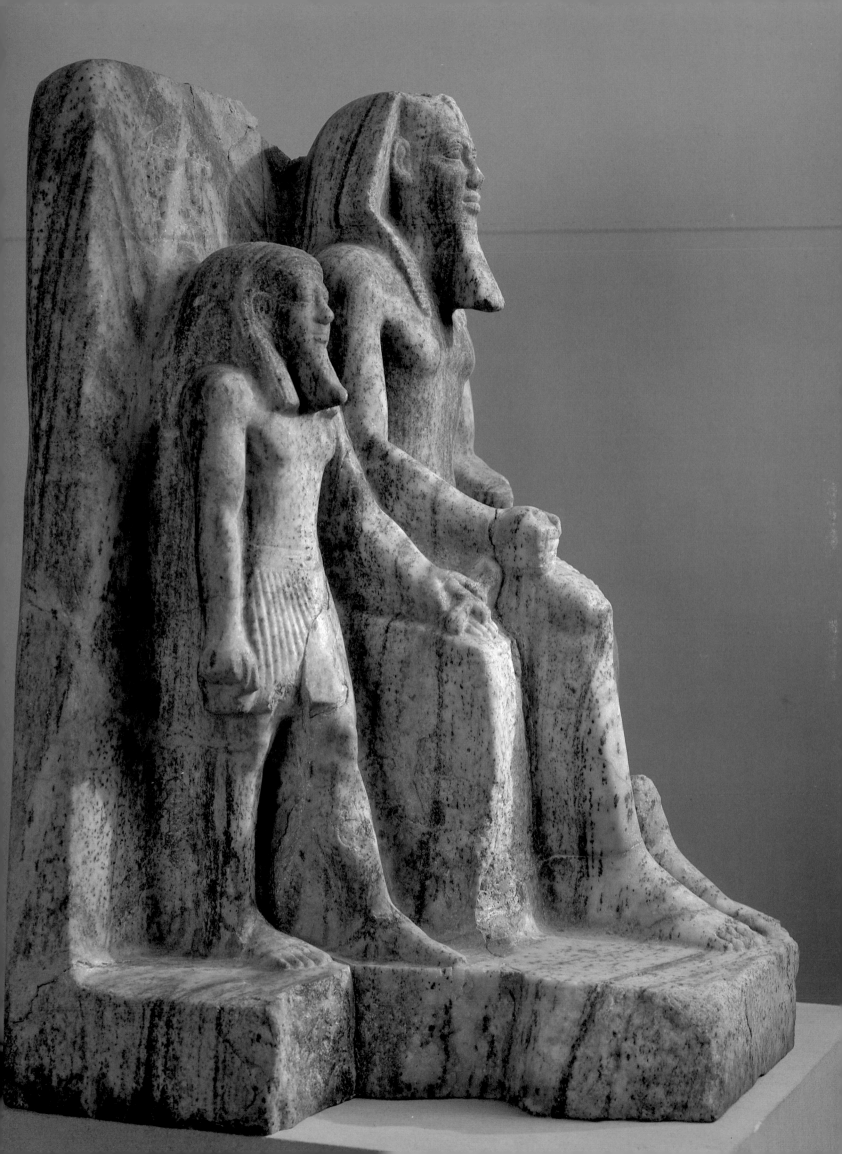

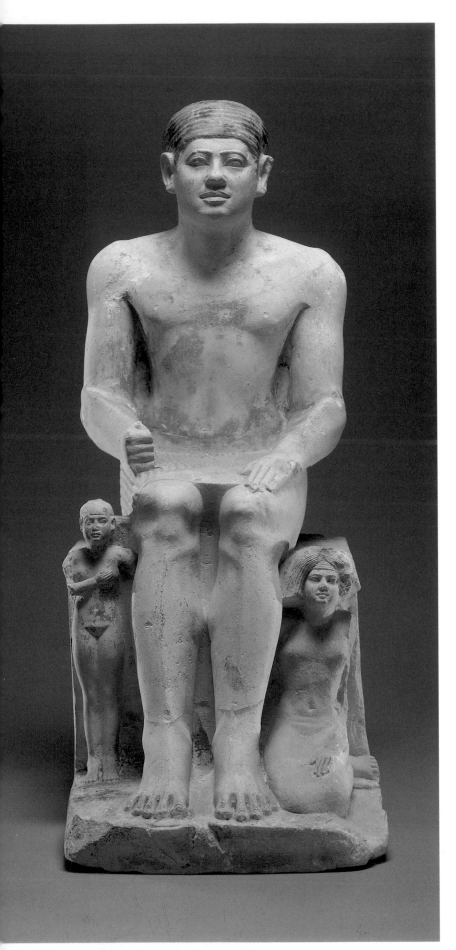

8 Statue of Merti
Saqqara; Dynasty 5,
ca. 2498–2345 B.C. Wood;
H. 39¼ in. (99.7 cm.)
Rogers Fund, 1926 (26.2.4)

TWO TOMB STATUES

The statues placed in Egyptian tombs of the Old Kingdom provided habitations for the *ka,* or spirit, of the deceased. Made either of stone or wood, they were normally painted in appropriate colors, which, though wholly conventional, added considerably to the naturalism of the figures.

The extent to which these *ka* statues were portraits of the tomb owner varied considerably with the individual sculptor. Certainly, reality and individuality were qualities much desired in a tomb statue, but so were good taste, dignity, and the wish to perpetuate the face and figure of a man, not as he may have appeared on the day the statue was ordered, but rather as he would want himself remembered throughout eternity—in the prime of life, with a face and figure unravaged by age and infirmity. Moreover, there was a tendency during all periods of Egyptian art for the artisans, trained in the ateliers of the court, to adopt the oft-studied features of the reigning pharaoh as the ideal facial type and, consciously or unconsciously, to make every portrait that they executed conform more or less to this type.

Statues such as the one at the right (Plate 8) of Merti, a provincial governor, privy councillor, and priest of Maat, the goddess of truth, provide us with the opportunity to study Old Kingdom costume in three-dimensional detail. Both men and women, for instance, appear to have cropped their hair close to their heads and, when appearing in public and on formal occasions, wore wigs made of numerous fine tresses or braids of human hair. Men's clothing consisted solely of a linen kilt, which could be either short and snug, ending well above the knees, or long and full, extending almost to the ankles. The full kilt, long or short, was frequently tailored and starched to form at the front a flaring, triangular apron such as the one worn by Merti.

There is, naturally enough, a difference in proportions and style between the stone statues and their wooden counterparts. Working in limestone or granite, the sculptor, though free to proportion his figures as he desired, was not always able to achieve the detail and sensitivity of modeling attainable by the wood carver. The latter, on the other hand, was restricted by the dimensions, especially the diameter, of the logs that he was able to obtain, and his figures tend to be unnaturally slender and attenuated.

The sculptors of the huge cemetery at Saqqara developed a style that was devoid of individuality but extremely competent and attractive. The statue at the left (Plate 7) of the granary foreman, Nykairau, with his wife and daughter is a good example. The faces of all three are nearly identical. The tomb owner, Nykairau, however, definitely holds pride of place. His naked little girl hangs on to one leg, while his wife, Nykainebty, nestles beside the other, in a charmingly feminine and clearly dependent pose. The fringe of curls on her forehead represents her own hair beneath her heavy wig. The great discrepancy in the size of the figures, common in Old Kingdom art, was modified in later periods but never entirely abandoned.

7 Nykairau, His Wife, and Daughter
Dynasty 5, ca. 2456–2345 B.C. Painted
limestone; H. 22½ in. (57.2 cm.)
Rogers Fund, 1952 (52.19)

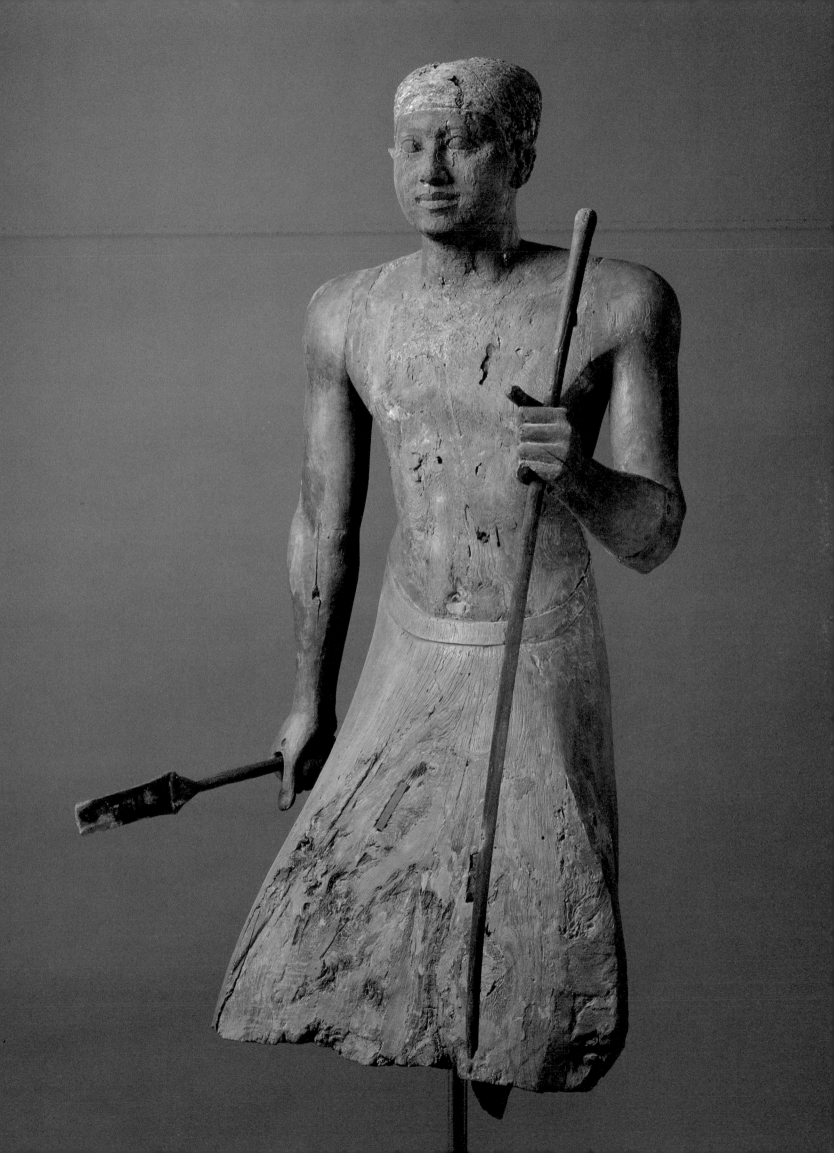

Cosmetic Jar in the Form of a Monkey

Even as early as the Old Kingdom (ca. 2686–2160 B.C.), monkeys were imported into Egypt from farther south in Africa. They were sometimes trained to gather fruits from the branches of trees out of reach of human hands, and they were frequently pictured assisting in wine pressing and jumping through the rigging of ships. But above all, they were prized as pets, and representations of monkeys were frequently used to adorn the intimate objects of daily use.

The long-tailed monkey represented in this alabaster vessel is of the *Cercopithecus aethiops* variety, whose natural habitat was the forest trees of sub-Saharan Africa. The monkey's pose is common in the minor arts of the late Old Kingdom: a mother, resting on her haunches, with her baby, who is clinging to her with all four limbs, clasped to her breast. Carved of semitranslucent alabaster, the vessel is one of the best-preserved examples of this popular motif.

The inscription on the right arm reads, "King of Upper and Lower Egypt, Merenra, living forever." The figure and the inscription are especially apt, since King Merenra (ca. 2283–2269 B.C.) is noted for having cut a series of ship canals through the rocks of the First Cataract of the Nile, thus facilitating communication and trade with the lands south of Egypt from which monkeys like this one were imported.

9 *Cosmetic Jar*
Dynasty 6, ca. 2283–2269 B.C.
Alabaster; H. 7¼ in. (18.5 cm.),
Diam. 3 in. (7.5 cm.)
Theodore M. Davis Collection,
Bequest of Theodore M. Davis,
1915 (30.8.134)

Memisabu and His Wife

The Fifth Dynasty saw a growth in government bureaucracy, both in its actual size and in the number of social strata represented by the officeholders. Statues such as this one depicting Memisabu, a steward and keeper of the king's property, and his wife were commissioned by officials of middle rank for placement in their tombs. This statue can be linked stylistically with monuments from the cemetery west of the Great Pyramid of Khufu (Cheops) at Giza.

Customarily in Egyptian sculpture the wife is represented embracing her husband, but here Memisabu and his wife each embrace the other. This suggests that she—and not her husband—was the tomb owner, a supposition further strengthened by another Old Kingdom statue in which a queen embraces her daughter, who is clearly identified as the owner elsewhere in the tomb.

10 *Memisabu and His Wife*
Dynasty 5, ca. 2360 B.C.
Painted limestone;
H. 24⅜ in. (62 cm.)
Rogers Fund, 1948 (48.111)

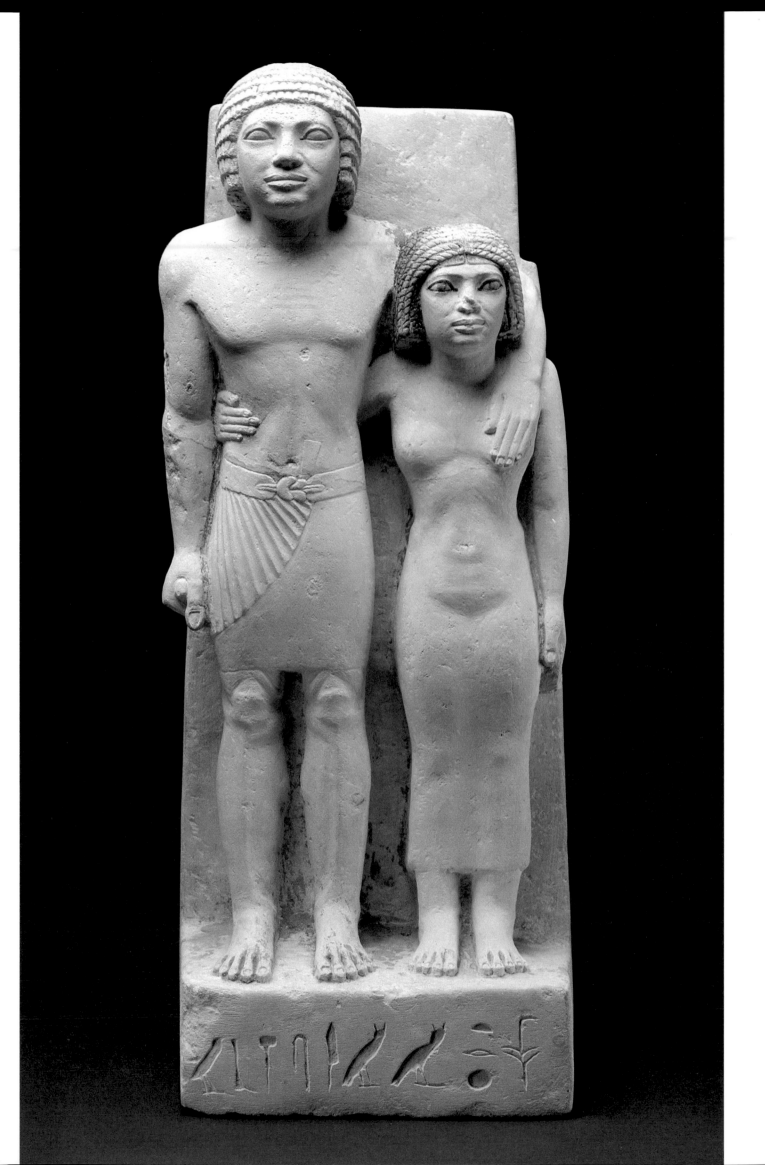

FALSE DOOR OF MECHECHI

The false-door stela, placed in the chapel of Old Kingdom mastabas—oblong-shaped tombs with sloping sides and flat roofs—served as a magic door through which the deceased in the next life received nourishment in material or ritual form. This false-door stela bears ten sunk-relief inscriptions that include the name of Mechechi, an overseer of the palace staff. The texts request offerings and beneficences on Mechechi's behalf. Several of the inscriptions describe the deceased as being "revered before Unis," the last king of the Fifth Dynasty, perhaps an indication that Mechechi's tomb was located near that of the king, at Saqqara. The fine quality of this piece is especially apparent in the sharp carving of the inscriptions and the eight portrayals of the deceased, whose elongated proportions and minimal modeling are typical of Sixth Dynasty reliefs.

11 False Door of Mechechi
Dynasty 6, ca. 2345–2181 B.C.
Limestone; 43 x 24⅜ in.
(109 x 66.5 cm.) Gift of
Mr. and Mrs. J. J. Klejman,
1964 (64.100)

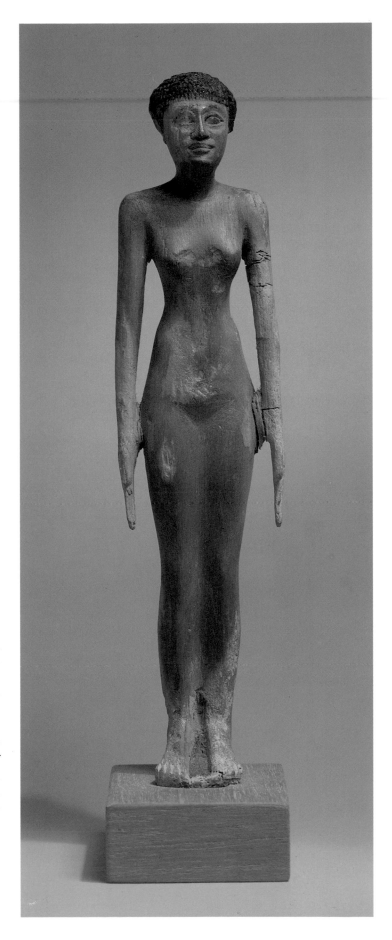

STATUE OF A YOUNG WOMAN

This late Old Kingdom wood figure was probably placed either in the sealed statue chamber of a mastaba tomb—together with other representations of the tomb owner and his family—or in the burial chamber of the young woman's own tomb. The face, with its large eyes and deeply incised lines, is lively rather than beautiful; the cranium, accentuated by the closely cropped hair, is unusually elongated, and the proportions of the slightly modeled body have been greatly attenuated in a manner characteristic of the late Old Kingdom. The arms and hands were formed from separate pieces and joined to the body. This carved statuette is one of the few extant objects of its kind convincingly dated to this early period.

12 Statue of a Young Woman
Dynasty 6, ca. 2345–2181 B.C.
Painted wood;
H. 11⅜ in. (28.8 cm.)
Harris Brisbane Dick Fund,
1958 (58.125.3)

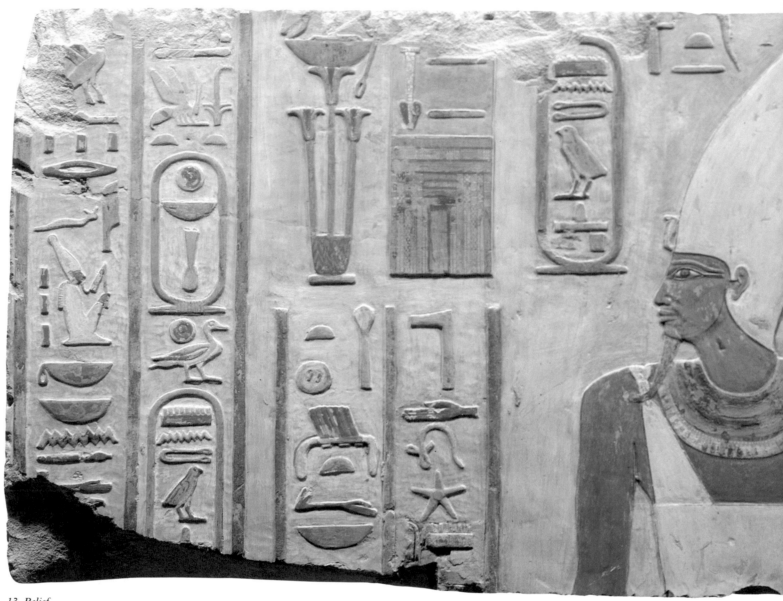

13 Relief
Thebes, Deir el Bahri,
Temple of Mentuhotpe II;
Dynasty 11, ca. 2040–2010 B.C.
Painted limestone;
14⅛ x 38⅝ in. (36.2 x 98 cm.)
Gift of Egypt Exploration
Fund, 1907 (07.230.2)

PAINTED LIMESTONE RELIEF

By around 2160 B.C. the Old Kingdom had collapsed. Centralized authority had already weakened, and the provincial governors of the nomes, or local districts, had regained a large measure of political control over their own territories. Although two dynasties, the Ninth and Tenth, reigned during this period, their authority seems to have been limited to the northern part of Egypt.

Egyptian art of the First Intermediate Period reflects the political fragmentation that prevailed during this unsettled time. Though often imbued with spirit and originality— qualities seldom emphasized in the royal ateliers of the Old Kingdom—the art of the period lacks the technical ability and sense of consistent style that marked the great works created during the Fourth and Fifth dynasties.

In about 2134 B.C., Inyotef I (ca. 2134–2131 B.C.), the ruler of Thebes, felt powerful enough to style himself "King of Upper and Lower Egypt." Although neither he nor the three rulers who followed him exercised any real authority over

the country, Inyotef I is traditionally regarded as the founder of the Eleventh Dynasty.

It was during the long reign of Mentuhotpe II (ca. 2060–2010 B.C.) that Thebes truly became the capital of a united kingdom. Mentuhotpe built extensively in and around Thebes. Just to the west of the city he erected an elaborate funerary temple from which comes this brilliantly colored limestone relief, discovered in 1906–07 by Edouard Naville. Mentuhotpe II is portrayed wearing the White Crown of Upper Egypt, a broad jeweled collar, and a white garment held in place by a shoulder strap. Uncommon care has been taken with the fine details of the hieroglyphs, the subtle shading of the king's eye, and the miniature patterning of the rectangular panel in front of the king's face.

The goddess Hathor, whose damaged figure, adorned with the horned sun disk, stands at the right, declares in the accompanying text, "I have united the Two Lands for you according to what the souls of Heliopolis have decreed." The words are conventional, but, in fact, they do commemorate Mentuhotpe's legacy: a restored and reunited kingdom.

The seat of royal power, located in the north at Memphis during the Old Kingdom, and at Herakleopolis during much of the First Intermediate Period, moved south to Thebes in Upper Egypt after the reunification of the land by Mentuhotpe II. There, artists of the late Eleventh Dynasty worked for a united state, as had their forebears during the great Fourth and Fifth dynasties. As Egypt regained its prosperity, the qualities we most admire in Old Kingdom art began to reemerge: the use of long-established conventions, consistent draftsmanship, technical perfection, and a fine sense of composition. But because the new artists of the south were the products of a provincial Theban tradition, now newly acquainted with the Memphite tradition of the Old Kingdom craftsmen, their homely interest in exquisitely rendered detail brought a freshness to the hallowed art of the past that still served as their model.

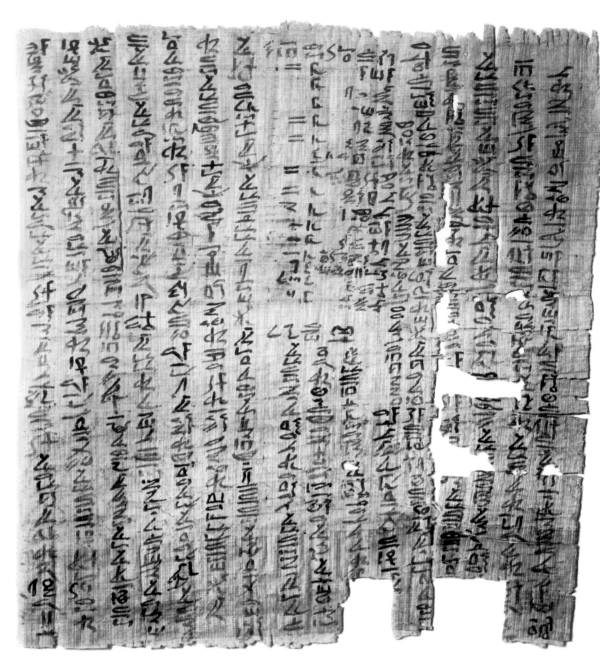

14 A Farmer's Letter
Thebes; Dynasty 11,
ca. 2009–1991 B.C.
Papyrus; H. of detail
10⅝ x 16⅛ in. (27 x 41 cm.)
Rogers Fund and
Edward S. Harkness Gift,
1922 (22.3.517)

Opposite: detail

A FARMER'S LETTER

These documents were found in a pile of debris in a tomb near Thebes. They belonged to a *ka* priest by the name of Hekanakhte, who may have served the funerary cult of the vizier Ipi during the Eleventh Dynasty (ca. 2133–1991 B.C.). The documents, only a portion of which is reproduced here, consist of four letters, three accounts, and some fragments. The letters deal with the affairs of Hekanakhte and his family; the accounts mostly reckon grain. The writer has apparently been traveling far from home on some unspecified business during a period of famine throughout the country.

Hekanakhte writes Ipi, his mother, and Hetepet, an unidentified female relative:

How are you two? Are you alive, prosperous, and healthy? Be in the favor of Montu, lord of Thebes! To the entire household: how are you? . . . Do not be anxious about me, for I am healthy and alive. Behold, you are like the one who eats his fill, having once been so hungry that his eyes sank in, although the entire land is dead from hunger. . . . Moreover, is the Nile very high?—for our rations have been fixed for us in accordance with the nature of the inundation

[A carefully itemized ration list follows.]

So it may be said that to be half alive is better than death outrightthey have begun eating people here

Farther on, he addresses Merisu, his eldest son:

Be very careful. Hoe my fields, sift with the sieve, hoe with your noses in the work. . . . Moreover, as for every possession of Anpu [the writer's middle son] which is with you, give it back to him; as for that which has been destroyed, repay him for it. Do not make me write to you again concerning it, for I have already written to you about it twice! If it be that Snefru [the writer's youngest son] is desirous of being in charge of the bull, you shall put him in charge of it. Neither did he want to be with you, cultivating and going back and forth, nor did he want to be here with me. Instead, it is with everything he desires that you will cause him to be content. . . .

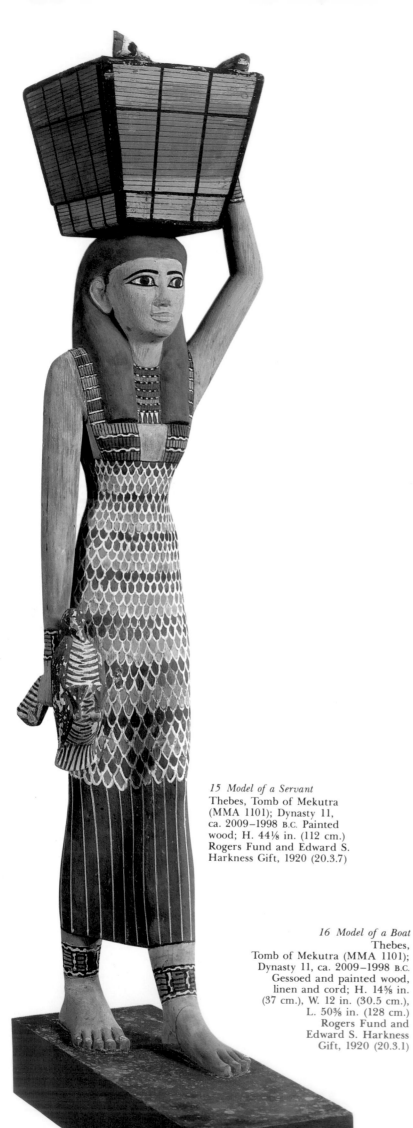

PAINTED WOODEN MODELS

Adequate provisioning for the afterlife was a paramount concern to Egyptians of every social and occupational class. While funerary offerings and activities of everyday life were most often portrayed in relief during the Old Kingdom, small painted models placed in the tomb became increasingly prevalent during the First Intermediate Period as a more effective way of perpetually ensuring the necessities and pleasures of life.

In the tomb of Mekutra, a chancellor who served both Mentuhotpe II and III, an expedition led by The Metropolitan Museum in 1920 uncovered twenty-three painted wooden replicas of the chancellor's house and garden, the shops of his estate, his fleet of ships, his herd of cattle, and his servants bringing offerings to his tomb—all executed in

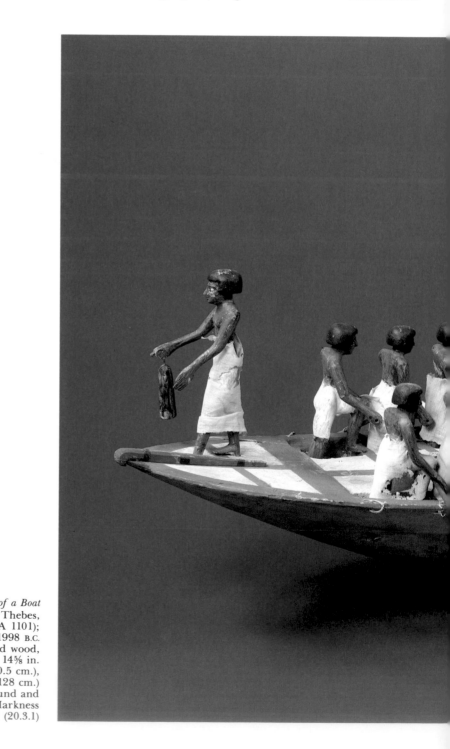

15 Model of a Servant
Thebes, Tomb of Mekutra
(MMA 1101); Dynasty 11,
ca. 2009–1998 B.C. Painted
wood; H. 44⅛ in. (112 cm.)
Rogers Fund and Edward S.
Harkness Gift, 1920 (20.3.7)

16 Model of a Boat
Thebes,
Tomb of Mekutra (MMA 1101);
Dynasty 11, ca. 2009–1998 B.C.
Gessoed and painted wood,
linen and cord; H. 14⅝ in.
(37 cm.), W. 12 in. (30.5 cm.),
L. 50⅝ in. (128 cm.)
Rogers Fund and
Edward S. Harkness
Gift, 1920 (20.3.1)

miniature, but with the utmost accuracy and attention to detail, and recovered in a state of almost perfect preservation. Probably no single find has contributed so graphically to our knowledge of the estates and other possessions of a wealthy Egyptian of the Middle Kingdom or provided us with such rich material for a general study of daily life in ancient Egypt.

The servant girl (Plate 15) bearing provisions from one of Mekutra's estates is carved to half life scale with remarkable sensitivity. Her eyes are large, her nose is rather wide and flat, and her mouth is drawn back in a tight smile—features characteristic of the royal style of the late Eleventh Dynasty. Despite the stiffness of the conventional striding stance, her slim torso is modeled with unusual subtlety, and the figure is

further enlivened by the brilliant colors of her costume and jewelry. On her head she balances a tall pannier containing bread, vegetables, and choice cuts of meat, and she carries a sacrificial duck by its wings.

In the underworld as in everyday life, the Nile was the highway for commerce and travel, and riverine craft were therefore necessary equipage for the deceased. Mekutra's traveling boat (Plate 16) is faithfully recreated. The cabin is covered with woven matting and decorated with shields painted in imitation of cowhide; mat curtains are rolled up over the windows. As the captain makes his obeisance, Mekutra sits before the cabin door, inhaling the fragrance of a lotus bud and enjoying the music of a singer and a blind harpist.

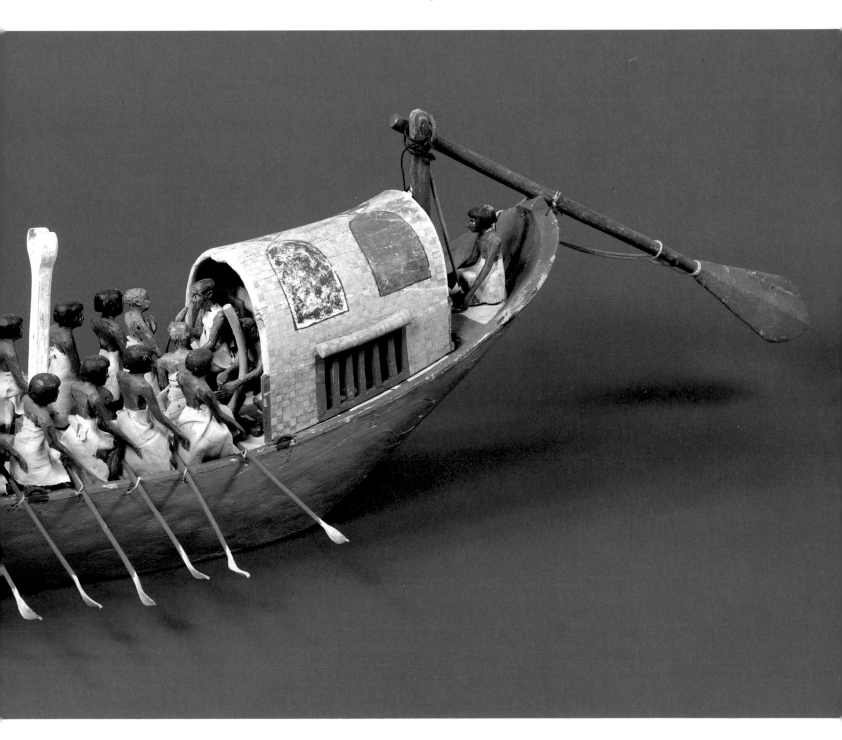

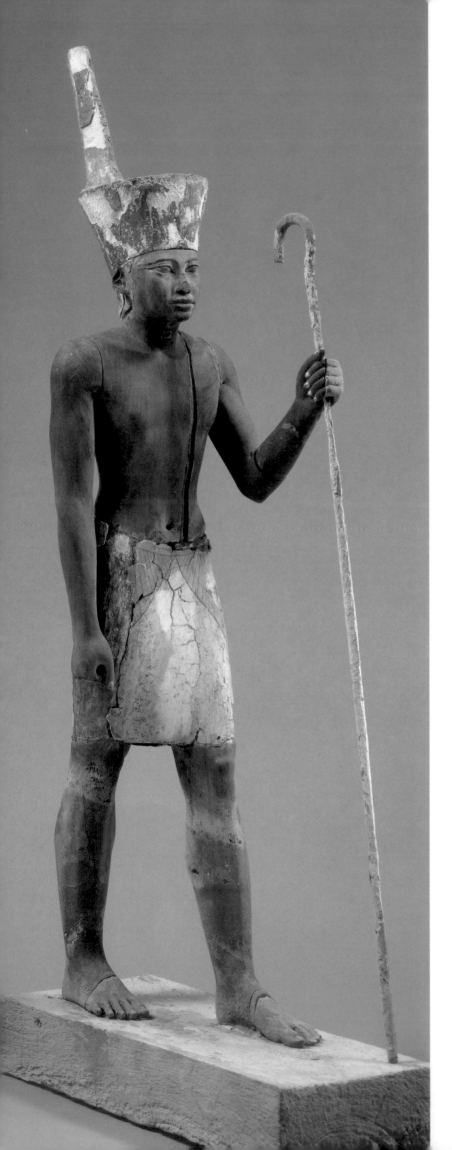

ROYAL STATUE

The last king of the Eleventh Dynasty, Mentuhotpe IV (ca. 1993–1991 B.C.) claimed that he sent ten thousand men to the Wadi Hammamat to procure stone blocks for his huge sarcophagus and lid. After the stones were quarried, three thousand men, led by the vizier and governor of the south, Amenemhat, were assigned to transport the material to Thebes. Although the course of events is unknown, it seems that the vizier succeeded his royal master and assumed power himself as Amenemhat I (ca. 1991–1962 B.C.). He became the founder of the Twelfth Dynasty (ca. 1991–1786 B.C.).

The new king succeeded in subduing both the hostile factions within Egypt and her external enemies, chiefly Libyans of the western desert and Asiatic nomads of the Sinai and southern Palestine. He secured his own dynasty and the boundaries of the nation, and inaugurated an era of prosperity and achievement unknown in Egypt since the great days of the Old Kingdom.

In about 1971 B.C., Amenemhat appointed his son, Senwosret I, coregent. For the next ten years father and son ruled jointly—a practice preserved throughout the Twelfth Dynasty. Amenemhat had moved his capital north from Thebes to a spot eighteen miles south of Memphis, thus founding his residence of Itjetaway. Nearby, Amenemhat and his successor built their pyramids, close to the modern town of Lisht, where this magnificent wooden sculpture was excavated by The Metropolitan Museum's Egyptian Expedition in 1914. It had been placed in the enclosure wall of a private tomb near the pyramid of Senwosret I.

The figure, who may be Senwosret himself, is clad in a short, tight-fitting kilt with double overfold. He is represented striding forward, holding in his left hand the long *hekat*-scepter, a symbol of kingly authority derived from the crook of the shepherd chieftains of primeval times. The statuette is made of sixteen pieces of wood skillfully joined together. The surfaces of the kilt and the crown were built up with white stucco before the application of the paint. Traces of a pinkish flesh color, applied directly to the fine dark cedar wood, appear on the body. The muscles of the torso and such small details as the eyes, ears, and hands are rendered with an exquisite and subtle attention to detail rarely found even in far larger statues. Though it is less than two feet high, there is a world of dignity and majesty in the beautifully modeled figure, and though stylized, it combines reserve with virility.

17 *Statue*
Lisht, South Pyramid cemetery;
Dynasty 12, ca. 1962–1928 B.C.
Gessoed and painted wood;
H. 22⅞ in. (55.5 cm.)
Rogers Fund and
Edward S. Harkness Gift,
1914 (14.3.17)

Opposite: detail

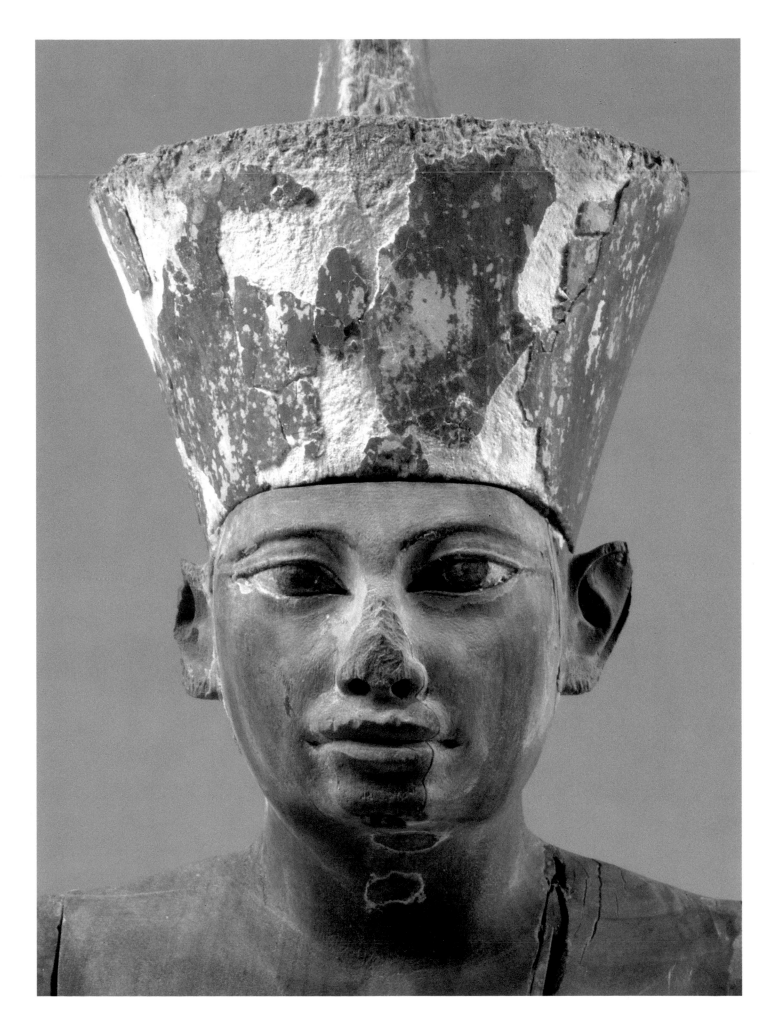

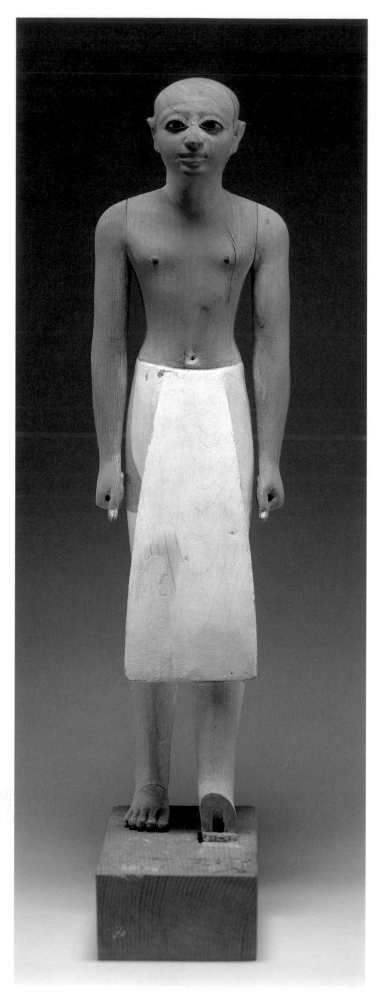

STATUE OF SENBI

In ancient Egypt it was believed that the *ka,* the individual's vital energy or personality, survived death and could reside in an image (particularly a statue) that preserved an idealized and unchanging version of the individual's features. This sensitively modeled *ka* statue of the steward Senbi was probably obtained from the clearance of his pit tomb in the necropolis at Meir in Middle Egypt. Although typical of its genre and period, the statuette is distinguished by the quality of both craftsmanship and materials. Made of costly imported wood, it was left unpainted to reveal the grain. The only additions of color are the painted and inlaid eyes and nipples and the long white kilt. The body of the figure was carved from one piece of wood, with the arms and front parts of the feet attached separately.

18 Statue of Senbi
Meir; Dynasty 12, ca. 1991–1786 B.C.
Painted wood, stone, and copper;
H. 16⅛ in. (41 cm.)
Rogers Fund, 1911 (11.150.27)

PAINTED LIMESTONE STELA

In the seventeenth year of his reign, Senwosret I (ca. 1971–1928 B.C.) donated this stela to his steward Montuwosre. It is a product of the royal workshop and is characterized by the consciously archaized poses of the figures. Montuwosre sits before an offering table in a classic composition used to portray the deceased on funerary monuments from the earliest days of the Old Kingdom. One hand grasps a folded piece of linen, and the other is outstretched to receive the provisions presented to the steward by three members of his family.

Despite the pure formalism of the scene, the musculature of Montuwosre's shoulders, arms, and legs is realistically modeled. The long inscription is biographical, enumerating the offices that the steward exercised on behalf of Senwosret, but typically for such stelae, it is couched in stereotyped phrases that do not describe specific events in his life. It can be inferred from geographic references given in the inscription that the stela was carved not for the steward's tomb but for his offering chapel at Abydos, which during the Middle Kingdom was thought to be the burial place of Osiris and was therefore a popular site for private memorials.

19 Stela
Dynasty 12, ca. 1955 B.C.
Painted limestone;
41 x 19⅝ in. (104 x 49.8 cm.)
Gift of Edward S. Harkness,
1912 (12.184)

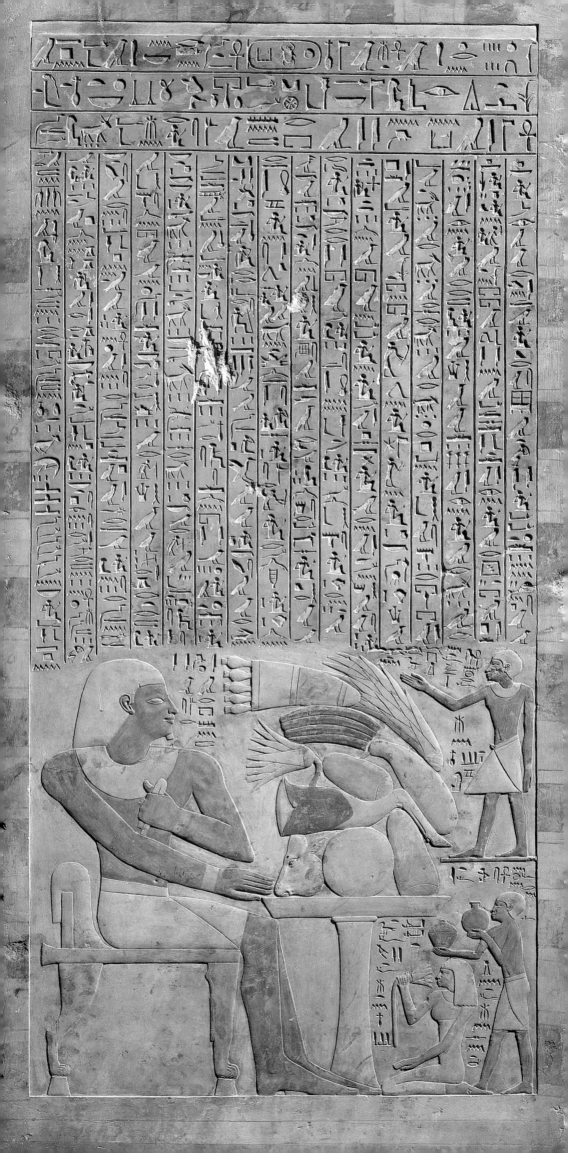

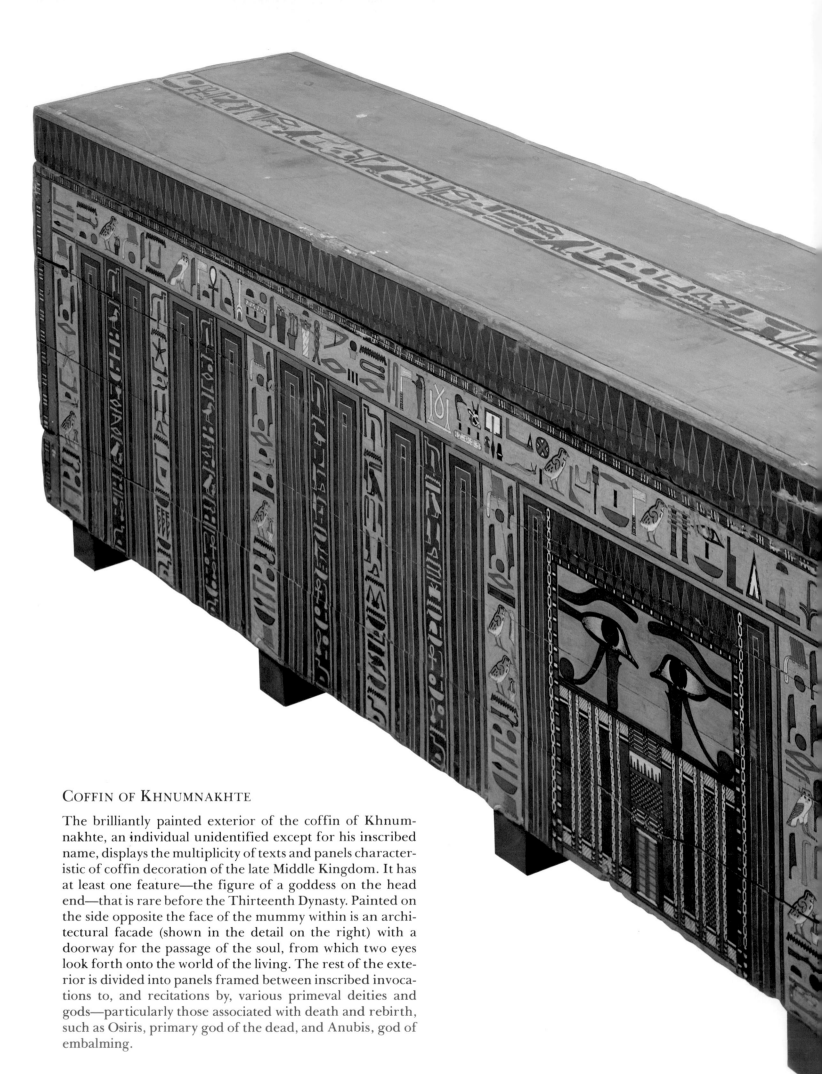

COFFIN OF KHNUMNAKHTE

The brilliantly painted exterior of the coffin of Khnumnakhte, an individual unidentified except for his inscribed name, displays the multiplicity of texts and panels characteristic of coffin decoration of the late Middle Kingdom. It has at least one feature—the figure of a goddess on the head end—that is rare before the Thirteenth Dynasty. Painted on the side opposite the face of the mummy within is an architectural facade (shown in the detail on the right) with a doorway for the passage of the soul, from which two eyes look forth onto the world of the living. The rest of the exterior is divided into panels framed between inscribed invocations to, and recitations by, various primeval deities and gods—particularly those associated with death and rebirth, such as Osiris, primary god of the dead, and Anubis, god of embalming.

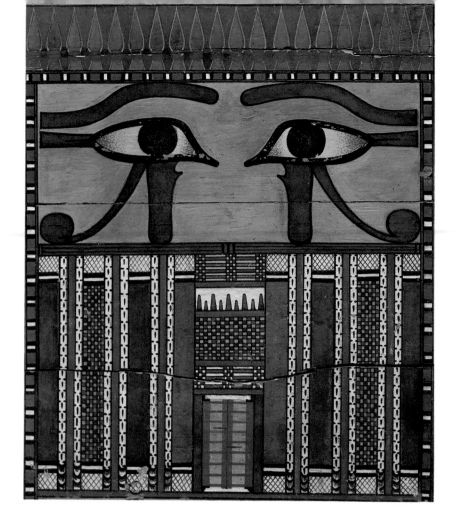

20 Coffin of Khnumnakhte
Meir; Dynasty 12, ca. 1991–1786 B.C.
Painted wood; L. 82 in. (208.3 cm.)
Rogers Fund, 1915 (15.2.2)

Right: detail

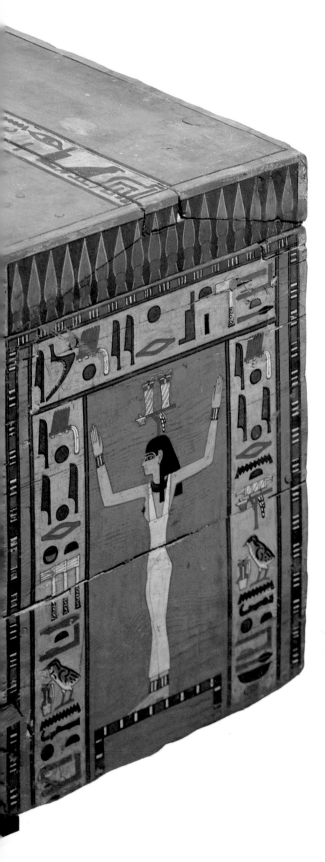

OVERLEAF:

COFFIN OF UKHHOTPE *(Pages 36–37)*

The mummy of the chief treasurer Ukhhotpe is wrapped simply in layers of bandages enclosed by an outer linen shroud, and the head is protected by a carved wooden funerary mask. In contrast to the stylized forms of the mouth and ears, the eyes are strikingly brought to life with inlays of polished obsidian and translucent alabaster, which are tinted red at the corners and set into ebony sockets. The skin areas are overlaid with reddish gold leaf, and the headdress and beard are painted blue.

In a burial typical of the Middle Kingdom, Ukhhotpe's mummy was placed in a rectangular wooden coffin decorated on the interior with selections of spells from the Coffin Texts, a corpus of funerary literature intended to equip the deceased with magical powers for the afterlife. The mummy was originally positioned on its left side, so that in death Ukhhotpe could peer through the eye panels that adorn the left side of the coffin. The horizontal band of text above the eyes is a conventional offering formula that invokes "Osiris, lord of eternity, foremost of Abydos, the great god, lord of the West." Ukhhotpe's was one of several rich private interments of the Middle Kingdom discovered at Meir.

21 Coffin of Ukhhotpe
Meir; Dynasty 12, ca. 1991–1786 B.C.
Wood, gold leaf, alabaster, obsidian, and various organic materials; L. 77 in. (95.5 cm.), W. 19 in. (48.2 cm.)
Rogers Fund, 1912 (12.182.132C)

35

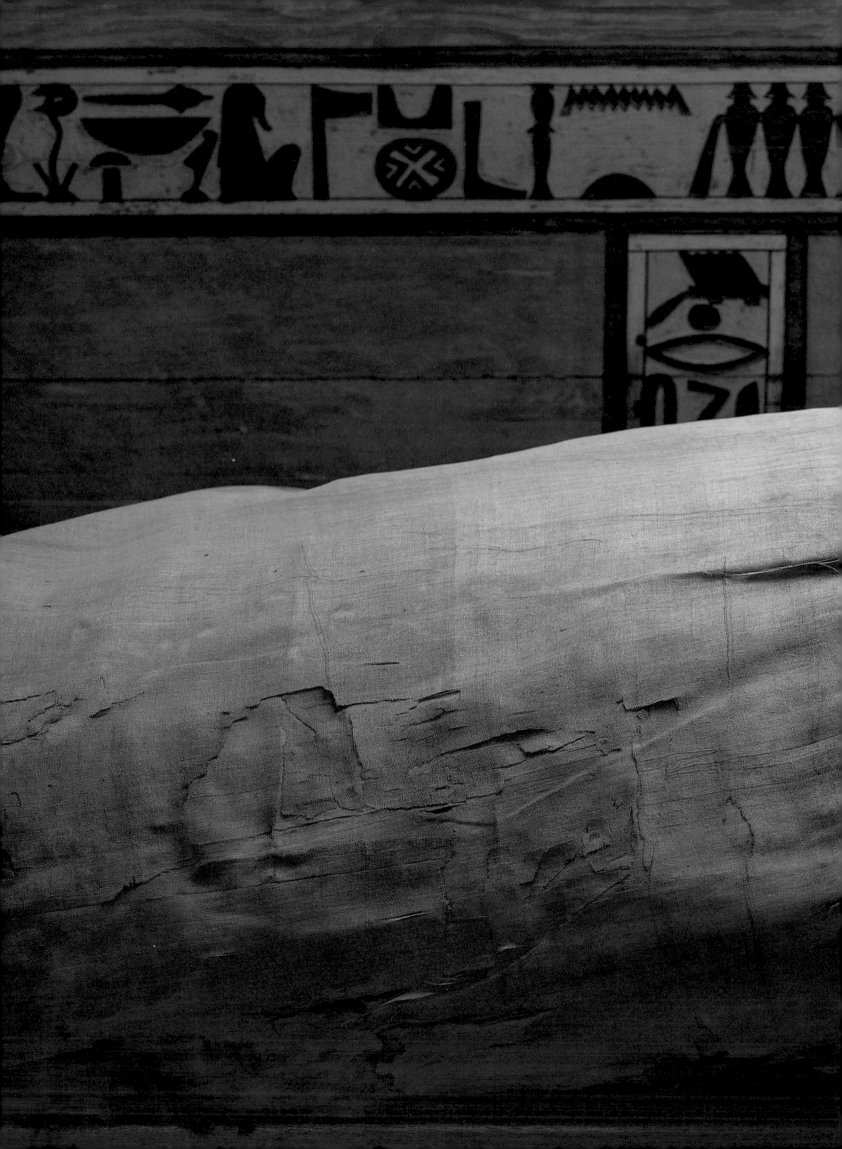

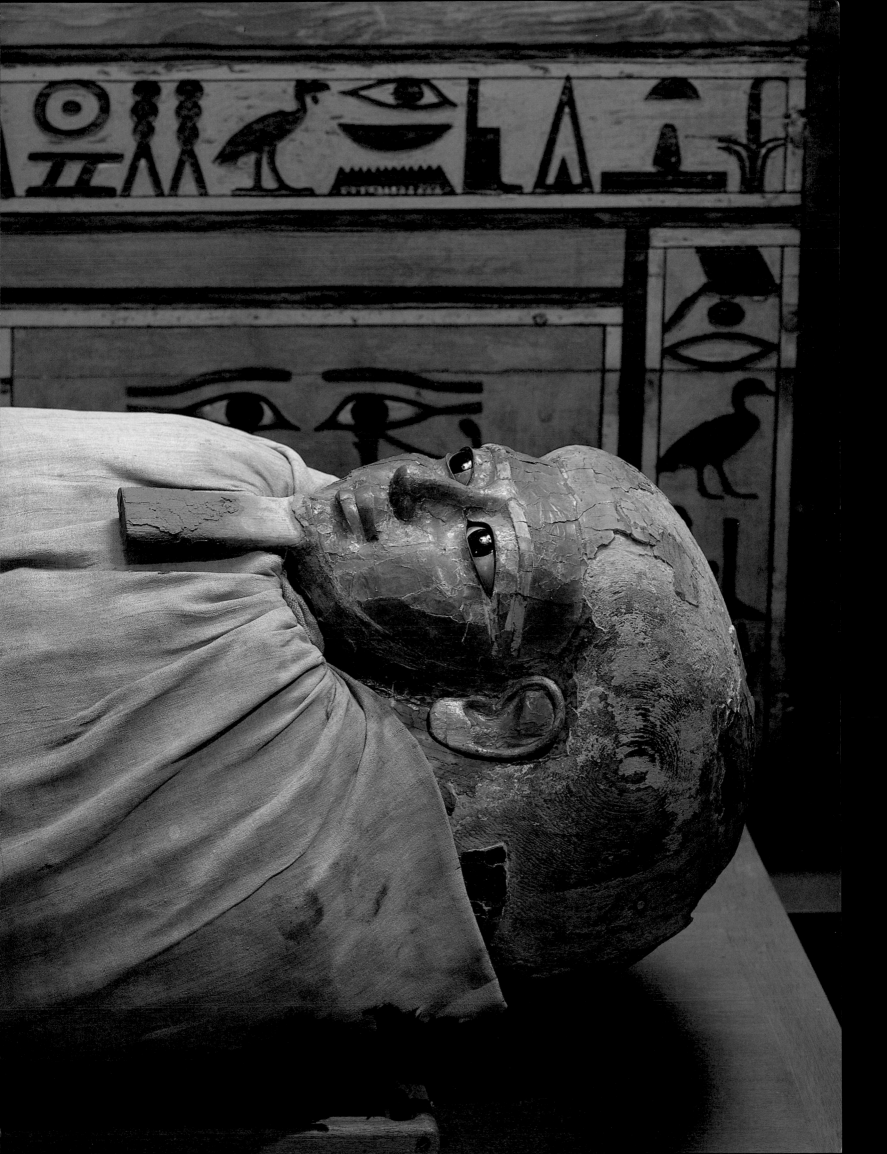

To judge from her title of King's Daughter, Sithathoryunet never became queen of Egypt and was buried at Lahun in the pyramid complex of Senwosret II, apparently her father. Her treasure includes some of the finest pieces of royal jewelry preserved from the Middle Kingdom, a period of Egyptian history unsurpassed for its elegance and workmanship in the minor arts. Several of the ornaments from Princess Sithathoryunet's tomb bear the cartouche of Amenemhat III, presumably her nephew, into whose reign she survived and who must have arranged for her funeral. Her jewelry was deposited in a small niche that was inadvertently ignored by ancient plunderers and was later inundated by flood waters pouring down the open burial shaft. In 1914 the dislocated elements of pectorals, diadems, girdles, and bracelets were painstakingly recovered from a mass of sediment by Guy Brunton, whose careful archaeological methods—together with more recent research—have enabled the reconstruction of the princess's jewelry.

The pectoral (Plate 22) is a masterpiece of goldworking and lapidary craftsmanship. Three hundred and seventy-two carved bits of turquoise, lapis lazuli, carnelian, and garnet are inlaid into individual cloisons fused onto a gold base. The central motif of the pectoral is the cartouche of Senwosret II, which is flanked by two falcons surmounted by sun disks and is supported by a kneeling deity grasping two palm strips. Entirely made up of hieroglyphic signs, the composition can be read as a wish for long life: "May the sun god [Ra-Harakhty] grant that Senwosret II live for hundreds of thousands of years." Sithathoryunet wore the pendant around her neck, attached to a chain of beads made of gold, carnelian, feldspar, and turquoise.

Wild cats form the dominant motif of Sithathoryunet's girdle (Plate 23) and its accessories, all fashioned from deep-purple amethyst and burnished gold. The hollow gold leopard-head spacers of the girdle were each fashioned in two halves that were then fused together. Of the seven large double-head elements, six contain tiny stone pellets that would have produced a seductive jingling sound when the princess walked, and the seventh functions as a sliding clasp. These are strung alternately with seven smaller quadruple-head spacers and double rows of amethyst ball beads. A pair of wristlets (Plate 24) features crouching lions; matching anklets (Plate 25) are adorned with gold claws and are secured by a clasp in the shape of a square knot.

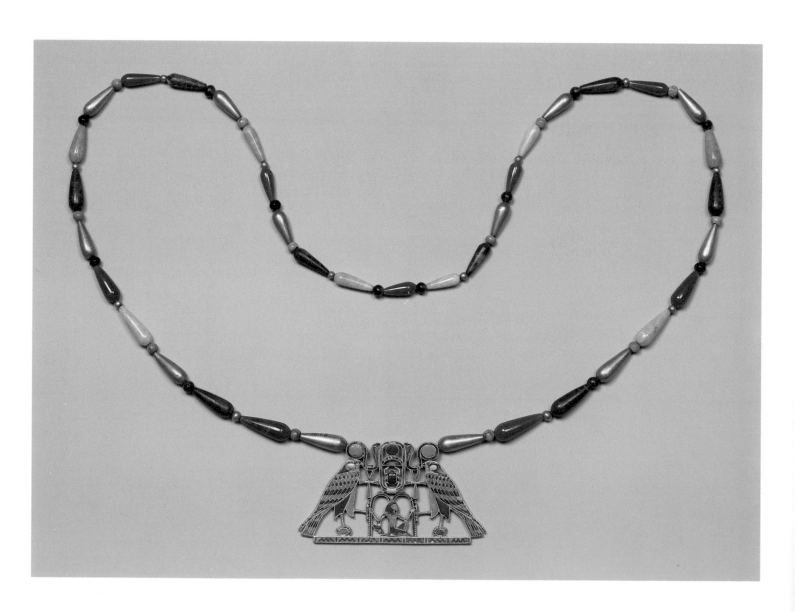

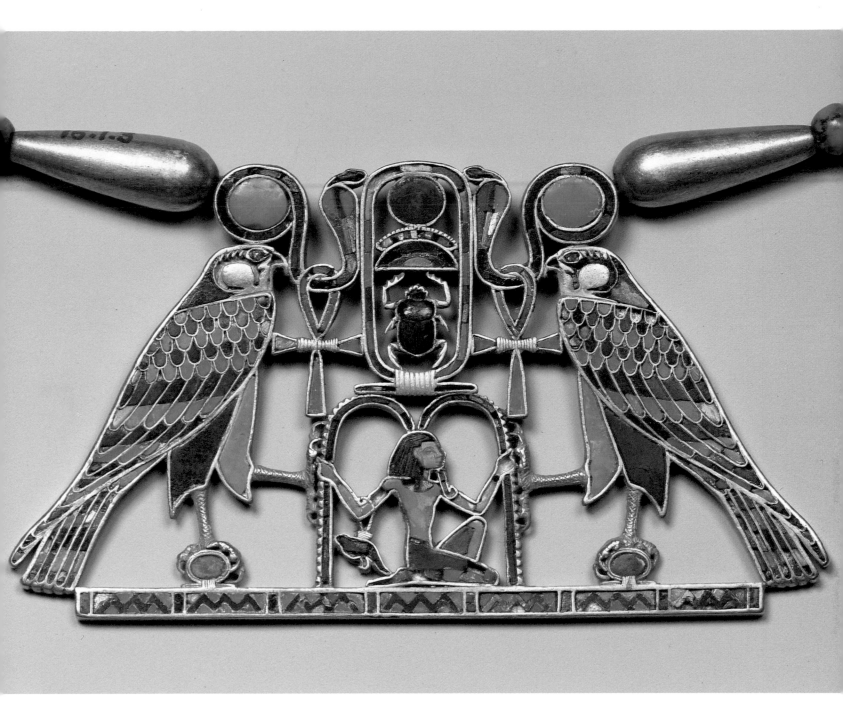

22 *Pectoral*
Lahun, Tomb 8; Dynasty 12,
ca. 1897–1878 B.C.
Gold, amethyst, turquoise, feldspar,
carnelian, lapis lazuli, and garnet;
H. 1¾ in. (4.4 cm.), L. 3¼ in. (8.2 cm.)
Purchase, Rogers Fund and
Henry Walters Gift, 1916 (16.1.3)

Above: detail

24 Wristlets
Lahun, Tomb 8; Dynasty 12,
ca. 1897–1878 B.C. Gold and
amethyst; L. 5¾ in. (14.6 cm.)
Purchase, Rogers Fund and
Henry Walters Gift, 1916
(16.1.14,15)

Page 38: text

23 Girdle
Lahun, Tomb 8; Dynasty 12,
ca. 1897–1878 B.C. Gold and
amethyst; L. 31⅞ in. (81 cm.)
Purchase, Rogers Fund and
Henry Walters Gift, 1916 (16.1.6)

Page 38: text

40

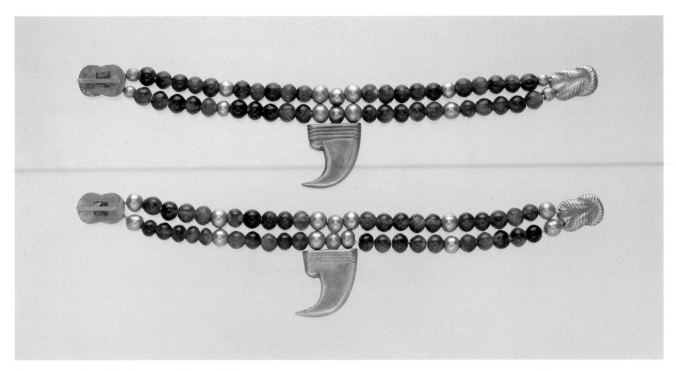

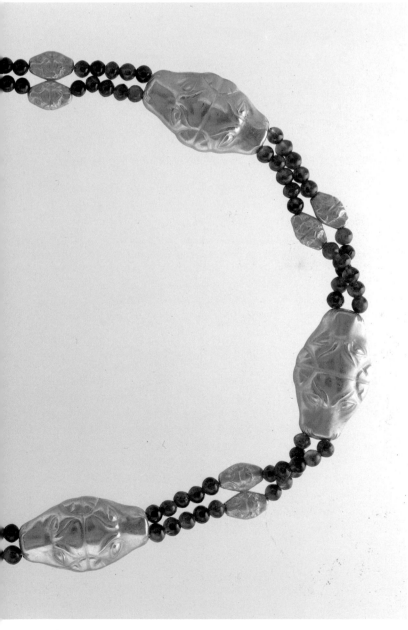

25 *Anklets*
Lahun, Tomb 8; Dynasty 12,
ca. 1897–1878 B.C. Gold and
amethyst; L. 7⅛ in. (18.1 cm.)
Purchase, Rogers Fund and
Henry Walters Gift, 1916
(16.1.17a,b,55)

Page 38: text

Senwosret III

When Senwosret I died in around 1928 B.C., in the forty-fifth year of his reign, his son, Amenemhat II (ca. 1929–1895 B.C.), had shared the throne with him for two years. Neither the new king nor his successor, Senwosret II (ca. 1897–1878 B.C.), seems to have been interested in the consolidation and expansion of Egypt's modest foreign conquests. Each was content to continue the exploitation of the mines and quarries and to occupy himself with agricultural improvements at home and commercial ventures abroad. Senwosret III (ca. 1879–1841 B.C.) is remembered by posterity chiefly for his complete reconquest and subjugation of Nubia.

Outstanding among the artistic productions of the latter half of the Twelfth Dynasty are the majestic and intensely forceful representations of the kings. The magnificent sphinx·of Senwosret III (Plate 27) is carved with great power and incomparable skill from a block of beautifully grained gneiss from the quarries of Nubia. The massive headdress conceals what might otherwise have been an awkward transition between the human head and the lion's body. The sculptor's attention was chiefly focused on the grim, deeply lined face of the pharaoh, a masterpiece of naturalistic portrayal; but the subtle modeling and superb finish of the heavily muscled animal body is scarcely less admirable.

The face of a royal head (Plate 26) in quartzite, formerly in the Carnarvon collection, portrays in unmistakable fashion the well-known features of Senwosret III. Here we see again the brooding, melancholy countenance of the great pharaoh—the furrowed brow, the heavy-lidded eyes, and the grim, disdainful mouth. The modeling is subtler and more restrained than in most other portraits of the king, and the selection of the dull-surfaced, gritty brown stone as the medium has produced an effect of strength and ruggedness.

Senwosret III was succeeded by Amenemhat III (ca. 1842–1797 B.C.), the last of the great rulers of the Twelfth Dynasty. The brief and undistinguished reign of his heir, Amenemhat IV (ca. 1798–1790 B.C.), and the even briefer reign of Queen Sobkneferu (ca. 1789–1786 B.C.) marked the end of the dynasty and the decline of the Middle Kingdom. The Second Intermediate Period (ca. 1786–1559 B.C.) that followed was marked by instability in the succession to the throne and by the conquest and domination of Egypt by a group of foreign invaders, the Hyksos.

26 Head of Senwosret III
Dynasty 12, ca. 1878–1843 B.C.
Red quartzite; H. 6½ in. (16.5 cm.)
Purchase, Edward S. Harkness Gift,
1926 (26.7.1394)

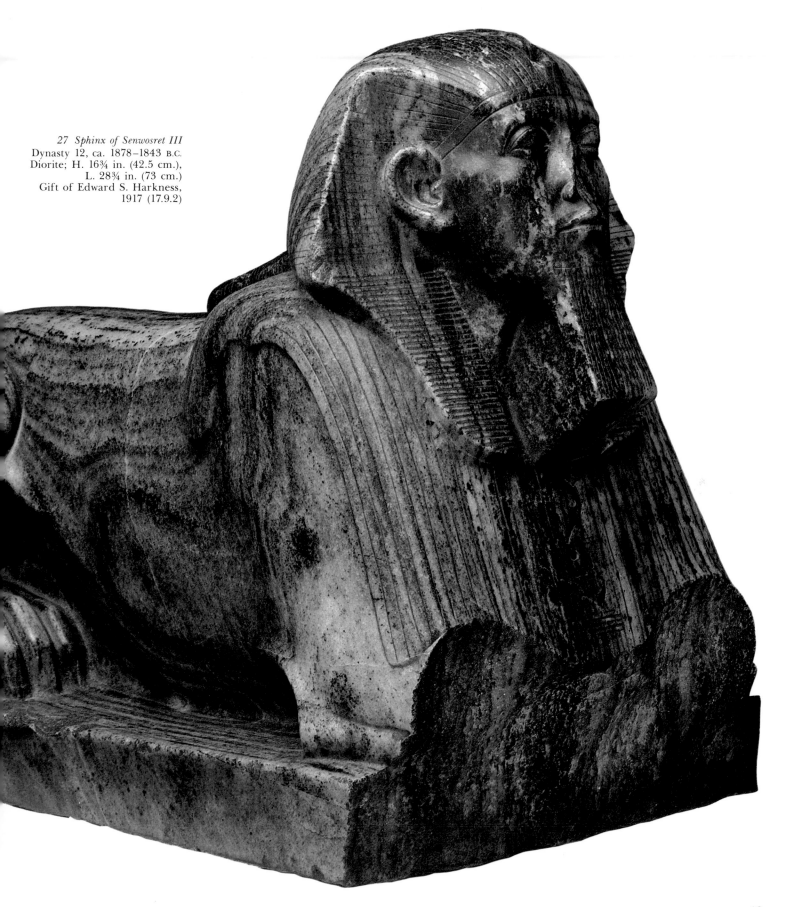

27 Sphinx of Senwosret III
Dynasty 12, ca. 1878–1843 B.C.
Diorite; H. 16¾ in. (42.5 cm.),
L. 28¾ in. (73 cm.)
Gift of Edward S. Harkness,
1917 (17.9.2)

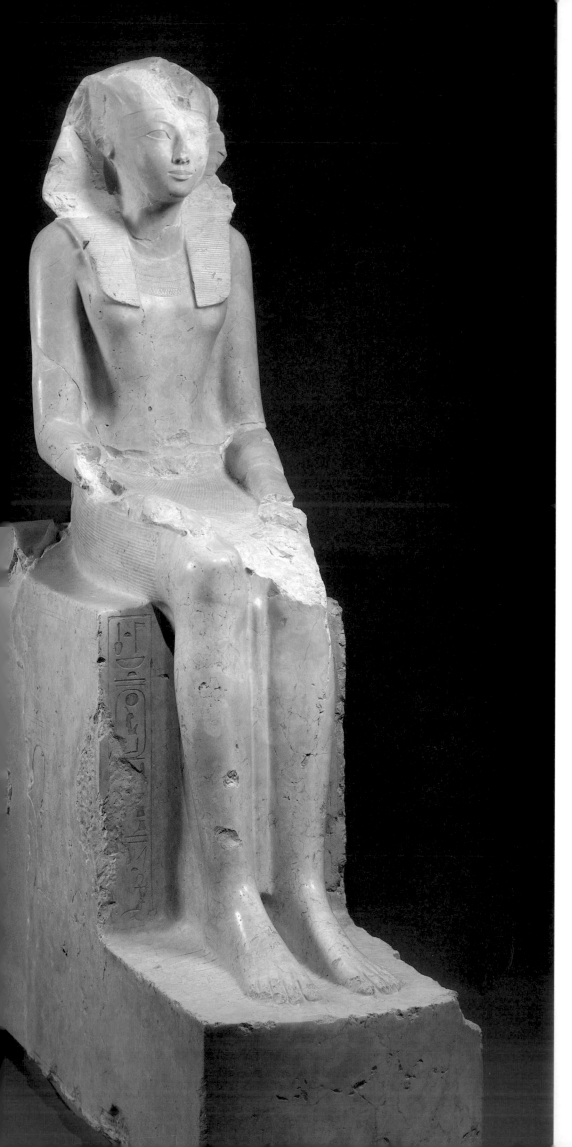

28 *Statue of Queen Hatshepsut*
Thebes, Deir el Bahri,
Temple of Hatshepsut;
Dynasty 18, ca. 1503–1482 B.C.
Painted indurated limestone;
H. 76¾ in. (195 cm.)
Rogers Fund, 1929 (29.3.2)

Opposite: detail

Page 46: text

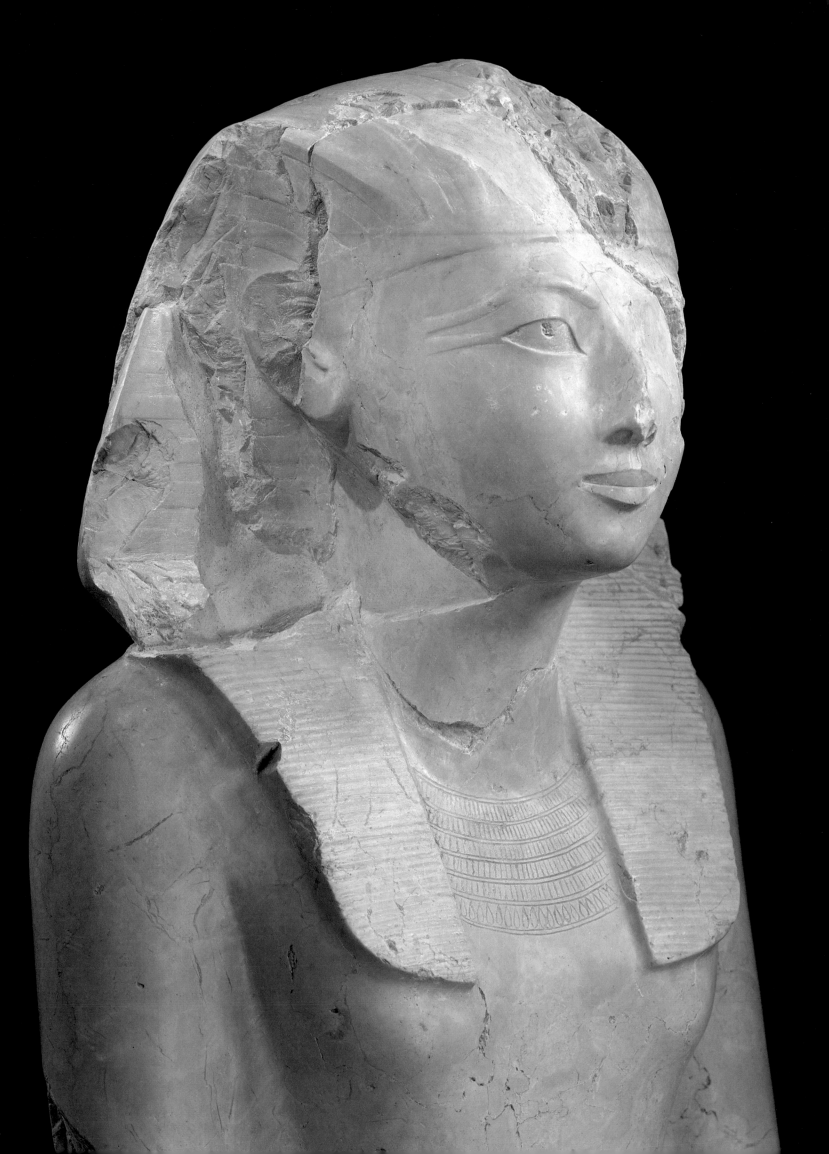

There were five dynasties, the Thirteenth through the Seventeenth, during the Second Intermediate Period (ca. 1786–1559 B.C.). The rulers of the concurrent Thirteenth and Fourteenth dynasties were native to Egypt, but thereafter followed two dynasties of Asiatic kings, referred to by later historians as Hyksos, a generic term derived from the ancient Egyptian phrase *hekau-khasut,* meaning "rulers of foreign lands." Although the Theban propagandists of the New Kingdom conjured up images of ruthless barbarians, it seems likely that the Hyksos were not unduly harsh or oppressive. Indeed, they appear to have borrowed extensively from the Egyptian culture in which they found themselves, copying native works of art and modeling their administration after the traditional forms of Egyptian government.

In around 1559 B.C., Avaris, the Hyksos capital in the northeastern delta, fell to Ahmose, a Theban ruler, whom posterity has credited with founding the Eighteenth Dynasty and inaugurating the New Kingdom. He reigned for twenty-five years and was succeeded in around 1546 B.C. by his son, Amenhotpe I, who died in about 1526 B.C. With Amenhotpe's successors, Tuthmosis I (ca. 1525–1512 B.C.), Tuthmosis II (ca. 1512–1504 B.C.), and Queen Hatshepsut (ca. 1503–1482 B.C.), Egypt entered upon what must be regarded as the most glorious period in her long history—the period of her greatest military strength, territorial expansion, and material prosperity.

When King Tuthmosis II died in about 1504 B.C., his rightful heir, Tuthmosis III, was still a child, and so Hatshepsut, his consort and the stepmother of Tuthmosis, became regent. Within a few years, this remarkable woman had contrived to have herself crowned king, with full pharaonic powers. Her magnificent funerary temple at Deir el Bahri was intended to both legitimize and commemorate her rule. Statues of Hatshepsut made of limestone, granite, or sandstone were placed throughout the temple, either freestanding or built into the temple structure itself.

One such freestanding sculpture, carved of polished indurated limestone (Plate 28), shows the great queen in masculine guise, a useful fiction since the pharaoh was traditionally both god and priest, roles that were masculine by definition. Not only the royal kilt and headdress, but even the bare torso, are those of a man. Nevertheless, the prim little face and the delicate figure give a distinctly feminine impression. Though certainly idealized, the face, with its broad forehead, softly rounded cheeks, pointed and slightly receding chin, small, pleasant mouth, and delicately arched nose, gives us without doubt one of the finest representations of Hatshepsut extant. We know her subjects were fully aware of the anomaly of a female king; it is easy to believe that the sculptor here tried, with some success, to reconcile the political myth with human reality.

KNEELING FIGURE OF QUEEN HATSHEPSUT

Eight colossal kneeling figures adorned various areas of Hatshepsut's funerary complex at Deir el Bahri. Ranging in height from eight and a half to nine feet and weighing an average of four and a half tons, these massive pieces of architectural sculpture employ a stylization and simplified modeling that are characteristic of colossal statuary. The pose—in which the pharaoh is represented as kneeling before his god and holding in each hand a small, globular offering jar—is known from earlier periods but did not achieve real popularity until the Eighteenth Dynasty (ca. 1570–1304 B.C.), when it began to be used with great frequency for both royal and private statues. In working out the pose, the Egyptian sculptor has elongated the legs and other portions of the figure to an absurd degree—a fact that is not apparent until we imagine such figures as unfolding and standing upright.

29 Kneeling Figure of Queen Hatshepsut
Thebes, Deir el Bahri, Temple of
Hatshepsut; Dynasty 18, ca. 1503–1482 B.C.
Red granite; H. 8 ft. 7 in. (261.5 cm.)
Rogers Fund, 1929 (29.3.1)

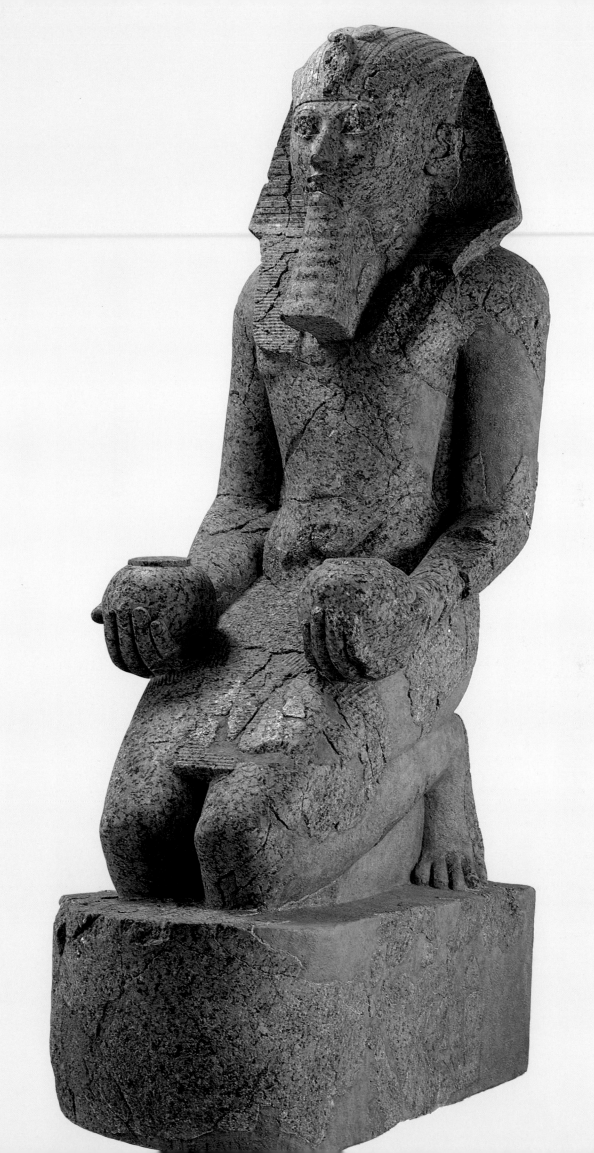

FUNERARY STELA

This private-tomb stela is unfinished. The sculptor—perhaps one of the artists working at the temple of Tuthmosis III (ca. 1504–1450 B.C.) at Deir el Bahri, who may have made the stela in his spare time—has carved only the opening phrases of a prayer for offerings and has left a blank space for the name and titles of the deceased. The stela's purchaser would also have had his own name, those of his two female relatives, and that of the son who officiates at the offering table carved over the four figures in the offering scene. The classic simplicity of the composition is characteristic of the Tuthmoside period.

30 Funerary Stela
Thebes, Deir el Bahri;
Dynasty 18, ca. 1503–1450 B.C.
Painted limestone; 17¾ x 12 in.
(45 x 30.5 cm.)
Rogers Fund, 1923 (23.3.48)

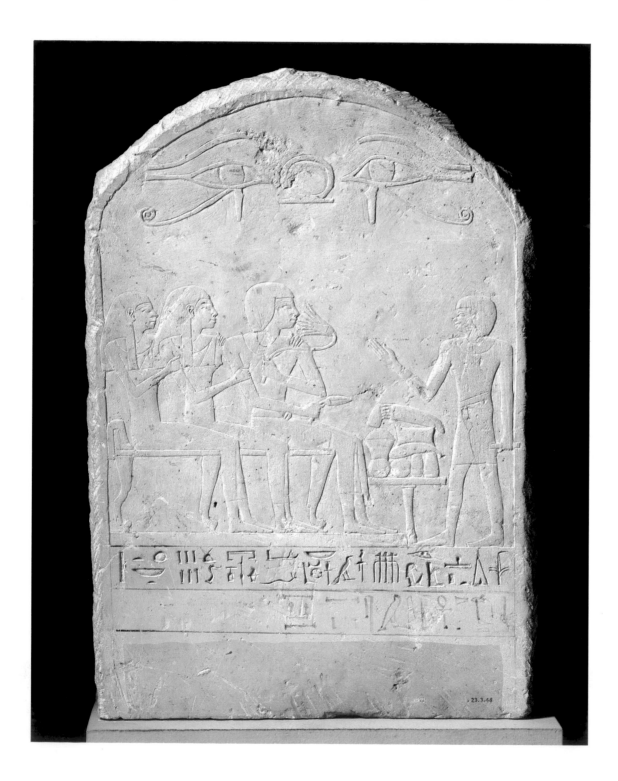

CHAIR OF RENYSENEB

The back of this wooden chair, belonging to a scribe, Renyseneb, is handsomely veneered with ivory and embellished by incised decoration (see detail at the left) showing the owner seated on a chair of identical form. The scene and text have funerary import and would not have been usual for furniture in daily use. If, as seems likely from its solid construction, this chair was used by Renyseneb during his lifetime, the design may have been added following his death to make the chair a more suitable funerary object. The high quality of its joinery and the harmony of its proportions testify to the skill of ancient Egyptian carpenters. The mesh seat has been restored according to ancient models.

31 Chair of Renyseneb
Dynasty 18, ca. 1570–1450 B.C.
Ebony with ivory; H. 34¹⁵/₁₆ in.
(86.2 cm.) Purchase, Patricia R.
Lassalle Gift, 1968 (68.58)

Above: detail

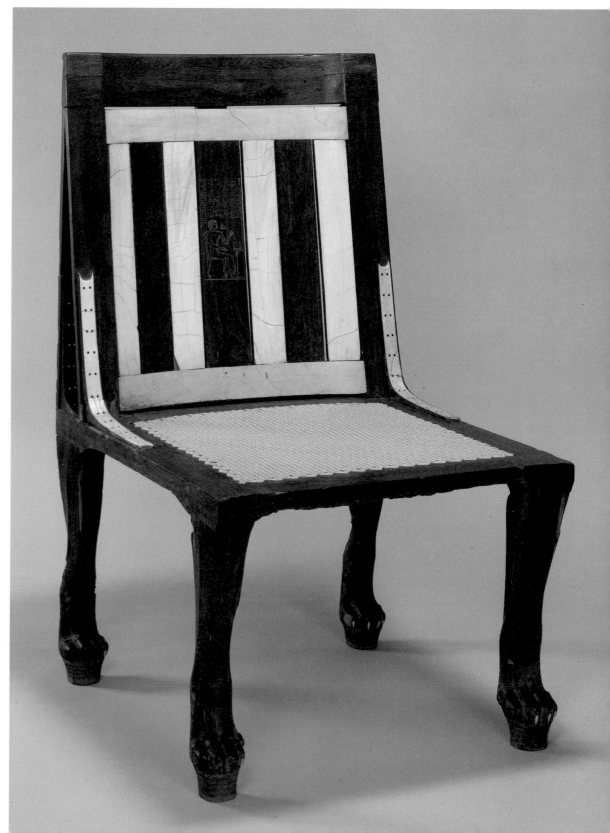

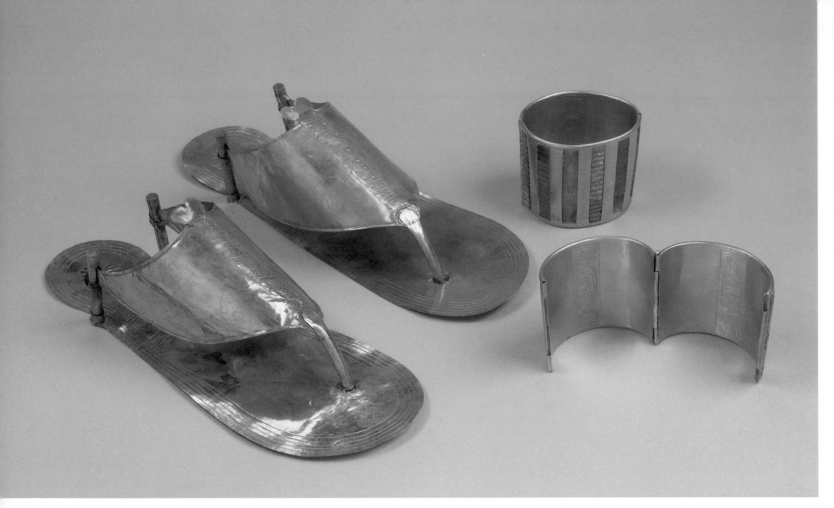

32 *Sandals and Bracelets*
Dynasty 18, ca. 1482–1450 B.C.
Sandals: gold; L. 10 in. (25.4 cm.),
W. 3¾ in. (9.5 cm.); bracelets:
gold, carnelian, and turquoise glass;
L. 7¾ in. (19.7 cm.), W. 2⅜ in.
(6 cm.) Fletcher Fund, 1926
(26.8.146a,b; 26.8.125,127)

33 *Headdress*
Dynasty 18, ca. 1482–1450 B.C.
Gold, carnelian, turquoise glass, and
clear glass; Max. diam. 12 in. (30.5 cm.),
H. 9½ in. (24.1 cm.) Purchase, Frederick
P. Huntley Bequest, 1958; Purchase,
Lila Acheson Wallace Gift, 1982;
Purchase, Lila Acheson Wallace Gift,
1983; Purchase, Joseph Pulitzer
Bequest, 1966; Fletcher Fund, 1926
(58.153 [selective]; 58.153.2,3; 1982.137.1;
1983.1–13; 66.2.77; 26.8.117A)

ROYAL TREASURES OF THE EIGHTEENTH DYNASTY

The treasure of the three minor wives of Tuthmosis III, of which only a few objects are illustrated here, comprises the most spectacular corpus of royal jewelry of the Eighteenth Dynasty prior to the reign of Tutankhamun (ca. 1361–1352 B.C.). The objects include items that were made for everyday use—and accordingly show signs of wear—as well as equipment intended expressly for the tomb. Although the names of the three queens—Menhet, Merti, and Menwai—occur only on certain funerary artifacts, their association with Tuthmosis III is assumed because of the appearance of his cartouches on some of the everyday jewelry and alabaster unguent jars. The unusual spellings of the names indicate a non-Egyptian origin and suggest that the queens' marriages to Tuthmosis may have strengthened a number of diplomatic alliances with foreign lands.

The hinged bracelets (Plate 32, right) are fashioned of gold, beaten to shape, burnished to a high gloss, and inlaid with alternating pieces of turquoise, carnelian, and a third, unidentified substance. Inscribed on the interior with the royal titles of Tuthmosis III, they are skillfully chased so that the broad grooves reflect light brilliantly. Although the bracelets were apparently intended to be worn as a matched pair, the texts display a number of idiosyncracies indicating that each was done by a different hand.

Cut from sheet gold, the sandals (Plate 32, left) closely imitate tooled leatherwork, but their fragile construction is typical of objects made only to adorn a mummy.

A unique oval gold plate, chased with a palmette design, is the centerpiece for this reconstruction of a magnificent headdress (Plate 33). Four hundred and fifty gold elements, graduated in size and inlaid in rosette patterns with carnelian, turquoise glass, and clear glass, are strung vertically in jeweled strips that descend from the oval plate and cover the wig below. The discovery of similar rosette elements at the purported findspot of the treasure indicates a link between the tomb and the headdress.

34 Tomb Painting
Thebes; Dynasty 18,
ca. 1424–1417 B.C.
Paint on mud plaster;
H. 28⅞ in. (73.3 cm.)
Rogers Fund, 1930 (30.2.1)

Page 54: text

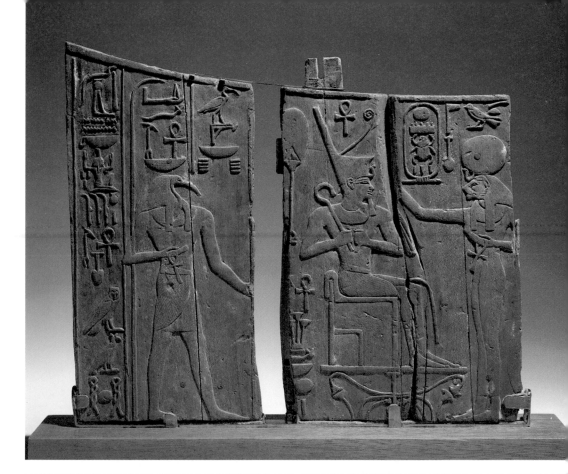

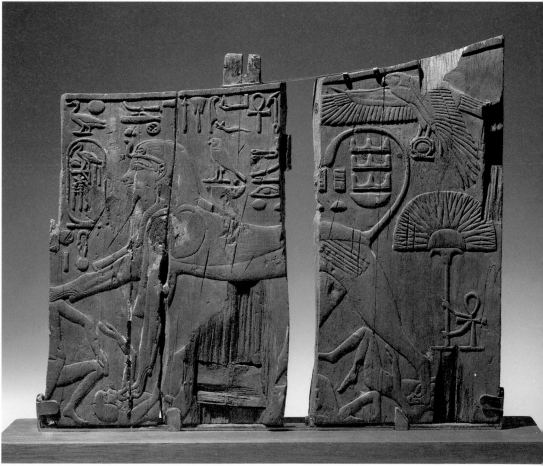

35 Carved Wooden Panels
Thebes, Valley of the Kings,
Tomb 43; Dynasty 18, ca. 1424–1417 B.C.
Cedar wood; H. 9⅞ in. (25.1 cm.)
Theodore M. Davis Collection,
Bequest of Theodore M. Davis,
1915 (30.8.45 A–C)

Page 54: text

53

Tuthmosis III (ca. 1504–1450 B.C.) was incontestably the greatest pharaoh ever to occupy the throne of Egypt, but it was not until the twenty-second year of his reign (ca. 1482 B.C.) that he was able to reclaim sole mastery of Egypt after the death of his stepmother and coregent, Hatshepsut. Having assumed control of the nation, Tuthmosis III embarked upon a long series of campaigns that brought Palestine and Syria firmly under Egyptian hegemony and instilled into the other great nations of the Near East a profound respect for Egypt's newfound military strength.

Tuthmosis III died in about 1450 B.C. and was succeeded by his son Amenhotpe II (ca. 1450–1424 B.C.), a youth of eighteen. His reign was prosperous and long—over twenty-five years. Tuthmosis IV (ca. 1424–1417 B.C.), Amenhotpe's son, came to the throne in about 1424 and died while still a fairly young man after a reign of about seven years.

Among the most important and interesting objects recovered from the tomb of Tuthmosis IV are the carved wooden arms (Plate 35), or side panels, of a chair of state. Crafted of thin pieces of cedar dovetailed and pinned together, the carved panel was attached to the left arm by the tenon at the top. On the outer side Tuthmosis in the guise of a sphinx crushes underfoot a group of enemies conventionally represented as Nubians. Above the sphinx's tail hovers a protective Horus of Behdet and behind stands an animated hieroglyph of life, the *ankh*, wielding a fan and literally providing the king with the "breath of life." The inner side of the panel portrays Tuthmosis IV enthroned, wearing the Red Crown of Lower Egypt. The lion-headed goddess Werethekau reaches up to touch the crown, while the ibis-headed god, Thoth, approaches from the opposite side. He carries three hieroglyphs—an *ankh* (life) and two palm strips (years)—that reinforce his declaration: "I have brought you millions of years of life and dominion united with eternity."

The chaste, sober style of early Eighteenth Dynasty tomb painting is reflected in the anonymous male figures (Plate 34), portrayed in the tomb of Sobekhotpe for the sole purpose of eternally presenting their offerings of papyrus, lotus, and waterfowl. The painter felt constrained to render this ritual scene in formal patterns. Because he was working, however, during the reign of Tuthmosis IV, a period of transition to a livelier, more painterly style in the Theban tombs, his awareness of new developments can be seen in small details, such as the freely placed brushstrokes of the ducks' feathers. Although he was buried at Thebes, Sobekhotpe—whose name refers to Sobek, the crocodile god of the Fayum—was mayor of the marshy Fayum district. Conceivably, the swamp products, though often found in offering scenes, may here have special reference to his jurisdiction. "Sobek" is written in hieroglyphs with a crocodile; some timorous soul of ancient times has excised this dangerous creature from Sobekhotpe's name in the inscription at the lower right.

HEAD OF AMENHOTPE III

The accession to the throne of Amenhotpe III (ca. 1417–1379 B.C.) came at a moment in Egyptian history when, after almost two centuries of unparalleled achievement both at home and abroad, the country was at the pinnacle of its political power, economic prosperity, and cultural development. Moreover, the world was at peace and there was leisure for the court of Egypt to enjoy the many pleasures and luxuries that life now had to offer and to indulge to the full a penchant for opulence and display. As in every respect of the brilliant setting over which he presided, Amenhotpe III undertook throughout his long reign a program of self-glorification more elaborate and on a far grander scale than any previously attempted.

It was as a builder and patron of the arts that Amenhotpe III most truly earned the reputation for magnificence that to the present day is associated with his name. Breathtaking richness and vast size characterize his great temple to the god Amun at Luxor, the impressive additions that he made to the principal shrine and precinct of the god at Karnak, his palace-city and inland lake south of Medinet Habu, his enormous mortuary temple a mile and a half to the north, and the huge rock-cut tomb that he prepared for himself in the western branch of the Valley of the Kings.

One of the most striking portraits of Amenhotpe III that has come down to us is a fragmentary quartzite head (Plate 36), slightly under life size. The king's features are curiously childlike: round cheeks and a soft chin; a full mouth with a distinctively shaped upper lip slightly thicker than the lower; large, slanted, elegantly outlined eyes; and a pleasant but somewhat enigmatic expression. The nose and a portion of the left side of the face are missing, but despite these mishaps the head still retains much of the beauty that must have made it one of the masterpieces of New Kingdom sculpture.

The personality behind this face remains elusive, although we have considerable information about Amenhotpe's reign. He claimed to have been a mighty lion hunter in his youth, but to judge from statues in The Metropolitan and elsewhere, he became corpulent in later years.

36 Head of Amenhotpe III
Dynasty 18, ca. 1417–1379 B.C.
Quartzite; H. 13¾ in. (33.7 cm.)
Rogers Fund, 1956 (56.138)

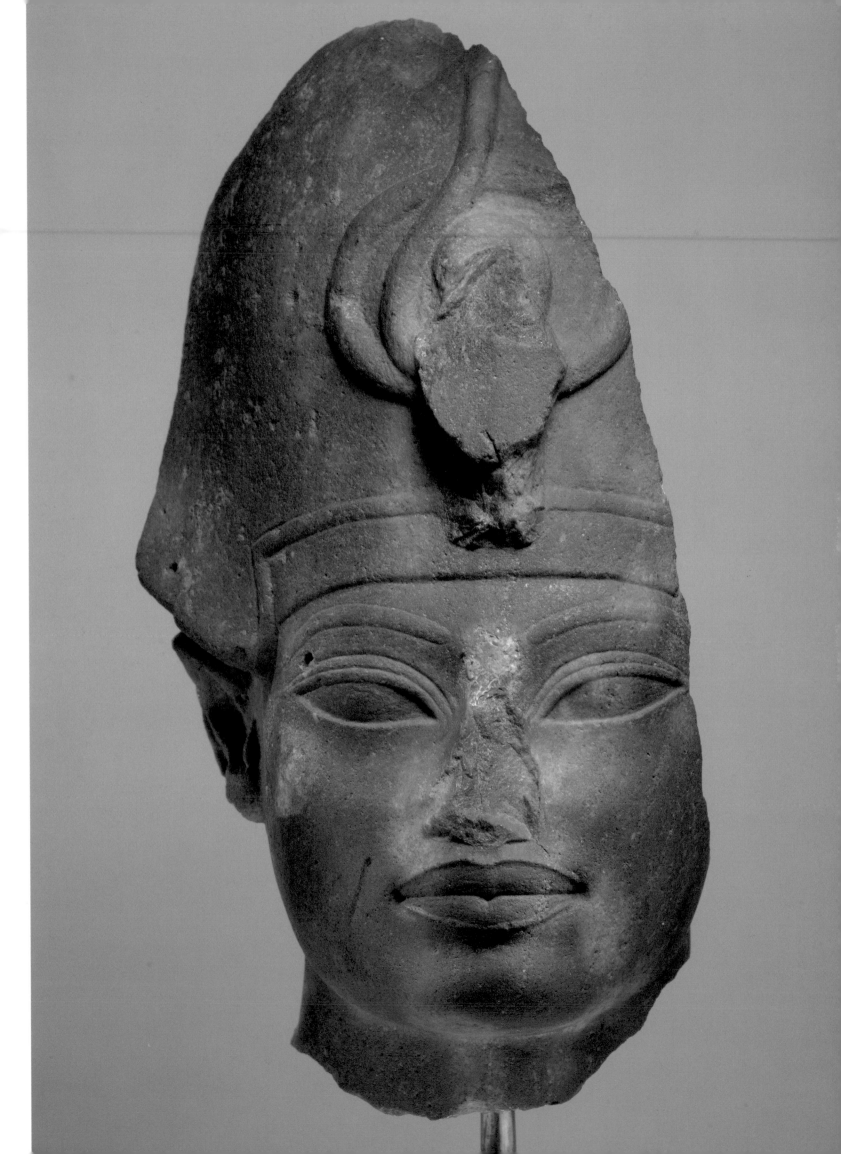

SPHINX OF AMENHOTPE III

Known for its colossal monuments, Amenhotpe's reign also saw jewellike achievements in the minor arts. This inscribed faience sculpture with its fine blue glaze portrays Amenhotpe III with a human head and hands and the forelegs and body of a lion. He wears a broad collar, bracelets, and the *nemes* headdress; in outstretched hands he holds jars of wine as offerings to a god. In its completeness and perfection of form this faience object is unique among ancient Egyptian statuary.

37 Sphinx of Amenhotpe III
Dynasty 18, ca. 1417–1379 B.C.
Faience; L. 9⅞ in. (25 cm.)
Purchase, Lila Acheson Wallace
Gift, 1972 (1972.125)

38 Fragmentary Head of a Queen
Dynasty 18, ca. 1417–1379 B.C.
Yellow jasper; H. 5½ in. (14 cm.)
Purchase, Edward S. Harkness
Gift, 1926 (26.7.1396)

FRAGMENTARY HEAD OF A QUEEN

This extraordinary fragment, polished to a mirrorlike finish, is both sensual and elegant in expression, reflecting the sophistication of the court of Amenhotpe III, to whose reign it can be assigned on stylistic grounds. When complete, this head probably belonged to a composite statue, in which the exposed flesh parts were of jasper and the remaining elements of other appropriate permanent materials. The use of yellow stone for the skin indicates that the person represented is female; the scale and superb quality of the work make it probable that she is a goddess or a queen of Amenhotpe III. The similarity of the full, curved lips with downturned corners to known representations of the Great Royal Wife, Tiye, suggests that it is she who is depicted here.

AMARNA PAINTED RELIEF

The extraordinary episode in Egyptian history known as the Amarna Period began in about 1379 B.C. with the coronation of Amenhotpe IV and ended with his death seventeen years later. The period takes its name from the site in Middle Egypt where the new king and his court resided, modern Tell el Amarna, or Akhetaton, as it was then called.

During his seventeen-year reign, Amenhotpe IV (ca. 1379–1362 B.C.)—who changed his name to Akhenaton—radically altered the official state religion by proscribing the worship of any god but Aton, the power embodied in the sun. Whatever may have motivated Akhenaton, Egypt's experiment in qualified monotheism really impinged only upon the courtiers who surrounded the king and, at his death, the traditional forms of worship reasserted themselves. For his unorthodoxy, Akhenaton was to suffer the destruction of his monuments and his name at the hands of posterity.

This relief block, originally from Akhetaton, is carved in the mannered and expressive style peculiar to Akhenaton's reign. The king is shown making an offering of a pintail duck to Aton, whose rays, ending in hands, stream down on him. One of the hands holds an *ankh*—the symbol of life—to the king's nose.

FUNERARY STELA OF SENU

The fine workmanship and suave style characteristic of all the arts of Amenhotpe III's reign are clear in this limestone stela. The Royal Scribe Senu appears at the right, worshiping Imsety and Hapy, two of the funerary deities known as the Four Sons of Horus. His own son, the lector-priest Pawahy, stands below, making the prescribed gesture as he recites for his father the funerary hymn written in front of him. The graceful figures, with their slight limbs, rather large heads, and great slanting eyes, recall the elegant but vaguely juvenile appearance of Amenhotpe himself.

39 Painted Relief
Dynasty 18, ca. 1373–1362 B.C.
Limestone; 9⅝ x 21½ in.
(24.5 x 54.5 cm.)
Lent by Norbert Schimmel
(L1979.8.2)

40 Funerary Stela of Senu
Dynasty 18, ca. 1417–1379 B.C.
Limestone; 29½ x 12⅝ in.
(75 x 32 cm.) Rogers Fund,
1912 (12.182.39)

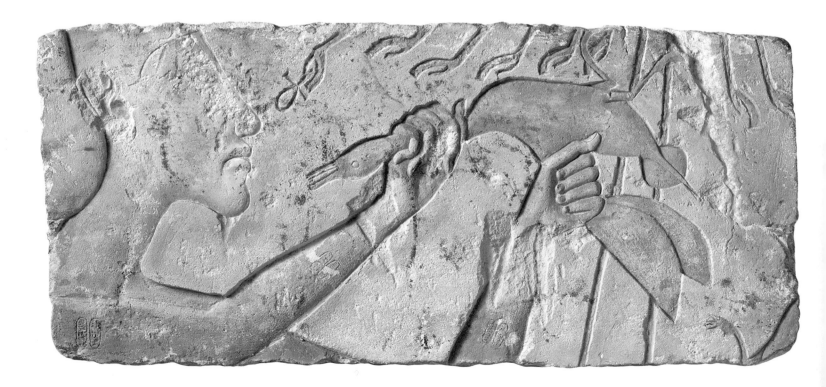

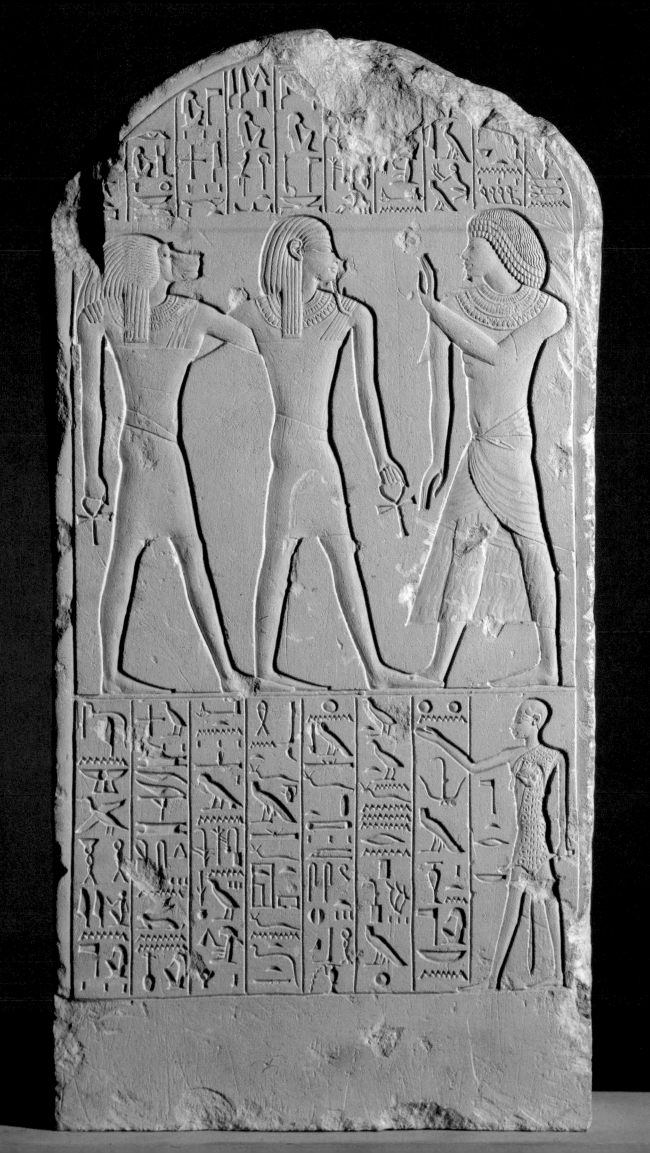

AMARNA PAVEMENT FRAGMENT

The painted walls and pavements of the royal palaces and private villas of Akhenaton's new capital city of Akhetaton are among the most attractive manifestations of Amarna art. The paintings have much in common with the floor, wall, and ceiling paintings that decorated the approximately contemporary palace of his father, Amenhotpe III, at Thebes. While retaining conventional principles of artistic organization, they reveal in general a greater freedom, naturalism, and feeling for space and a more subtle and harmonious palette than do the Theban tomb paintings of the same period. This pavement fragment, which depicts a walking duck surrounded by papyrus plants, is typical of the marsh scenes that decorated palace floors during the late Eighteenth Dynasty.

41 Pavement Fragment
Tell el Amarna; Dynasty 18,
ca. 1373–1362 B.C.
Painted stucco; 16¾ x 20½ in.
(42.5 x 52 cm.)
Rogers Fund, 1920 (20.2.2)

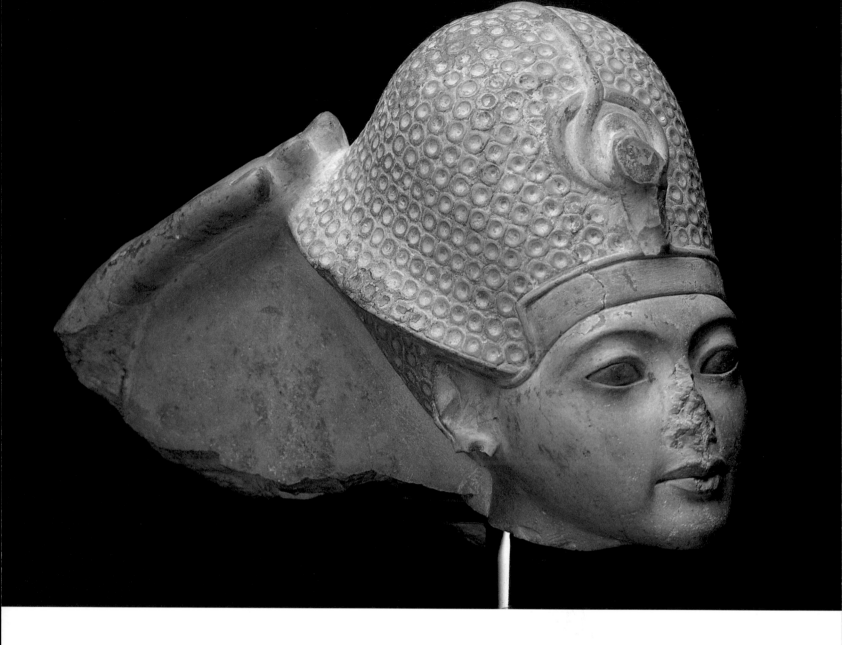

TUTANKHAMUN CROWNED BY AMUN

Akhenaton was succeeded by Smenkhara (ca. 1364–1361 B.C.), his erstwhile coregent, who enjoyed a brief reign; he, in turn, was succeeded by Tutankhamun (ca. 1361–1352 B.C.), whose parentage is uncertain. When he was a child of nine or ten, Tutankhamun was already married to Akhenaton's third daughter—a marriage that presumably strengthened his claim to the throne. Tutankhamun's brief life ended before he was twenty. His modern fame rests chiefly on the magnificent treasure with which he was buried, discovered in 1922 by Lord Carnarvon and Howard Carter. But he lived long enough to return to Thebes and restore the monuments and material wealth of the estates of the god Amun, who had suffered iconoclastic attacks during the reign of Akhenaton.

This sculpture, from a group commemorating his coronation, depicted the god, seated behind the king, in the act of placing the Blue Crown on the royal brow. All that remains is the head of Tutankhamun and the much larger hand of the god, touching the rim of the crown in back. The statue is of the hard, marblelike material known as indurated limestone, much favored by the sculptors of Amarna.

42 Head of Tutankhamun
Dynasty 18, ca. 1362–1361 B.C.
Indurated limestone;
H. 6 in. (15.2 cm.)
Rogers Fund, 1950 (50.6)

Ivory Gazelle

It is altogether in keeping with the warm and lighthearted spirit that pervaded the life of the court during the last half century of the Eighteenth Dynasty that this period should have been particularly productive of little figures such as dwarfs, animals, and birds, carved of wood, ivory, or stone.

Although Egyptian artisans generally restricted themselves to formal stylistic conventions and repetitious subject matter, they were nevertheless capable of creating works of startling realism. A charming series of little ivory carvings portray, in lively, sensitive, and sympathetic fashion, the animals most familiar to and beloved by the people of the late Eighteenth Dynasty. The body of this gazelle is carved from a single piece of ivory, with hooves painted black and hairs along the spine rendered by small scores; the missing horns were probably of another material, such as ebony. Attached to the wooden base by tenons protruding from its tiny hooves, the gazelle is shown poised on a desert hillock, tail raised and eyes alert to danger. The smoothed surfaces, slender legs, and delicate coloring contribute to this consummate portrayal of fragile grace. The wooden base is inlaid in blue pigment with flowering shrubs of the sort found in the rocky valleys of the desert highlands.

Royal Head

The dark red quartzite head of an anonymous royal personage is characteristic of the less drastic tendencies of Amarna art, in which the revolutionary stylistic standards were not carried through to such an extreme degree. In spite of the disconcertingly dark shadows left by the missing eye inlays, the facial features, especially the full lips with turned-down corners, resemble other representations of Queen Tiye, the mother of Akhenaton. The lines that descend from the sides of the figure's nose past the corners of the mouth add a touch of weariness to a rather bitter expression.

The statue, or large statuette, to which this head belonged was probably made of several materials, only the exposed flesh portions being of red quartzite, while the clothing may have been of limestone or alabaster and the missing headdress of faience or some similar substance.

43 Gazelle
Dynasty 18, ca. 1379–1362 B.C.
Ivory, wood, and Egyptian-blue
pigment; L. 3⅞ in. (9.5 cm.),
H. 4½ in. (11.4 cm.)
Purchase, Edward S. Harkness
Gift, 1926 (26.7.1292)

44 Royal Head
Dynasty 18, ca. 1379–1362 B.C.
Dark red quartzite; H. 4⅜ in.
(11.2 cm.) Rogers Fund, 1911
(11.150.26)

45 *Canopic Jar*
Thebes, Valley of the Kings, Tomb 55;
Dynasty 18, ca. 1365 B.C. Alabaster,
obsidian, and blue paste; H. 20½
in. (52 cm.), Diam. 9½ in. (24.1 cm.)
Jar: Gift of Theodore M. Davis, 1907;
Lid: Theodore M. Davis Collection,
Bequest of Theodore M. Davis, 1915
(Jar: 07.226.1; Lid: 30.8.54)

Opposite: detail

Page 66: text

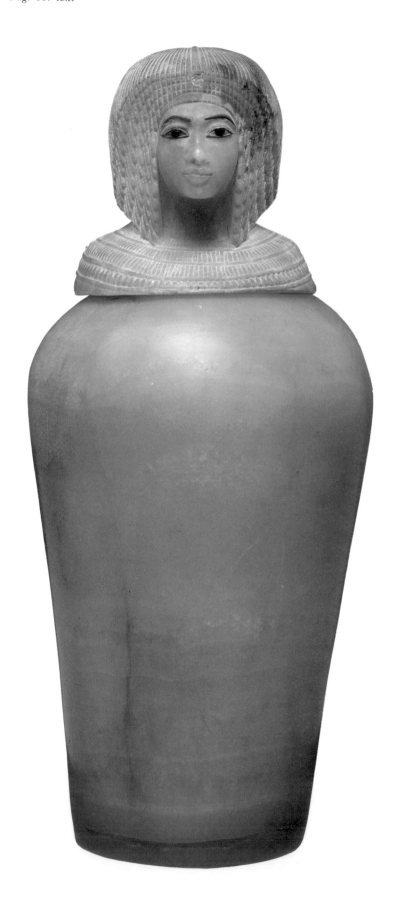

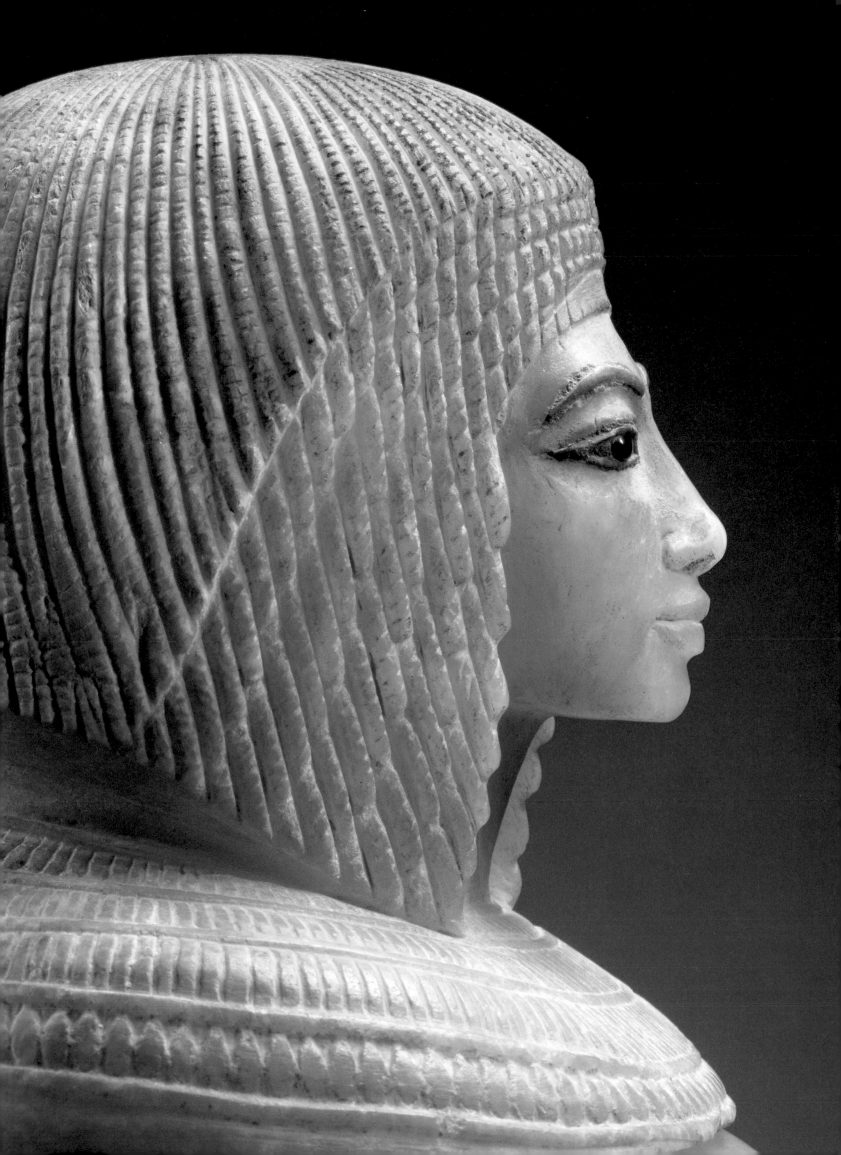

ALABASTER CANOPIC JAR (Pages 64–65)

Although this alabaster canopic jar (Plate 45) was fashioned for a practical purpose—as a container for an enbalmed human organ—its lid (pages 64–65) is an unusually fine representation of a royal woman that can be dated to the reign of Akhenaton or shortly thereafter. The woman's serene features are animated by eyes inlaid with carved bits of alabaster, obsidian, and blue paste, and her face is framed by a massive wig of layered curls, a headdress favored by Akhenaton's queen, Nefertiti, and their six daughters.

Together with three identical jars now in Cairo, this one was discovered by Theodore M. Davis in a tomb in the Valley of the Kings that has aroused great controversy concerning the events surrounding Akhenaton's death and succession. The tomb also contained a shrine dedicated to Akhenaton's mother, Queen Tiye; the coffin of a minor queen, Kiya, reinscribed for Akhenaton; and mud seals of Tutankhamun.

Deliberate erasure of the names and figures on most of the pieces from the tomb has deepened the mystery of the objects' common archaeological context. Even the jar has suffered depredations: the uraeus on the woman's brow has been knocked off; her collar has been recut; and the inscriptions on the front have been removed, leaving her identity as inscrutable as her expression.

STATUE OF HOREMHAB

General of the army, royal scribe, and deputy for King Tutankhamun, Horemhab sits cross-legged in the pose of an ordinary scribe, holding a scroll on which is written a hymn to Thoth. His heavy-lidded eyes, sensitive full lips, and sweet, rather drowsy expression are modeled on the features of his young king. But the importance of Horemhab—who played a major role in governing Egypt during the reign of Tutankhamun and who would one day become king himself—is unmistakably conveyed by the superb quality of this lifesize statue, a major work from a great royal atelier. That such a man should be portrayed as a scribe shows the respect accorded to literacy. The pose was also appropriate for a statue dedicated to Thoth, god of writing, and it may have had a special significance for Horemhab, whose inscriptions on this statue and elsewhere stress the administrative aspect of his many achievements.

46 Statue of Horemhab
Dynasty 18, ca. 1361–1352 B.C.
Gray granite; H. 46 in. (116.8 cm.)
Gift of Mr. and Mrs. V. Everit Macy,
1923 (23.10.1)

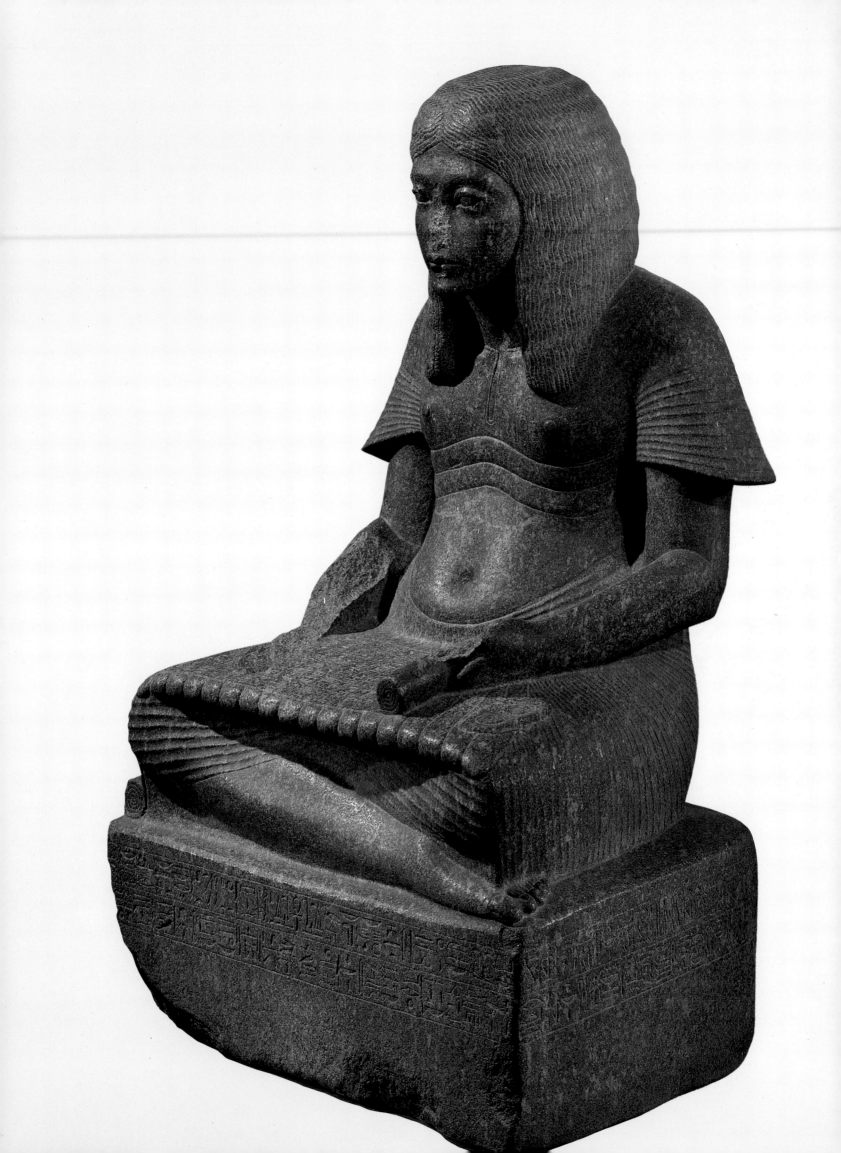

47 Statue of Yuny
Assint Dynasty 19, ca. 1304–1237 B.C.
Painted indurated limestone; H. 50¾ in.
(128.8 cm.) Rogers Fund, 1933 (33.2.1)

Left: front view

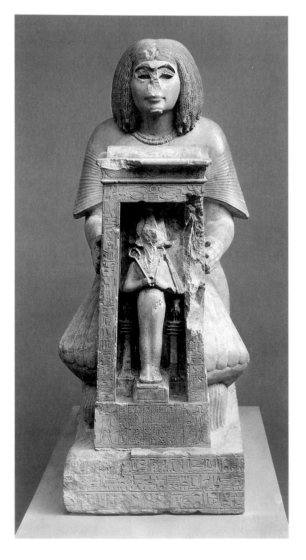

STATUE OF YUNY

Although his parentage is unknown, Tutankhamun was probably the last male descendant of the Tuthmoside pharaohs, and when he died he was succeeded by Ay (ca. 1352–1348 B.C.), an elderly counselor to Tutankhamun. At Ay's death, around 1348 B.C., the throne passed to Horemhab, the leading military figure of the time, who reigned until about 1320 B.C.

Horemhab was followed by Ramesses I (ca. 1320–1318 B.C.), another prominent general and the founder of the Nineteenth Dynasty. Elderly at the time of his accession, Ramesses reigned a mere two years and was succeeded by his son, Sety I (ca. 1318–1304 B.C.), whose fourteen-year reign was one of the most brilliant in New Kingdom history. Around 1304 B.C., Ramesses II—"the Great"—ascended the throne; he was to rule for sixty-seven years.

This magnificent statue of Yuny (Plate 47), a chief royal scribe of Ramesses II, was found in the tomb of Yuny's father, Amenhotpe, a chief physician. Here, Yuny kneels, holding before him an elaborately carved shrine containing a small figure of the god Osiris (see detail at the left). He wears the fashionable costume of a nobleman of the day: long, billowing linen garments; a heavy, curled wig; and papyrus sandals.

Yuny's jewelry consists of a heavy bracelet worn on the right wrist, an amulet around the neck, and a necklace of large lenticular beads known as the "gold of valor," a decoration given by the king for distinguished service. Two holes at the back of the neck may be for the attachment of real garlands during special festivals. Small figures of Rennutet, his wife, stand in raised relief at the sides of the back pilaster.

Yuny's eyebrows and the rims of his eyes were made of metal but were gouged out by an ancient thief, who may have broken the nose accidentally at the same time.

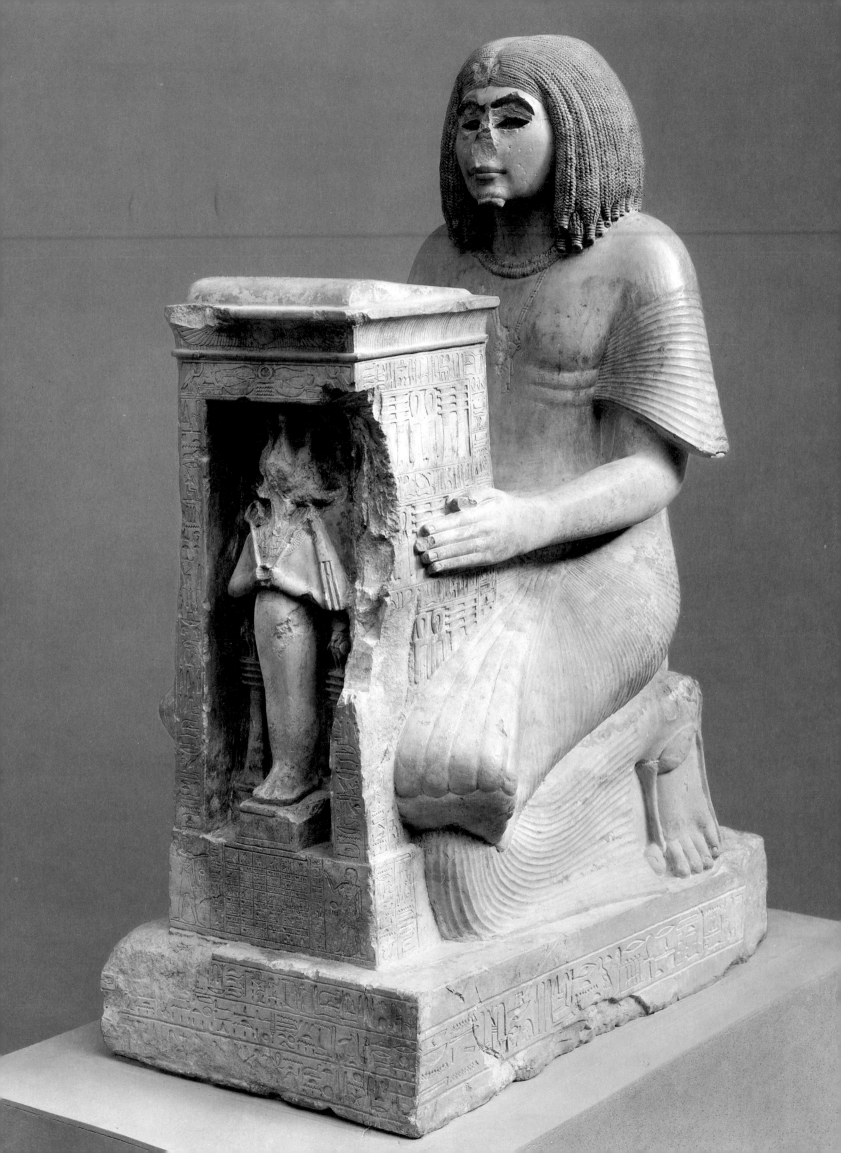

PAINTED SANDSTONE RELIEF

The pandemonium of the battlefield and the anguish of the wounded are portrayed on this sandstone block, which once formed part of a large war relief. The scene may not refer to an historical event, but may be a conventionalized representation of the Egyptian king triumphant over his foes, identifiable as northerners by their distinctive dress and hairstyles. Transfixed by the feathered shafts of the pharaoh's arrows, several dying Asiatics lie entangled in a heap, trampled beneath the hooves of the king's chariot team, whose underbellies are visible along the upper border. One of the fallen enemy, with yellow skin and a white long-sleeved garment, is apparently a man of social or military rank different from that of the red-skinned soldiers in short embroidered kilts, whose longer hair is bound by fillets.

Although the carving is cursory and the painting imprecise, the hasty execution of the relief seems to suit the confusion of armed conflict. Originally part of a battle scene in a temple of Ramesses II, the block was reused by Ramesses IV (ca. 1166–1160 B.C.) in the foundations of his mortuary temple in western Thebes, where it was discovered by The Metropolitan Museum in 1912.

Although justly famous as a warrior in his youth, Ramesses II spent much of his long reign enjoying the fruits of his earlier victories. When he finally died in around 1237 B.C. he had outlived twelve of his innumerable sons, and Merneptah (ca. 1236–1223 B.C.), his thirteenth son, who succeeded him, was well over fifty at his accession. He inherited a country weakened internally by decades of extravagance and threatened from abroad by peoples hungry for the rich delta lands. He successfully thwarted an attempted invasion from the west, and he and the four rulers who followed him were able to maintain the integrity of Egypt's borders. But by about 1200 B.C., the Nineteenth Dynasty had ended.

The last great pharaoh of the New Kingdom was Ramesses III (ca. 1198–1166 B.C.), perhaps an abler warrior than his vainglorious namesake. He halted the invasions of the Sea Peoples, migrant waves that threatened Egypt in the west and to whom most other nations of the ancient Near East had succumbed. But Egypt's decline appears to have been irreversible: Her lack of iron ore had left her effectively still in the Bronze Age, while other nations that had been producing and refining iron weapons and implements for centuries posed an economic as well as military threat. The administration had grown while the assets it had to manage dwindled. By the end of the New Kingdom (ca. 1085 B.C.), there are indications that the population had lost a measure of confidence in the kingship itself.

The last eight Ramesside rulers did little to restore the nation's fortunes. By around 1085 B.C., when the last ruler of the Twentieth Dynasty, Ramesses XI (ca. 1113–1085 B.C.), died, the political authority of the Egyptian kings, ruling from Tanis, was rivaled by the powerful high priests of Amun at Thebes: Egypt was effectively split in two. This marks the end of the New Kingdom and the beginning of the Third Intermediate Period (ca. 1085–656 B.C.).

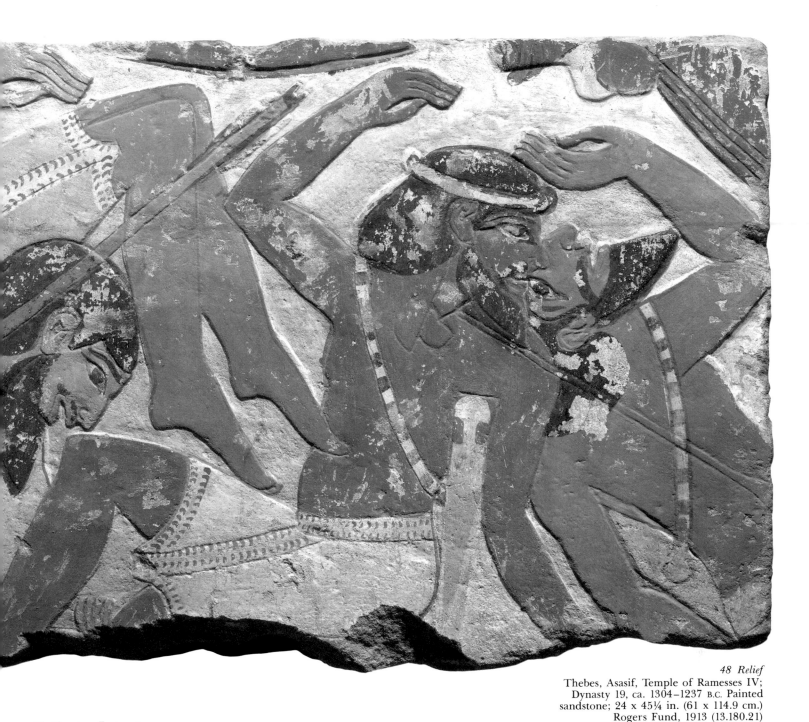

LIMESTONE FRAGMENT

Smooth limestone flakes from the excavation of rock-cut tombs were often used by draftsmen and scribes for practicing their professional freehand skills as well as for idle doodling. This fragment, discovered in the Valley of the Kings, bears sketches of both serious and humorous intent, doubtless drawn by one of the workmen engaged in decorating the royal tombs. The first sketch is that of a Ramesside king, whose almond-shaped eyes and gracefully curved nose were completed with a few confident strokes; but the dome of the crown apparently required correction.

The artist also drew two standing figures whose names appear above: Pay and his wife, Meresger. Pay seems to be drinking beer from a jar through a tube, and his thin physique and conventional dress are an amusing contrast to the corpulence and near-nakedness of Meresger. Her hair, which normally would have been covered by a long wig, is close-cropped, and her shoulders have been rendered in clumsy foreshortening for comic effect.

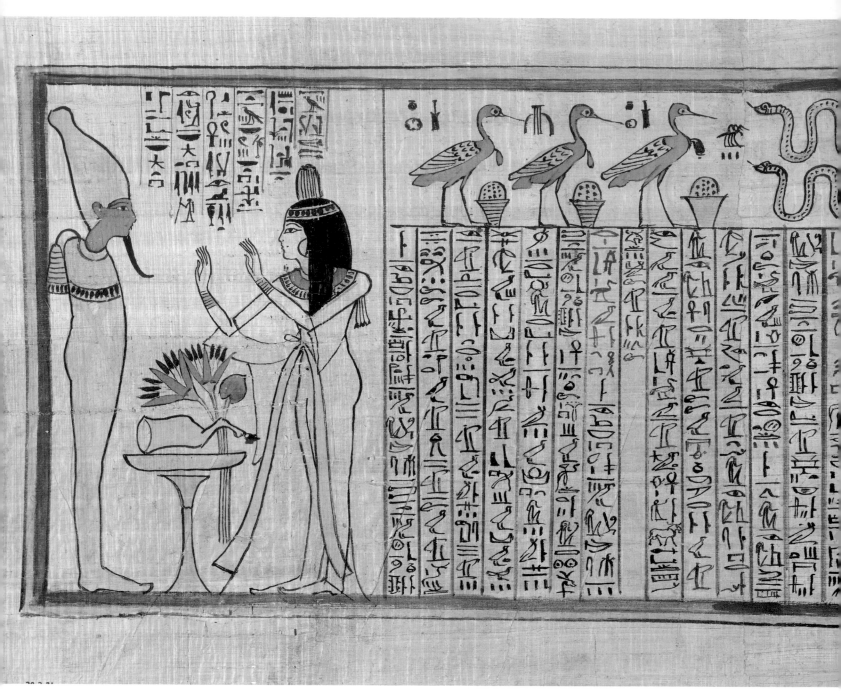

50 Funerary Papyrus
Thebes, Deir el Bahri;
Dynasty 21, ca. 1085–945 B.C.
Painted and inscribed papyrus;
H. 13¾–14⅛ in. (35–36 cm.)
Rogers Fund, 1930 (30.3.31)

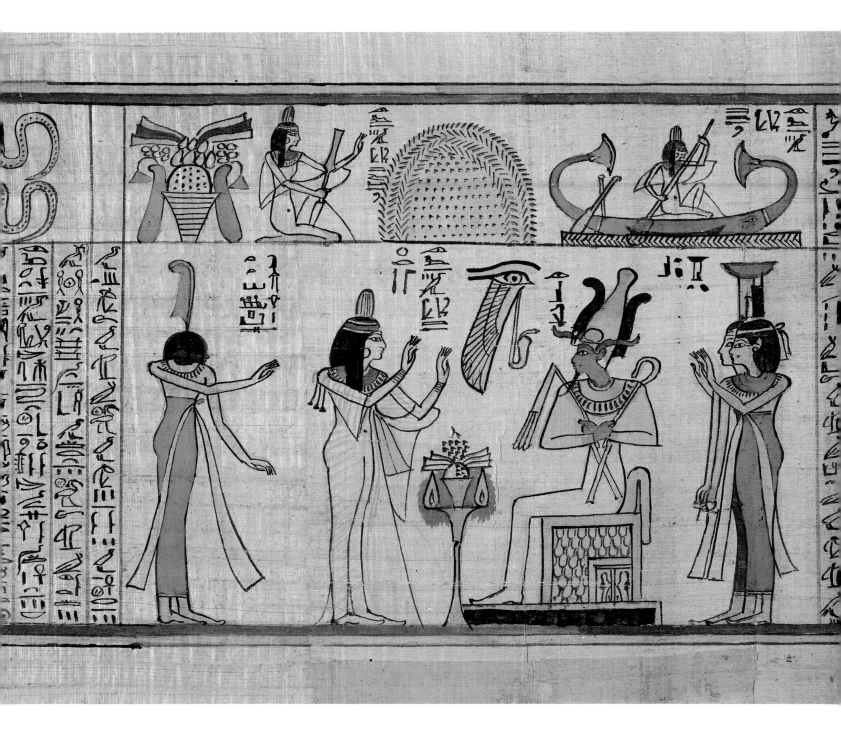

Funerary Papyrus

Despite the variety of its content, all Egyptian funerary literature served the fundamental purpose of providing the deceased with a compendium of magical spells that would facilitate entry into the underworld. From the New Kingdom onward, these spells were written most frequently on papyrus and included original compositions as well as derivatives of the earlier Pyramid Texts and Coffin Texts. The spells and their accompanying vignettes are collectively known as the Book of the Dead; only a selection occurs on any one papyrus, with the texts apparently arranged in random order. The papyrus of the songstress of Amun, Nany, who lived during the Twenty-First Dynasty (ca. 1085–945 B.C.), displays the freedom with which spells were intermingled and abridged, often with garbled results.

The text pictured above is written in cursive hieroglyphs and is made up of parts of Chapters 72 and 105, spells for "coming forth by day and opening the netherworld." The large vignette on the left represents Nany adoring the mummiform figure of Osiris. On the far right, Nany worships Osiris enthroned, in a scene that illustrates Chapter 125, which is written elsewhere on the papyrus. Behind her stands the goddess of the West, and Osiris is flanked by Isis and Nephthys. The smaller vignettes at the top belong to Chapter 110: Nany in a papyrus skiff and kneeling before a pile of grain; and three *ba* birds confronting two serpents.

The papyrus was found by The Metropolitan Museum in 1929 among Nany's burial equipment, deposited in the earlier tomb of Queen Meritamun in western Thebes.

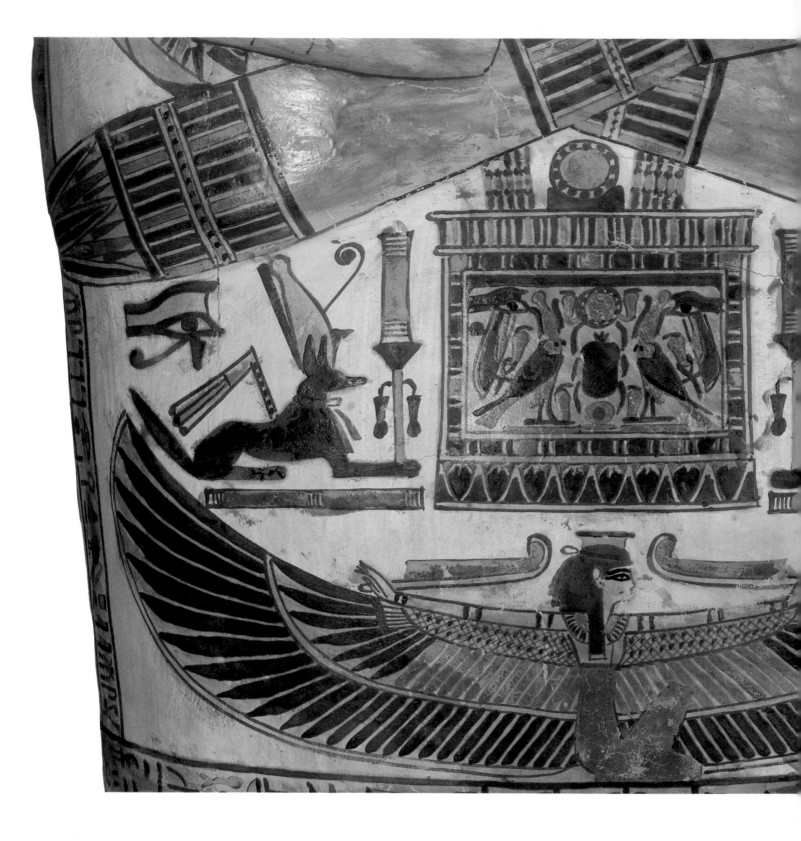

Outer Coffin of Henettawy

During the Third Intermediate Period, an unsettled time, the individual private tomb was abandoned in favor of family shafts (or caches) that could be more easily guarded from thieves; often tombs that had already been robbed were reused for this purpose. Henettawy, a mistress of the house and chantress of Amen-Ra, was buried in such a tomb. Since her burial chamber, like most others of the time, was undecorated, the paintings on her coffin (Plate 51), with their emphasis on elaborate religious symbolism and imagery, re-

placed the wall decorations of previous periods and reflect a style and iconography developed during the last years of the New Kingdom.

In the detail above, the sky-goddess Nut spreads her wings in a protective gesture. In her hands she holds two feathers representing *maat*, "truth" or "righteousness." The rectangular panel just above her is painted like a large, jeweled pectoral worn by Henettawy—there are even necklace straps painted just above the panel itself. Excavations have,

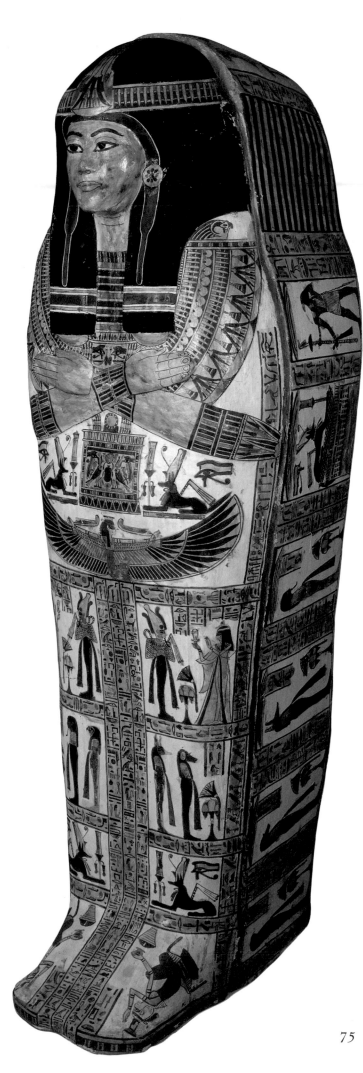

51 Outer Coffin of Henettawy
Thebes, Deir el Bahri;
Dynasty 21, ca. 1039–992 B.C.
Gessoed and painted wood;
L. 79⅞ in. (203 cm.)
Rogers Fund, 1925 (25.3.182)

Left: detail

in fact, uncovered many examples of real pectorals that resemble this one in shape and figuration. The central element of the pectoral is the scarab-beetle pushing the disk of the morning sun over the eastern horizon. On either side of the pectoral are recumbent figures of Anubis, god of embalming and of the Theban necropolis. Two magical *udjat* eyes are painted above the Anubis figures. The eyes—which are efficacious symbols—resemble the markings around a falcon's eyes and thus recall Horus, the falcon-god.

BLUE FAIENCE VESSEL

The collapse of the New Kingdom marked the end of Egyptian dominance in international affairs. The rulers of Egypt during the Twenty-Second Dynasty (ca. 945–715 B.C.) were of Libyan descent. The first royal scion of this line was Shoshenq I (ca. 945–924 B.C.). Shoshenq is the biblical Sheshak, who plundered Jerusalem, the capital of Judah, after the death of King Solomon.

This faience chalice is one of many lovely small objects that can be dated to the Twenty-Second Dynasty. The fragrant blossom of the blue lotus (water lily) was much loved by the ancient Egyptians, who saw in the unfolding of its petals upon the water each morning a constant reenactment of creation and rebirth. Many vessels imitated its slender form, usually in brilliant blue faience. This chalice also includes the flower's watery habitat in miniature reliefs. Above the sepals encircling the bowl of the cup, a ring of fish is shown, over, although theoretically in, the wavy water. In the two registers above, men, beasts, and fowl go about among papyrus and marsh reeds. The minute figures show elements of playful absurdity, especially the clumsily gamboling bull calves. Nevertheless, the cup is a truly religious object, probably made for a tomb, symbolizing the eternal renewal of life in all its richness and variety.

52 Blue Vessel
Dynasty 22, ca. 945–715 B.C.
Faience; H. 5¾ in. (14.6 cm.)
Purchase, Edward S. Harkness
Gift, 1926 (26.7.971)

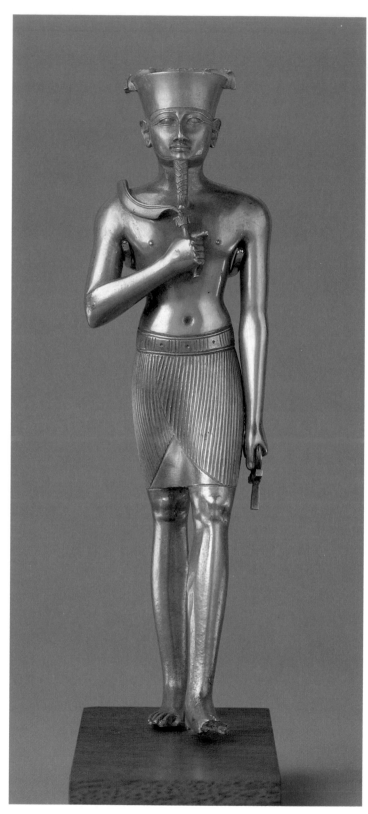

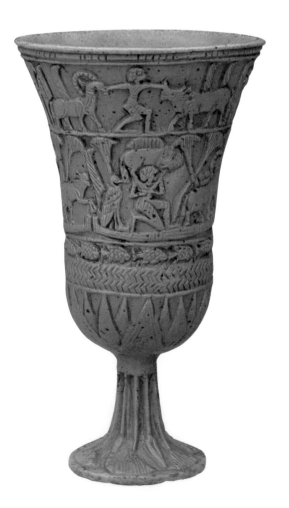

53 Statuette of Amun
Dynasty 22, ca. 945–715 B.C.
Gold; H. 6⅞ in. (17.5 cm.)
Purchase, Edward S. Harkness
Gift, 1926 (26.7.1412)

GOLD STATUETTE OF THE GOD AMUN

The fabled gold of ancient Egypt has survived mainly in the form of jewelry and funerary objects buried in hidden tombs. This statuette of the god Amun is an extremely rare example of the precious statuary and cult objects with which—ancient accounts tell us—the great temples were equipped. Amun, king of the gods, is identifiable by his characteristic crown, though only traces remain of its two tall plumes. As a god, he carries an *ankh,* the sign of life, in one hand. Against his chest he holds a scimitar, symbol of power. The style of the slender, wasp-waisted figure and its high technical quality indicate a date after the end of the New Kingdom (ca. 1085 B.C.), when Egypt, though growing weaker and poorer, produced its finest metal statuary.

FUNERARY STELA OF AAFENMUT

This small, exceptionally well-preserved wood stela was found in 1914–15 at Thebes by The Metropolitan Museum's Egyptian expedition during its clearance of a tomb containing the burial pit of Aafenmut, a scribe of the treasury. It was discovered along with some other small finds, which included a pair of leather tabs from a set of mummy braces bearing the name of Osorkon I (ca. 924–889 B.C.), the second king of the Twenty-Second Dynasty. Solar worship is the theme of the stela's decoration: In the lunette the sun disk crosses the sky in its bark, while below, the falcon-headed Ra-Harakhty, the Lord of Heaven, receives food offerings and incense from Aafenmut. The same episodes appear in a virtually identical style on the painted coffins of the period.

54 Funerary Stela of Aafenmut
Thebes, Khokha; Dynasty 22,
ca. 924–889 B.C. Painted wood;
9 x 7¼ in. (23 x 18.2 cm.)
Rogers Fund, 1928 (28.3.35)

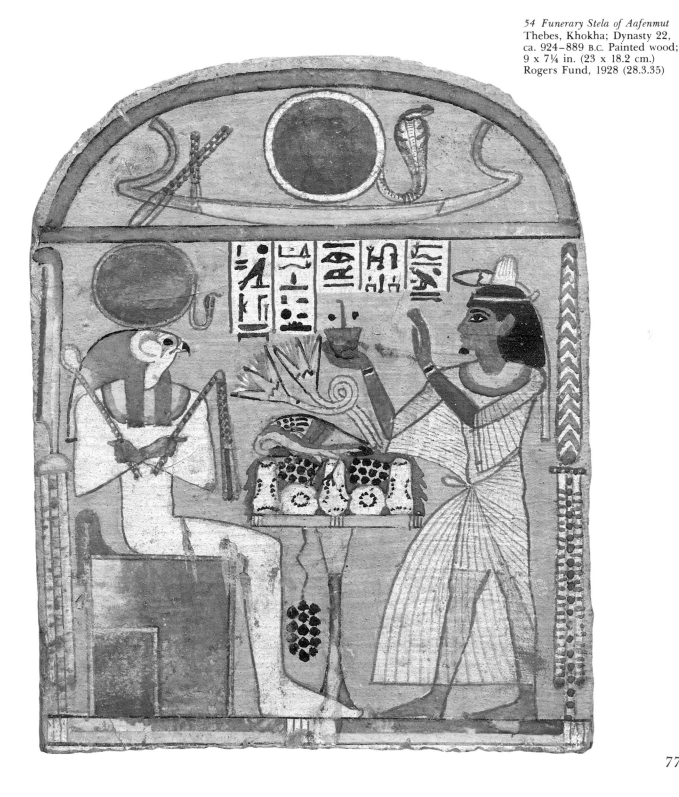

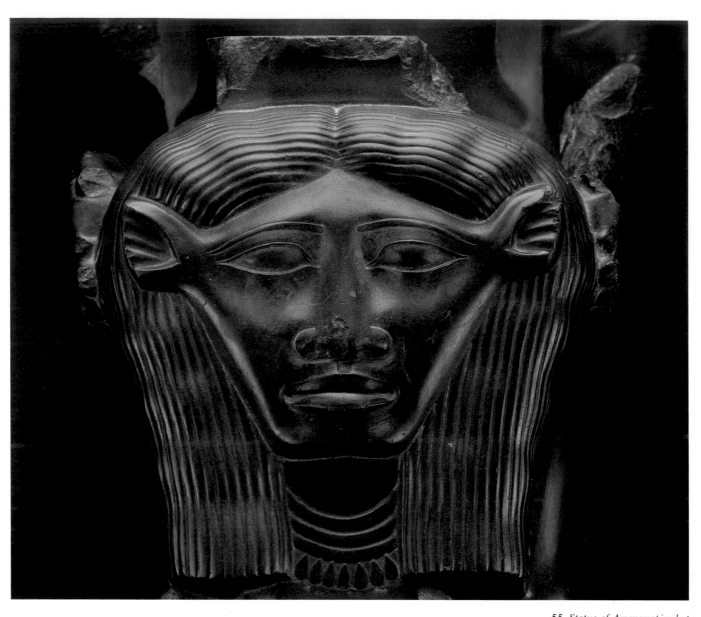

55 Statue of Amenemopiemhat
Dynasty 26, ca. 664–610 B.C.
Graywacke; H. 25¼ in. (64.2 cm.)
Rogers Fund, 1924 (24.2.2)

Above: detail

STATUE OF AMENEMOPIEMHAT

During the latter part of the Third Intermediate Period, Egypt continued to be divided, with rulers maintaining contemporaneous dynasties (the Twenty-Second, Twenty-Third, and Twenty-Fourth) resident in Bubastis, Tanis, and Sais, respectively. The disintegration of the internal affairs of Egypt, as the result of a divided country, made possible an invasion by the Kushite King Piye in around 728 B.C. In 663 B.C. the Assyrian king Assurbanipal sacked Thebes and drove the Kushites out of Egypt. The Assyrians quickly withdrew from Egypt to deal with their own internal problems, but their support of the local rulers of Sais enabled this family to gain control of all Egypt and establish the Twenty-Sixth Dynasty (ca. 664–525 B.C.). During the Saite Period, the Egyptians fought several inconclusive battles with the Babylonians over control of Palestine and skirmished with both the Nubians to the south and the Greeks of Cyrene to the west.

There was a substantial influx of foreign settlers into Egypt: Syrians, Jews, and, most of all, Greeks. Culturally, the Egyptians turned to their own past, reviving earlier traditions in religion and the arts, as evidenced by this kneeling statue of the overseer of singers of Amun of Luxor, Amenemopiemhat.

Both Amenemopiemhat's name and title indicate that he was closely associated with a cult of Amun of Luxor in or near Memphis. The statue was designed for a Memphite temple, probably the main temple of the city's major deities, Ptah and Sekhmet, who are named in the inscriptions. Amenemopiemhat holds a cult object of the cow-eared goddess Hathor. The proportions of his figure, its muscularity, and such details as the slanted ridges of the collarbone and the shallow depression down the center of the torso represent a conscious attempt in the Late Period to emulate the classic works of the Old and Middle kingdoms.

78

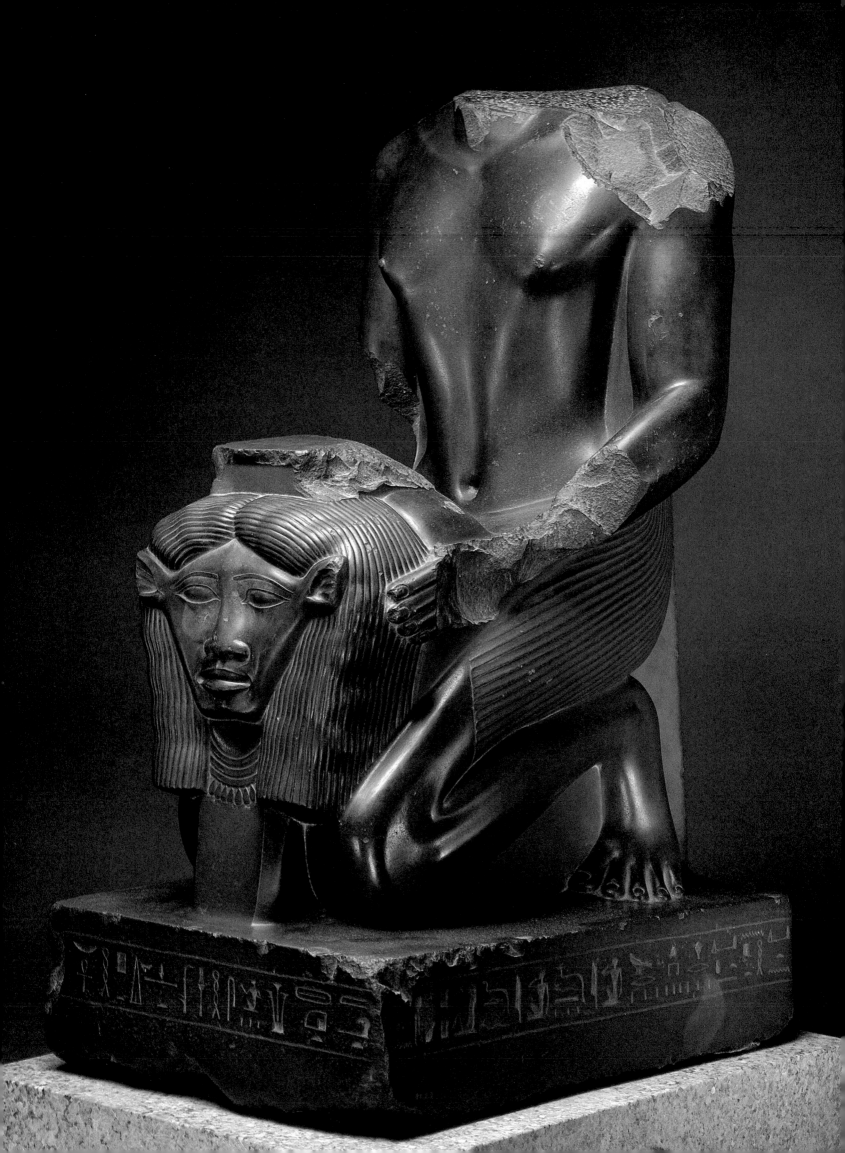

The Metternich Stela

The Achaemenid Persians ruled Egypt from 525 to 404 B.C. as the Twenty-Seventh Dynasty. They were repelled in 404 B.C., and the succeeding dynasties—the Twenty-Eighth, Twenty-Ninth, and Thirtieth (404–342 B.C.)—were the last native Egyptian rulers. This stela is dated to the reign of the last king, Nectanebo II (360–342 B.C.). Carved of graywacke, it is the finest and most elaborate example of the magical stelae that originated in the late New Kingdom.

The child Horus standing on two crocodiles is the dominant motif of these monuments, which were inscribed with magical texts that were recited to cure ailments and to protect against animal bites. The gemlike vignettes of this stela portray a number of gods counteracting the influences of snakes, crocodiles, and scorpions. Above, the sun god is worshiped by eight baboons and a kneeling Nectanebo.

One text explains the centrality of Horus on magical stelae by recounting the young god's cure of poisonous bites by the god Thoth. Apparently erected in a necropolis of sacred bulls by the priest Esatum, the stela was presented in 1828 to Prince Metternich of Austria-Hungary.

56 The Metternich Stela
Dynasty 30, ca. 360–342 B.C.
Graywacke; 32⅞ x 10⅛ in.
(83.5 x 25.7 cm.)
Fletcher Fund, 1950 (50.85)

This page: front and back
Opposite: detail

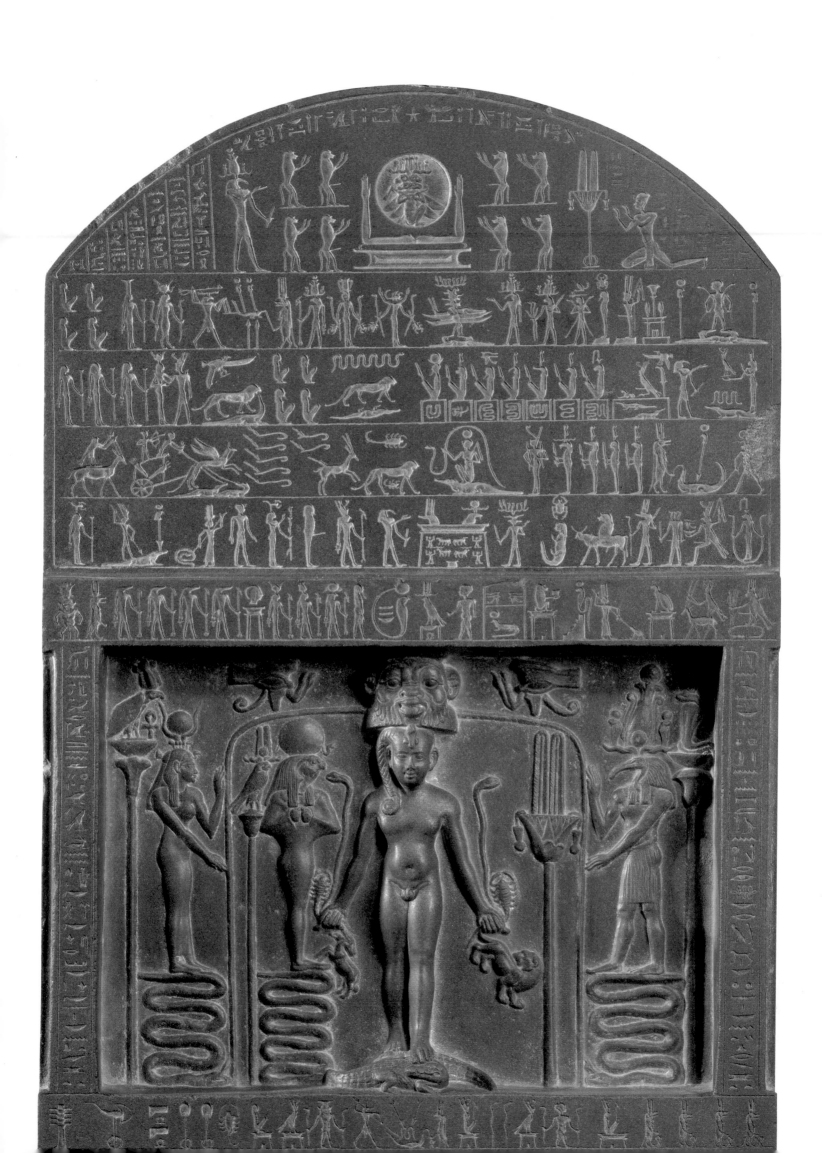

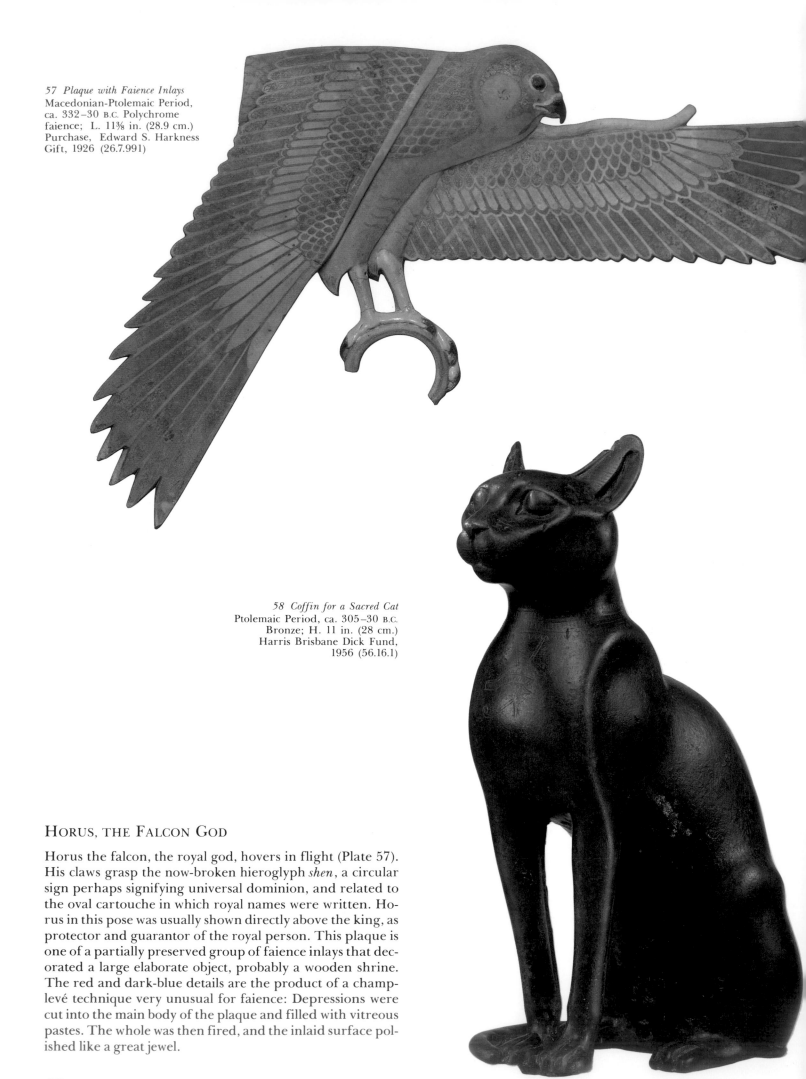

57 Plaque with Faience Inlays
Macedonian-Ptolemaic Period,
ca. 332–30 B.C. Polychrome
faience; L. 11⅜ in. (28.9 cm.)
Purchase, Edward S. Harkness
Gift, 1926 (26.7.991)

58 Coffin for a Sacred Cat
Ptolemaic Period, ca. 305–30 B.C.
Bronze; H. 11 in. (28 cm.)
Harris Brisbane Dick Fund,
1956 (56.16.1)

HORUS, THE FALCON GOD

Horus the falcon, the royal god, hovers in flight (Plate 57).
His claws grasp the now-broken hieroglyph *shen*, a circular
sign perhaps signifying universal dominion, and related to
the oval cartouche in which royal names were written. Ho-
rus in this pose was usually shown directly above the king, as
protector and guarantor of the royal person. This plaque is
one of a partially preserved group of faience inlays that dec-
orated a large elaborate object, probably a wooden shrine.
The red and dark-blue details are the product of a champ-
levé technique very unusual for faience: Depressions were
cut into the main body of the plaque and filled with vitreous
pastes. The whole was then fired, and the inlaid surface pol-
ished like a great jewel.

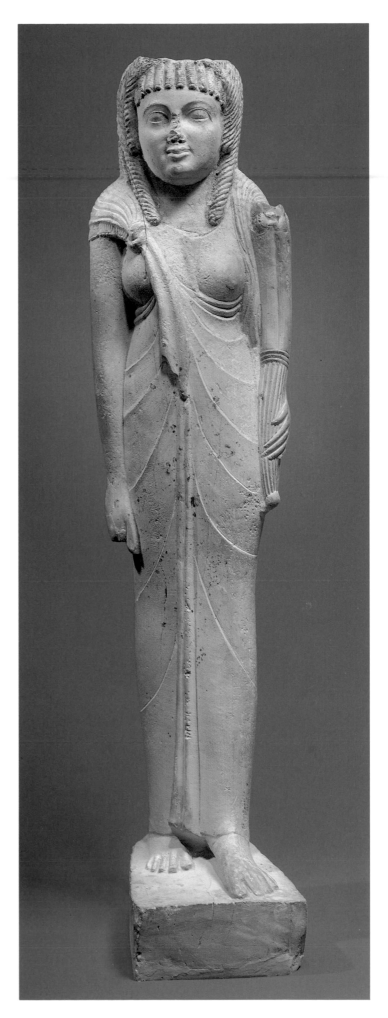

59 Statue of Arsinoe II
Ptolemaic Period, after 270 B.C.
Limestone with traces of gilding
and paint; H. 15 in. (38.1 cm.)
Rogers Fund, 1920 (20.2.21)

COFFIN FOR A SACRED CAT

In 332 B.C. Egypt was conquered by Alexander the Great, and when his vast but short-lived empire came apart after his death (323 B.C.), Egypt was claimed by his general, Ptolemy, the first of thirteen Ptolemaic kings. Ptolemy I (323–283/2 B.C.) exercised firm control over the economy, which supported a large bureaucracy, an army, and a navy. During the third century B.C., Alexandria, the city founded by Alexander, became an important center of Hellenistic culture in Egypt. The Ptolemies did not impose their culture on Egypt, however, but adopted the indigenous traditions and religion and styled themselves as pharaohs.

During the later periods of Egyptian history, the cat was venerated as the sacred animal of Bastet, a goddess worshiped at the delta town of Bubastis. In the fifth century B.C., the Greek historian Herodotus described the great annual festival of Bastet and her beautiful temple, near which mummified cats were interred in large cemeteries as votive objects. This hollow bronze figure (Plate 58) served as a coffin for a mummified cat. The figure's smooth contours are complemented by a finely incised broad collar and a pectoral in the shape of an *udjat* eye—the sacred eye of Horus. Holes for attaching earrings pierce the cat's ears.

ARSINOE II

Since the inscription on the back of this figure (Plate 59) refers to Arsinoe II as a goddess, it was probably made after her death in 270 B.C., when her cult was established by her brother and husband Ptolemy II (283/2–247 B.C.). The queen stands in a traditional Egyptian pose, strictly frontal, with her left foot advanced and right arm, hand clenched, at her side. The statuette, one of only two known with her name inscribed, is a fine example of the tendency during the Ptolemaic Period to combine Egyptian artistic conventions with those of the classical world; the style of her coiffure and the cornucopia (a divine attribute) she holds are Greek elements, while her stylized features and garments and the pillar are established Egyptian conventions of the period.

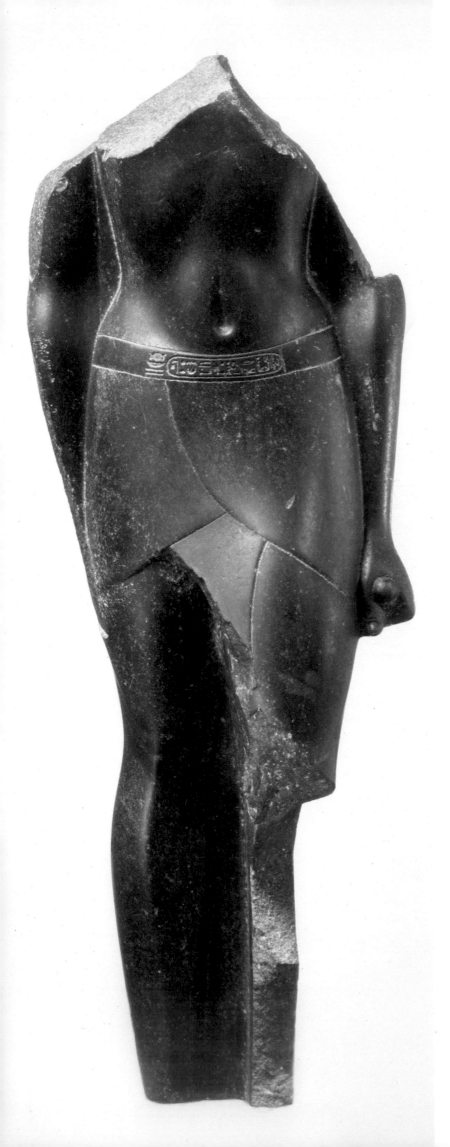

STATUE OF A PTOLEMAIC RULER

Ptolemaic Egypt became part of the Roman Empire after the Battle of Actium in 31 B.C. in spite of the efforts of Cleopatra VII (51–30 B.C.) to prevent Egypt from becoming engulfed by Rome. This queen was allied first with Caesar and then with his successor, Mark Antony, but was finally defeated when Octavian—who was to become the emperor Augustus—entered Egypt in 31 B.C.

The tenacity of Egyptian traditions is nowhere more evident than in this figure (Plate 60 and detail) of a late Ptolemaic ruler of the middle of the first century B.C. (80–30 B.C.), possibly Ptolemy XII, the father of Cleopatra or one of his ephemeral successors, her brothers and son. The pose, costume, and inscriptions follow conventions developed as

60 Statue of a Ptolemaic Ruler
Ptolemaic Period, ca. 50–30 B.C.
Basalt; H. 36⅝ in. (93 cm.)
Purchase, Lila Acheson Wallace
Gift and Rogers Fund, 1981
(1981.224.1)

Opposite: back view

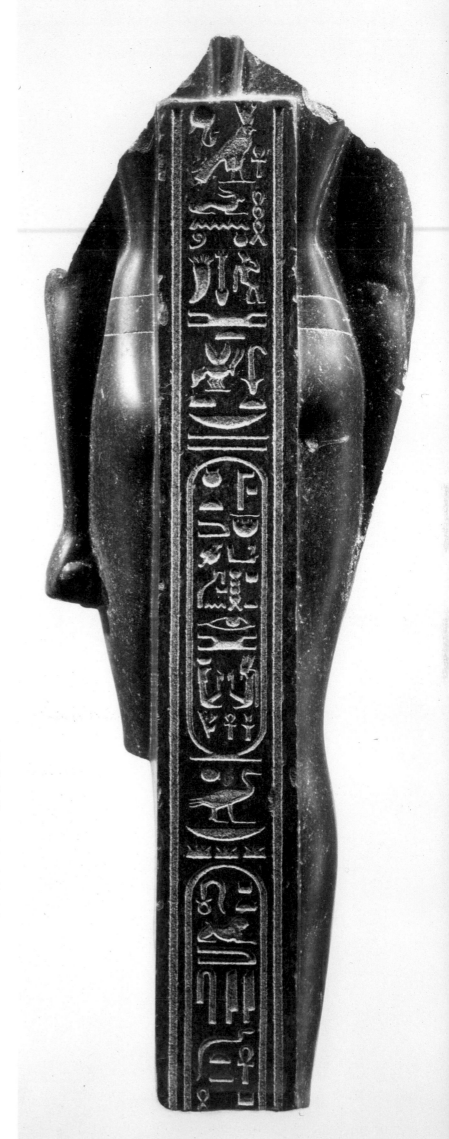

much as twenty-five hundred years earlier. In this case, extreme orthodoxy has, in part, a political motivation, for the foreign-bred, internationally minded Ptolemies sought to hold their subjects' loyalty by appearing in temple statues and reliefs as true heirs to the divine and priestly functions of the pharaoh.

Perhaps the most remarkable thing about the statue is its freshness. A master sculptor has not just recapitulated the old forms, but has recreated them by means of small variations. This high-waisted, young-looking, crisply turned-out figure is a product of the individual response within rigid guidelines that enlivens the best Egyptian art from every period.

61 Fayum Portrait of a Young Boy
Roman Period, ca. A.D. 138–61
Encaustic on wood; H. 15 in. (38 cm.)
Gift of Edward S. Harkness,
1918 (18.9.2)

62 Fayum Portrait of a Woman
Roman Period, ca. A.D. 138–61
Encaustic on wood;
H. 15 in. (38.1 cm.)
Rogers Fund, 1909 (09.181.6)

86

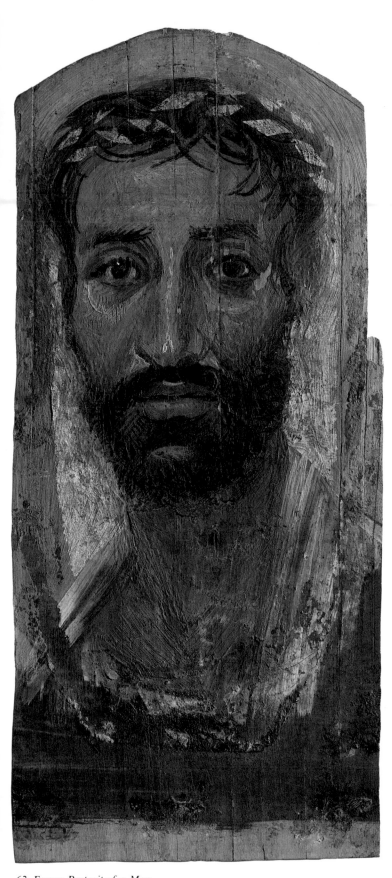

THREE FAYUM PORTRAITS

Fayum portraits are named after the part of Egypt in which they were found. The extensive Greek communities of the Fayum, founded in the Ptolemaic Period, maintained their ethnic identities. They followed current Mediterranean fashions, but they adopted some Egyptian customs, including mummification: Panels like these were made to be fitted into the wrappings of the dead, serving the function of the traditional mummy mask. They were painted in encaustic (pigment applied in melted wax) on wood.

The immediacy of Fayum portraits such as these, with their luminous eyes gazing intently out of faces modeled by loosely brushed highlights, contrasts sharply with the cool precision of most pharaonic images. Three very different individuals peer out of these panels: a long-faced man with a beard, a young woman with fashionably long lashes, and a boy named "Eutyches, freedman of Kasianos." Their garments and wreaths, and the style of these portraits, which date to the second century A.D., are Hellenistic-Roman.

OVERLEAF:

TEMPLE OF DENDUR *(Pages 88–89)*

The Temple of Dendur, an Egyptian monument originally erected in Nubia, forty-five miles south of the First Cataract, would have been completely submerged by the lake formed by the construction of the Aswan High Dam, which was begun in 1960. Instead, it came to the United States as a gift from the Egyptian government in recognition of the American contribution to the international campaign to save the ancient Nubian monuments.

The temple was erected by the Roman emperor Augustus (31 B.C.–A.D. 14) after his occupation of Egypt and Lower Nubia. It honors the goddess Isis and—in a move to secure the loyalty of the local population—two sons of a Nubian chieftain, who were deified because they drowned in the sacred Nile.

The temple, consisting of three rooms—*pronaos,* antechamber, and sanctuary—has been reassembled as it appeared on the banks of the Nile in a modern simulation of the entire temple site. The complex is a simplified version of the standard Egyptian cult temple, whose plan had remained fairly consistent for three thousand years. In the temple reliefs Augustus himself makes the offerings; however, he is represented in the traditional Egyptian manner with its related iconography.

63 Fayum Portrait of a Man
Roman Period, A.D. 150–61
Encaustic on wood;
H. 15¾ in. (40 cm.)
Rogers Fund, 1909 (09.181.3)

64 Temple of Dendur
Dendur; Early Roman Period,
ca. 15 B.C. Aeolian sandstone;
L. of gateway and temple 82 ft. (25 m.)
Given to the United States by Egypt in
1965, awarded to The Metropolitan
Museum of Art in 1967 and installed
in The Sackler Wing in 1978 (68.154)

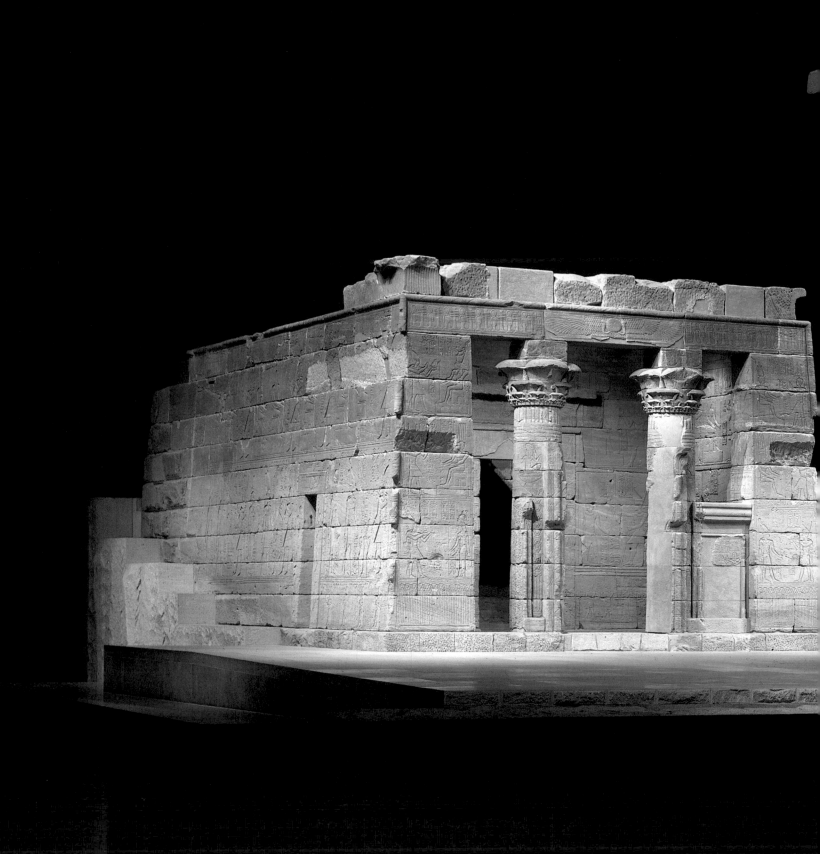

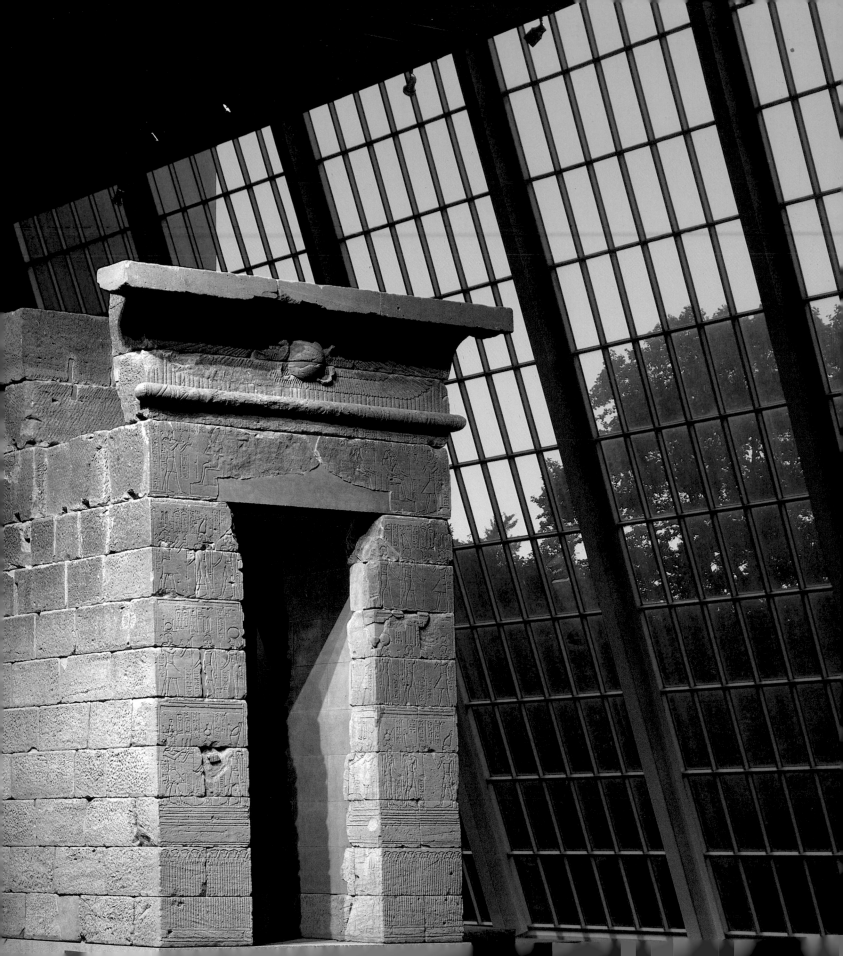

ANCIENT NEAR EAST

The origin of many features of Western civilization lies in the lands of the Near East where communities evolved from small villages of hunters, gatherers, and farmers into the first true cities. "Ancient Near East" is a general term that embraces both an enormous geographical territory and a long chronological span. From the earliest settled villages of the eighth and seventh millennia B.C. until the collapse of the Sasanian Empire before the armies of the Islamic prophet Muhammad in the middle of the seventh century A.D., many different ethnic groups lived in an area of more than three million square miles. It extended from the western edge of Anatolia, now Turkey, east to the valley of the Indus River in modern-day Pakistan. The variety of ecological environments in this vast expanse includes the alluvial plains of river valleys, coastal plains, high mountain steppes, deserts, and oases. The combination of so many different living conditions and ethnic groups produced the rich and complex cultures of the ancient Near East. This brief introduction will touch only on the high points of this important phase in the history of civilization.

The first steps to retrieve the history of this land were taken in the mid 1800s. They began with the decipherment of the languages written in the ancient script called cuneiform because of the wedgelike shapes of the signs. This important achievement was accomplished through a trilingual inscription carved high on a rock face at Bisitun in the Zagros mountains in which the Persian king Darius I documented his victory over rebellious tribes. The identical inscription was written in the Old Elamite, Babylonian (Akkadian), and Old Persian dialects. Based on the first accurate copy of this inscription made by the Englishman Henry C. Rawlinson, between 1836 and 1847, the difficult task of decoding the written records of the Near East was begun. Because Old Persian was written in a form of alphabetic cuneiform that had a small number of signs, it was the first of the ancient languages to be deciphered. By the late 1850s, Babylonian was also, to some degree, understood. To this day scholars continue to study new texts in order to understand more about the languages and cultures of these long-vanished civilizations.

While philologists were solving the cuneiform puzzles, archaeologists were beginning to excavate in Mesopotamia, now Iraq, at the sites of ancient Assyrian and Babylonian cities. These cities had been deserted for millennia and were now huge mounds of crumbling mudbrick. The British archaeologists at Nimrud and the French archaeologists at Nineveh and Khorsabad, both sites in northern Iraq, began to reveal to an unsuspecting world the splendor and richness of the Assyrian Empire. These first excavations were little more than treasure hunts to fill museum galleries. But by the last decade of the nineteenth century, the German excavators at Warka and Babylon in southern Mesopotamia had developed basic techniques of systematic excavation and record-keeping that allowed archaeologists to begin to document and reconstruct the various phases of the history of an ancient site. Since then, archaeological activity has been continuous throughout the Near East. Together with the invaluable information gained from the translation of the written records of the literate civilizations of the pre-Islamic Near East, the excavation and survey projects undertaken in the field are our most important sources of information about the past.

MESOPOTAMIA

Mesopotamia, which lay between the Tigris and the Euphrates rivers, was the heart of the ancient Near East. As early as the seventh millennium B.C., those great meandering waterways were major routes of communication, connecting distant regions. They were the source of water that, through irrigation, transformed the parched alluvial plain into fertile soil suitable for grazing and for growing crops—food for men and animals. It was there, in the south, that urban civilization first evolved during the fourth millennium B.C. For the next five thousand years, southern Mesopotamia remained an important center, strategically located on the land and water routes to Egypt and the Mediterranean world in the west and to Iran, the Indus Valley, and Central Asia in the east. The capital cities of the Sumerians, Akkadians, Babylonians, Seleucids, Parthians, and Sasanians all lay in this fertile agricultural region.

Sumerian Period (2900–2334 B.C.)

The word "civilization" connotes many things. In the Near East the beginning of civilization is associated, among other things, with the agglomeration of large numbers of people in a single place, namely a city, and with the invention of a system of writing. Archaeological excavations at such ancient urban sites as Uruk, modern Warka, and biblical Erech, have uncovered evidence that, in southern Meso-

potamia, this stage in the history of mankind was reached sometime before 3000 B.C. Urban centers dominated the pastoral village economy. Relationships previously based on kinship ties became more complex because they were now determined by the needs of a larger group. Specialized full-time occupations such as architect, artist, scribe, craftsman, farmer, and such institutions as the priesthood and kingship came into existence.

The people responsible for this urban revolution, as it has been called, were the Sumerians, who spoke and eventually wrote a language that has no recognized linguistic origin. The Sumerians are thought to have entered southern Mesopotamia during the fifth millennium and to have developed the first known script, a system of pictographs that later evolved into wedge-shaped cuneiform signs.

The Sumerians controlled southern Mesopotamia for about a thousand years, into the second half of the third millennium. Many of the institutions and traditions they established, including literary forms and religious tenets and rituals, endured until the fall of Babylon in the middle of the first millennium B.C. The political structure of Sumer was theocratic. As society became more complex, the governing system evolved from a participatory rule by the elders and priests, who appointed temporary military leaders, into a system of city-states, all of which competed intensively for scarce resources. Each city-state was led by a *lugal,* or big man, who was, in fact, a king, legitimized by his place at the head of the religious institution. Much of the art of the Early Dynastic Period, as this time between 2900 and about 2334 B.C. is called, depicted sacred or ritual scenes; only late in the period were secular representations common. Throughout this time, styles varied from region to region, reflecting the fragmented nature of the city-state system.

Before the fertility of the land was limited by salinization caused through overirrigation in the early second millennium, southern Mesopotamia was a fertile alluvial plain that produced an agricultural abundance; it was, however, poor in such natural resources as metal, stone, and wood. At an early period, therefore, the inhabitants of Sumer established contacts with neighboring countries rich in raw materials. Excavations of the archaeological levels of human occupation during the mid-fourth millennium B.C., at sites in the surrounding lands of eastern Anatolia, Syria, and western Iran, have shown not only that the Sumerians of southern Mesopotamia traded with the inhabitants of these regions, but also that they maintained trading outposts there. By the mid-third millennium B.C., gold, silver, tin, copper, and semiprecious stones such as carnelian and lapis lazuli were imported from the regions east and west of Mesopotamia. Usually these items were imported unfinished, but sometimes, as in the case of steatite and chlorite vessels from eastern Iran and the Gulf, they came as exotic luxury goods, perhaps as a gift from one ruler to another. This lively exchange is documented directly in the cuneiform texts and indirectly in the exotic contents of the rich burials in the Royal Cemetery at Ur (see Plate 67). The main exports of Mesopotamia were grains of various types, and textiles. A thriving textile industry developed in the third millennium in Sumer, and the woven goods manufactured in the south formed an important part of its foreign trade.

Akkadian Period (2334–2154 B.C.)

The Sumerians were succeeded by the Akkadians, a Semitic people who had entered southern Mesopotamia, probably from the west, during the centuries of Sumerian control. This new dynasty was founded by Sargon of Akkad (2334–2279 B.C.), who was the first ruler to have truly imperial aspirations. By the time of Sargon's grandson, Naram-Sin (2254–2218 B.C.), the dynasty had expanded its control within Mesopotamia and made its presence felt through trade and military invasion as far as the cedar forests of Lebanon, the silver-bearing Taurus mountains, and the highlands of Iran. Both Sargon I and Naram-Sin became the heroic subjects of later Mesopotamian literary epics that reflect the enormous impact each had on Mesopotamian society and record their role in extending Akkadian influence far beyond the boundaries of Mesopotamia.

The comparatively few works that have survived from the period of Akkadian rule lead us to the conclusion that this was a golden age, when the art of Mesopotamia reached a peak that some believe was never surpassed. Based on the artistic developments of the Early Dynastic Period, the Akkadian artist created and refined an aesthetic of idealized naturalism. This is best illustrated by the famous stele of Naram-Sin, which is now in the Musée du Louvre in Paris. The monument shows the divine king triumphant over his vanquished enemies. The formal features of this masterpiece, particularly the dynamic composition and the superb naturalism of the figures, all reinforce the literal message of this representation. Like the Naram-Sin stele, much of the art preserved from this period had secular themes. The cylinder seals (see Plate 70) show what must have been motifs on monumental works of art, now lost, illustrating the religious mythology that had been expanded as Semitic deities gained prominence.

Neo-Sumerian (2144–2004 B.C.) and Old Babylonian Periods (1894–1595 B.C.)

The brilliant Akkadian Period ended because the empire overextended itself. Around 2150 B.C. the Akkadian Dynasty collapsed under the invasions of the Guti, tribesmen from the Zagros mountains in western Iran. During the following decades a few Sumerian city-states gradually reestablished their authority over a limited area in the south. One of these states, Lagash, was ruled by a governor named Gudea (2144–2124 B.C.), who is prominent in the history of ancient Near Eastern art because of the large number of massive diorite sculptures that have survived from the period of his rule. These sculptures convey an attitude of religious piety, permanence, and perfection reflected in the texts that are often inscribed on them (Plate 71). With his son, Ur-

Ningirsu (2123–2119 B.C.), the rigid artistic conventions were relaxed somewhat, allowing for a greater sense of naturalism (Plate 72).

It was not until the great ruler, Ur-Nammu (2112–2095 B.C.), founded the Third Dynasty of Ur that unity and prosperity returned to southern Mesopotamia. This period is often referred to as the Neo-Sumerian revival because the rulers and priests consciously returned to pre-Akkadian artistic forms and to the use of the Sumerian language in official and cult documents in an effort to legitimize their rule in the eyes of both gods and men. For one hundred and fifty years, southern Mesopotamia thrived. International exchange and commerce extended from Anatolia in the west to the Gulf and adjacent Arabian coast in the south and to the Indus Valley in the east.

Throughout the Neo-Sumerian Period, a nomadic Semitic people called the Amorites slowly began to infiltrate both Mesopotamia and Egypt from the Syrian and Arabian deserts and were gradually incorporated into the urban fabric of the Near East. By the reign of Ibbi-Sin, the last ruler of the Third Dynasty of Ur, the Amorites had helped to subdue that ruling house. They then established their control in many of the city-states that again prevailed in Mesopotamia.

One of the most important contributions of the Amorites was the introduction of a common written language, the Old Babylonian dialect of Akkadian, which came into use over a wide area and opened the way to increasingly efficient communications. The most famous of the Amorite rulers was Hammurabi of Babylon (1792–1750 B.C.) whose code of laws, based on earlier Sumerian models, provides historians with a comprehensive record of legal practices and an important documentary account of Mesopotamian civilization.

Northern Mesopotamia in the Second Millennium B.C.: Old Assyrian, Mitannian, Middle Assyrian, and Kassite Periods

After the fall of the Third Dynasty of Ur at the beginning of the second millennium B.C., the Semitic kings of Assyria, said to have originally "lived in tents," began to consolidate their power in northern Mesopotamia at the city of Assur on the Tigris River. Although it was to take a thousand years before imperial Assyria dominated all of the Near East, this early Assyrian civilization was exceptionally vital. An international trade network was developed and commercial colonies of Assyrian merchants were established in the major centers on the Anatolian plateau; there the merchants exchanged tin and textiles for Anatolian gold, silver, and copper.

This Old Assyrian florescence was eclipsed for about five hundred years by the Indo-European Mitanni, who controlled all of Syria and northern Mesopotamia. During the fourteenth and especially the thirteenth centuries B.C. the Semites of Assyria rose to prominence again. Virtually no monumental works remain from this Middle Assyrian

Period, but evidence from the ancient cylinder seals shows that the art of this period reached another high point; naturalism was combined with vigorous movement and landscape elements to create works of art sometimes mistaken for products of classical Greece.

At the same time, the Kassites, a tribal people who entered Mesopotamia in the political vacuum created by the fall of the Amorite Dynasty at the beginning of the sixteenth century B.C., ruled in the south. The art of the Kassites is known through their seals, which were often inscribed with long prayerful inscriptions, and by *kudurrus,* or property boundary markers, carved at the top with divine symbols.

Neo-Assyrian Period (883–612 B.C.)

The first millennium was a period of great empires, first in Assyria, and later in Babylonia and Achaemenid Iran. Assyria differs geographically from its southern neighbor, Babylonia. Crops grown on the fertile northern plains produced sufficient food both to satisfy the needs of the people of Assyria and to sustain her armies and her empire. Stone and timber for building, lacking in the south, were also available in the more temperate mountain country to the north. While Babylonia was to some extent bordered and enclosed by the Tigris and Euphrates rivers, Assyria was not clearly defined by natural features; its boundaries could expand or contract according to the balance of power within the region.

From the ninth to the seventh century B.C., Assyria had a series of exceptionally effective rulers who achieved supreme power in the Near East. Beginning with Assurnasirpal I and Shalmaneser III in the ninth century, the Assyrian armies controlled the major trade routes and dominated the surrounding states in Babylonia, western Iran, Anatolia, and the Levant. This vast empire was sustained in the eighth century by Tiglathpileser III and Sargon II. Only with the death of Assurbanipal in 627 B.C. did the strength of Assyria falter.

The imperial palaces constructed in the Assyrian capital cities of Nimrud, Nineveh, Khorsabad, and Assur were lavishly decorated. Assurnasirpal began the practice of lining the lower walls of rooms in the palace with stone panels decorated with ritual and secular representations carved in low relief and brightly painted. Above them, on the mudbrick and plaster walls, were both figural and geometric designs. During the three centuries of its development, the art of the Assyrian Empire reflected an increasing concern with secular themes, which elaborated and glorified the royal image; this iconography of power influenced the art of neighboring peoples to the east and west, who imitated the Assyrian works of art, perhaps in an effort to associate themselves with Assyrian rulers.

Neo-Babylonian Period (625–539 B.C.)

At the end of the seventh century B.C., the mighty Assyrian kingdom was brought down by Babylonia, a long-standing

rival who was allied with both Median and Scythian forces. For a brief period after that, Babylonia, called Chaldea by the Greeks, replaced Assyria as the major Mesopotamian power. In the seventh and sixth centuries B.C. the Babylonian kings unified a diverse society and fended off attacks of Aramaean tribesmen—a group of Semites from the west.

During this short-lived empire the arts flourished. In the capital city of Babylon, Nebuchadnezzar (604–562 B.C.), the most famous of the Neo-Babylonian rulers, constructed the famous Hanging Gardens and the Ishtar Gate. This gateway and the adjoining Processional Way were decorated with friezes of striding lions (Plate 80), bulls, and demonic creatures sculpted in low relief from clay bricks glazed with intense colors. During the New Year's Festival each spring, statues of the deities were carried in litters along this colorful route as part of the elaborate religious festivities. By the middle of the sixth century B.C., rebellion within the kingdom had weakened the power of Nebuchadnezzar's dynasty, leaving Babylonia and all of Mesopotamia open to attack and conquest by the Medes and Persians, who, during this period, had been gathering strength in Iran to the east.

ANATOLIA

Ancient Turkey—in archaeological usage, Anatolia—was an area with many different climatic and topographic zones and an abundance of natural resources. Among these resources, the metal ores—gold, silver, and copper—in the mountains that ring the central plateau were particularly important in antiquity. Archaeological evidence suggests that the early stages of metallurgy, the hammering and melting of native copper, may first have occurred during the late Neolithic Period in eastern Anatolia, where there were enormous deposits of copper in the Taurus mountains. The skill of the Anatolian metalworker is evident in finds dating from the end of the third millennium B.C. (see Plate 81). Vessels of gold and silver, tools, weapons, ritual paraphernalia, and musical instruments made of copper alloyed with arsenic were found in the tombs of local rulers at Alaca Höyük and Horoztepe on the central plateau. The vessels, in particular, are masterpieces of craftsmanship, having long, delicate spouts and handsome curvilinear designs on the bodies, features that can also be seen on the exceptionally fine ceramic wares made in this period.

Sometime around the turn of the second millennium B.C., the Hittites, a people speaking an Indo-European language, came into Anatolia, probably from the east. They maintained many of the traditions in metalworking and pottery making established by their predecessors. The earliest reference to the Hittite people is among the names inscribed on tablets found in the nineteenth-century-B.C. levels at the site of Kültepe, ancient Kanesh. The lively trade in metals between the people of the Anatolian plateau and the Assyrians brought prosperity and cultural unity to central Anatolia. This trade was documented by the thousands of cuneiform texts found in the *karum* or merchants' quarter at Kültepe. Ivory carvings (Plates 83, 84, 85) from Acemhöyük show that during this period—before the foundation of the Hittite Empire—a distinctive style was formed that incorporated motifs and stylistic details from several foreign sources.

During the period of the empire (1650–1200 B.C.), the Hittites controlled all of the Anatolian plateau. A spectacular group of gold and silver objects in the collection of Norbert Schimmel deserves special mention here both as an illustration of the skill of the Hittite artist and as a rare example of the art made in court workshops (Plates 86, 87, 88).

The Hittite Empire collapsed at the end of the second millennium B.C., amid the foreign invasions and general chaos that also affected much of southwestern Anatolia and Syria. In the early first millennium B.C., a number of smaller kingdoms replaced the Hittites as the major political powers in Anatolia—notably Urartu, with its capital city near Lake Van in ancient Armenia, a rival of Assyria from the ninth to the end of the seventh century B.C., and Phrygia, which, in the eighth and seventh centuries B.C., occupied central and western Anatolia and established its center at Gordion.

The seventh century B.C. remained a period of political turmoil in Anatolia. The Phrygians, in their turn, were swept from power by tribesmen from the steppes north of the Caucasus mountains who poured into western Anatolia. From eastern Anatolia, Scythian tribes moved into Iran and Mesopotamia, where they joined with Median and Babylonian armies in their attack on Assyria late in the seventh century. The influence of the Scythians on the art of the Near East is apparent in works found in Iran, Anatolia, and Syria dating from this period. The objects, often of metal, are executed in a distinctive beveled style and display a repertory of designs in which stags, panthers, birds of prey, and griffins are favorite subjects.

By the beginning of the sixth century B.C., the Scythians had retreated from the Near East through Anatolia and had returned to the steppes around the Black Sea. The rising power of Achaemenid Iran reached into Anatolia, and in the middle of the sixth century, Persian satraps and officials, responsible to the Achaemenid king at Susa, extended their control as far as the Aegean seacoast. Many of the nomadic groups moved west across the steppe into northern Greece and eastern Europe. Hoards and burials containing metal vessels and armor, decorated with a western version of the Scythian animal style (Plate 89), have been found in the region of the Danube River.

SYRIA

Syria, to the south of Anatolia and west of Mesopotamia, was a crossroads between the great civilizations of the ancient world and was often disputed by rival powers. The rulers who controlled this land held vital trade routes linking the Mediterranean world and Asia. Evidence of trade between Syria and Mesopotamia in the late fourth millennium B.C. marks the beginning of direct contacts that increased over the centuries. Despite the continuous presence of for-

eigners, notably Mesopotamians, who lived and traded in Syria from the earliest times, the art of the region had its own distinctive character, as evidenced by finds in recent excavations of the third-millennium levels at such sites as Mari and Ebla. In the second millennium B.C., however, a truly international style developed in this region. Motifs and designs from Egypt and the Mediterranean world were adopted and, in time, passed from Syria into the art of Mesopotamia.

The second millennium ended in chaos in Syria and the Levant. Bedouins from the desert invaded and destroyed the thriving cultures that had flourished for more than five hundred years. At the beginning of the first millennium a number of independent states were established by the invaders who spoke a language called Aramaean. These states have been called Neo-Hittite even though the people who ruled them had no linguistic or ethnic relationship to the Hittites of Anatolia. Excavations at a number of the Neo-Hittite sites in northern Syria and southeastern Turkey have uncovered major architectural monuments. Often these structures were decorated with stone slabs carved in low relief (Plate 90) with scenes of political and religious significance.

The Assyrian Empire and Phoenicia replaced Egypt and the Mycenaean and Minoan empires as the major sources of influence in Syrian art. The small plaques with relief carvings of human, animal, and plant designs decorated furniture and objects of luxury. Egyptianizing motifs introduced through Phoenicia were combined with stylistic and iconographic details taken from the art of Assyria. Many ivories from Nimrud (Plates 76, 77, 78) in northern Mesopotamia are identical in style to those found in Syria. They were made by craftsmen from Syria or Phoenicia working at the Assyrian court. The Assyrians must also have received some ivories, which were considered treasured objects, as tribute and booty following their conquest of towns in western Syria in the early first millennium B.C.

The Assyrian domination of Syria was followed by Babylonian conquests and finally by Persian Achaemenid rule. With the invasion of Alexander the Great in the fourth century B.C., a large part of Syria fell into Greek hands and later came under Roman and then Byzantine control. The border between the western empires of Rome and Byzantium and the Parthian and Sasanian lands in the east ran through Syria, along the central and northern Euphrates.

IRAN

Iran is a large country divided topographically into a number of distinct regions. Southwestern Iran, now the province of Khuzistan, was Mesopotamia's closest neighbor, both geographically and politically. Known as Elam in antiquity, this region is an extension of the southern Mesopotamian plain; throughout history the development of civilization in this important cultural and political center was affected by events that occurred in the land between the Tigris and Euphrates rivers. In more distant areas, on the central plateau, the eastern desert, and the northern highlands of Iran, Mesopotamian influence was weaker.

During the fifth and fourth millennia B.C., both in Elam and on the central plateau, the inhabitants, living in small farming villages, made particularly striking pottery that was decorated with elaborate painted geometric, plant, and animal designs (Plate 92). Since there are no written records from before 3000 B.C., it is impossible to give a name or an ethnic identification to the people who made these wares.

Elam

Susa, the major center for most of the long history of the Elamites, was founded in the middle of the fifth millennium B.C. It was here, in the levels of the late fourth-millennium B.C. settlement, that French archaeologists found the earliest evidence of writing in Iran, during their century-long excavations at this important site. Although the script, called Proto-Elamite, is different from that of contemporary archaic texts found at Uruk in Mesopotamia, it is probable that its invention reflects close contacts with the Sumerians who came to search for the stones and metals that were available in abundance in the highlands of Iran. For a short period, the Proto-Elamite script was used over wide areas of southern Iran, and it was at this time that the other important Elamite city, ancient Anshan, or modern Tal-i Malyan, was founded in the highland province of Fars to the southeast. Later Elamite texts record that the title of the Elamite rulers was "King of Anshan and Susa."

The art of the Proto-Elamite Period is distinctive both stylistically and iconographically. Works of small three-dimensional animal sculpture in silver and in stone are naturalistic and beautifully crafted. The kneeling bull holding a spouted vessel (Plate 93) is made of numerous pieces of silver joined together. In the glyptic art, animals, sometimes in human posture, are rendered in a highly abstracted linear style.

During the Old Elamite Period of the late third to early second millennium B.C., the works of art produced in this region were strongly influenced by the art of Sumerian and Akkadian Mesopotamia. The images, however—particularly those of animals and fantastic creatures—are rendered in a distinctive Elamite style that is characterized by naturally rendered forms and decorative surface patterns. Motifs like the snake and the winged dragon were distinctively Elamite and were probably sacred to deities of the Elamite pantheon.

Contacts with lands as far to the north and east as the area known today as Afghanistan, as well as with the peoples living in the valley of the Indus, exposed the artisans of Iran to cultures that were unfamiliar to their Mesopotamian neighbors, and this is reflected in the character and appearance of their works of art. Of particular importance were both the cultures of the Turkmenistan and Uzbekistan steppe, best known from the site of Namazga in the Atrek river valley, and the culture of the Desert of Lut, with an important center at the site of Shahdad.

Under kings ruling from Susa in the second half of the second millennium B.C., Elam became a major political force in the Near East. Whenever southern Mesopotamia was controlled by weak or ineffective leaders, Elamite armies invaded the region, destroyed its cities, and briefly controlled the course of events there.

Luristan

Northwest of Khuzistan, within the Zagros mountain chain, lies a region called Luristan, which in antiquity was the home of seminomadic peoples. From the third to the early first millennium B.C., the importance of the area as a center of horse breeding resulted in frequent contacts between the mountain people and their settled neighbors in Babylonia and Elam. Bronzes made in Luristan during the third and second millennia B.C. illustrate the influence of southern Mesopotamia and Elam.

In the first millennium B.C., the florescence of a distinctive local style is documented by a profusion of cast and hammered works of art—the "Luristan bronzes" for which this region is justifiably famous. Particularly common are items for horse harnesses and standard and pole tops, decorated with a variety of fantastic creatures whose curvilinear form reflects the wax model from which the pieces were cast. In recent years, excavations have uncovered buildings and tombs, but the ethnic origin of the inhabitants and the reason for this rich artistic production remain uncertain.

Achaemenid Period

Late in the second millennium B.C., the arrival in the Near East of Indo-Europeans, the Iranians, began a new period in the history of the region. By the middle of the first millennium B.C., Mesopotamia and Iran, under the rule of Achaemenid kings, were part of an empire that exceeded in its geographical extent anything that had come before. From capital cities at Susa, Ecbatana, and Babylon, the Iranian rulers controlled an empire that reached from Turkmenistan to the Mediterranean seacoast and Egypt. Influences from lands throughout the empire, including Assyria, Babylonia, Egypt, and Greece, are apparent in both the style and iconography of the art of the Achaemenid court.

The imperial ambitions of the Achaemenids, which led them twice to attack the Greek mainland, were the cause of their downfall. In 334 B.C., Alexander the Great invaded Asia from Macedonia, in Greece. Four years later, the victorious Greek army reached Persepolis in southern Iran and burned this great ceremonial center to the ground. Achaemenid rule in the Near East was at an end.

Parthians and Sasanians

The Greek conquest of the Achaemenid Empire interrupted the cultural development of the Near East and altered the course of civilization in that region. Earlier invasions, in the third and second millennia, had brought peoples, both from desert and mountain areas and from the steppes, into the fertile lands and urban centers of the Near East. The arrival of these seminomadic tribesmen from outside the civilized world did not radically transform the cultures that had developed over the millennia. New concepts and values were grafted onto existing traditions, the societies were modified, and the fabric of civilization was enriched.

The invasion of the Greeks, however, differed from these earlier incursions because for the first time it brought into the Near East a people who had highly developed cultural traditions. Greek soldiers and merchants came to live in Syria, Anatolia, Mesopotamia, and Iran; they founded cities and introduced a new way of life. When, in the late third century B.C., the Iranian Parthians reclaimed Mesopotamia and Iran from the Seleucids—the successors of Alexander the Great—the Greek settlers and their culture remained. The Orient had adopted the West, and for the next thousand years, in times of peace and war, the kingdoms of the Near East and the Roman and Byzantine empires in the West maintained political and economic ties as well as common cultural traditions.

A reassertion of a Near Eastern identity, an Iranian renaissance, is apparent in the arts of the beginning of the first century A.D., and it developed under another Iranian dynasty, the Sasanian, which ruled Mesopotamia, Iran, and parts of Syria and Anatolia from A.D. 226 to 651. Forms and motifs were adopted from the West, but their significance changed, and they expressed Oriental rather than Western concepts. Similarly, in the Iranian national epic, the *Shahnameh*, originally compiled from sources dating from the end of the Sasanian Period, a legendary Alexander the Great is half Persian and half Greek by birth. This modification of history made events understandable and meaningful to the Near Easterner.

For a thousand years, from the last centuries before Christ to the coming of Islam, the history of the ancient Near East was one of almost continual warfare as the great empires of Byzantium and Sasanian Iran battled and ultimately exhausted their resources in the effort to control the rich trade routes and cities of Anatolia and Syria. Finally, Arab armies from the western desert—followers of the prophet Muhammad—overran the Near East, and by the middle of the seventh century A.D. Mesopotamia and Iran and almost half of the Byzantine Empire had fallen under Islamic rule. With the introduction of this new religion and way of life another period in the history of the Near East began.

Prudence Oliver Harper and Holly Pittman

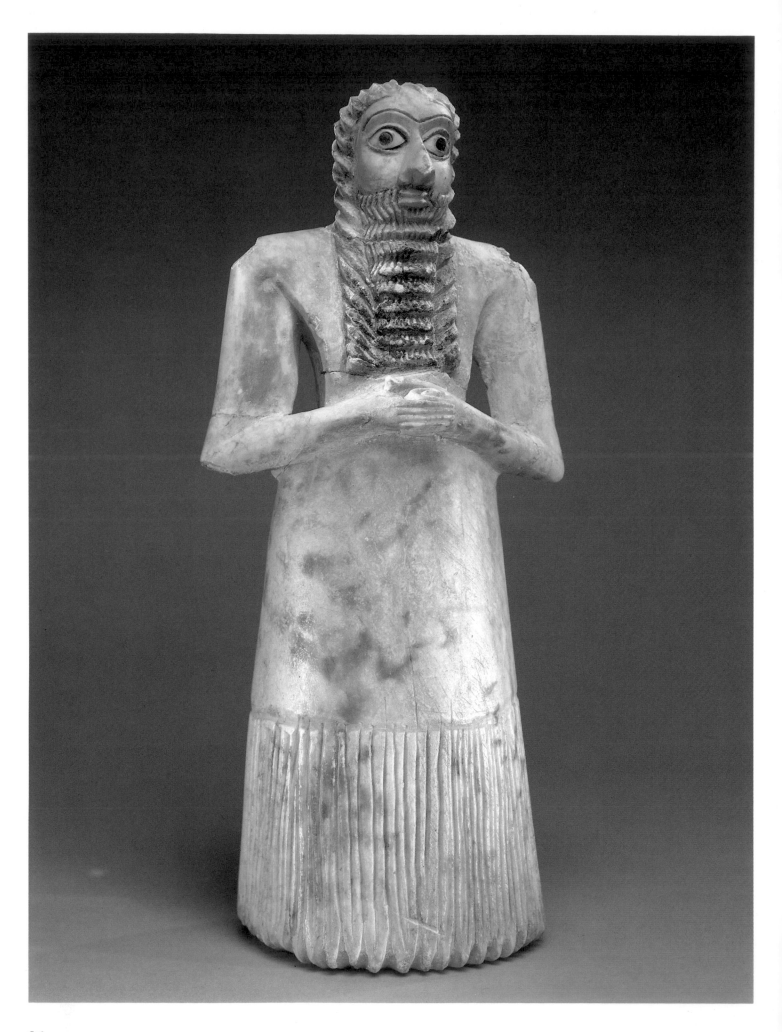

STANDING MALE FIGURE

The Sumerian civilization first developed in southern Mesopotamia during what is known as the Early Dynastic Period (2900–2334 B.C.). Myths of later date suggest that towns and cities were first governed by assemblies, which chose a temporary leader in times of emergency. As the needs of society became more complex, these leaders tended to prolong their authority, until finally the institution of hereditary kingship developed. Sumerian government was based on the city-state unit and each city had a patron deity, though many other gods were also worshiped. The life of the city was organized around the temple of the patron deity, and the city's leader served as both priest and king. The relationship of the common man to the gods was distant and formal. Deities were believed to inhabit cult images housed in temples, and contact with them could only be achieved through votive offerings and the elaborate rituals of an intermediary priest.

This male figure with its clasped hands and staring gaze was found in the Square Temple at Tell Asmar and is thought to represent a worshiper in perpetual prayer before his god. His large head has prominent eyes inlaid with shell and black limestone; a continuous arching brow incised across the forehead was also inlaid, perhaps with bitumen. Stylized tresses fall on either side of a rectangular beard and both hair and beard show traces of their original bitumen coating. The dark hair color recalls the Sumerian description of themselves as a "black-headed people." The figure is bare-chested and clad in a sheepskin skirt in the Sumerian style, with a tufted border and a padded belt at the waist. A composite of geometric volumes, the votive figure illustrates an abstract style of Sumerian sculpture.

65 Standing Male Figure
Mesopotamia, Sumerian,
Tell Asmar; ca. 2750–2600 B.C.
Gypsum; H. 11⅞ in. (29.5 cm.)
Fletcher Fund, by exchange,
1940 (40.156)

MAN CARRYING A BOX ON HIS HEAD

Nude but for a double belt around his waist, this statuette of a striding man carrying a box on his head is a fine example of Sumerian sculpture in metal. He shares the almond-shaped eyes and wedgelike nose of the Tell Asmar male (Plate 65), but his limbs are more roundly modeled and his stride is full of energy. He is cast of arsenical copper, an alloy of copper and arsenic that was used frequently throughout the third millennium B.C. A number of statues in copper alloy were found in the excavations of temple structures at the sites of Tell Agrab and at Khafajah in the Diyala river valley. They were found in building levels of the second Early Dynastic Period, around 2750–2600 B.C. The Metropolitan Museum's piece is dated to the same period on the basis of stylistic comparisons with these excavated pieces. This statue probably played a part in religious ritual or as a votive offering.

66 Man Carrying a Box
Mesopotamia, Sumerian;
ca. 2750–2600 B.C. Arsenical
copper; H. 15 in. (38.1 cm.)
Harris Brisbane Dick Fund,
1955 (55.142)

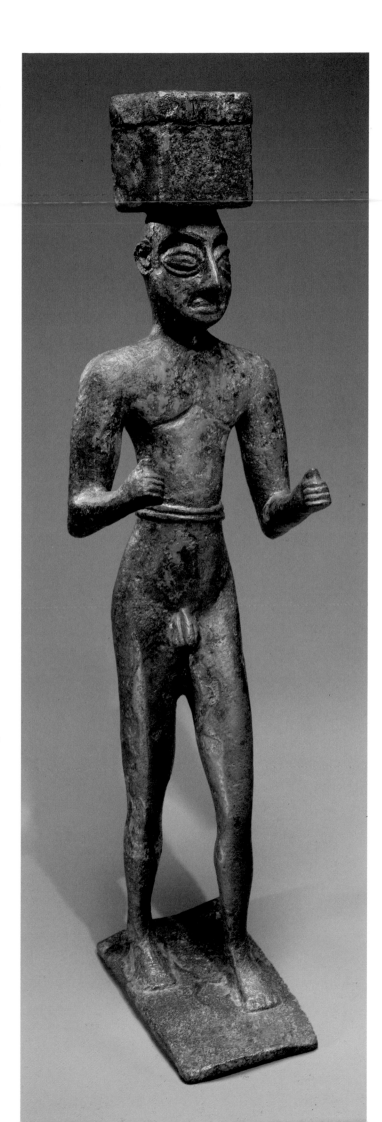

CHAPLET OF GOLD LEAVES

This delicate chaplet of gold leaves suspended from strings of lapis lazuli and carnelian beads was found in one of the richest graves in the Royal Cemetery at Ur. Ur is a site in southern Mesopotamia that was the seat of the First Dynasty of Ur and was excavated in the 1920s and 1930s by Sir Leonard Woolley. The headdress adorned the forehead of one of the female attendants in the so-called King's Tomb. Ancient royal tombs are rarely preserved intact, but the Royal Cemetery at Ur is a fortunate exception. As well as the chaplet illustrated here, the entombed attendant wore two necklaces of gold and lapis lazuli, gold hair ribbons, and two silver hair rings. Since gold, silver, lapis, and carnelian are not found in Mesopotamia, the presence of these rich adornments in the royal tombs attests both to the wealth of the Early Dynastic Sumerians and to the existence of a complex system of trade that extended far beyond the Mesopotamian river valley.

IBEX ON STAND

From the back of this ibex rises a group of rings that are thought to have supported lamps or bowls holding offerings or incense. The creator of this stand, which is made of arsenical copper, used the lost-wax technique. In this process, the desired image is sculpted in wax and surrounded by clay that hardens into a mold when baked. The wax is burnt and "lost" during the baking process, leaving a negative space that corresponds to the wax image. Molten metal is then poured into the cavity to produce a more permanent reproduction of the original wax model. Both the material and technique used to create this piece illustrate the sophisticated Sumerian knowledge of the properties of metal.

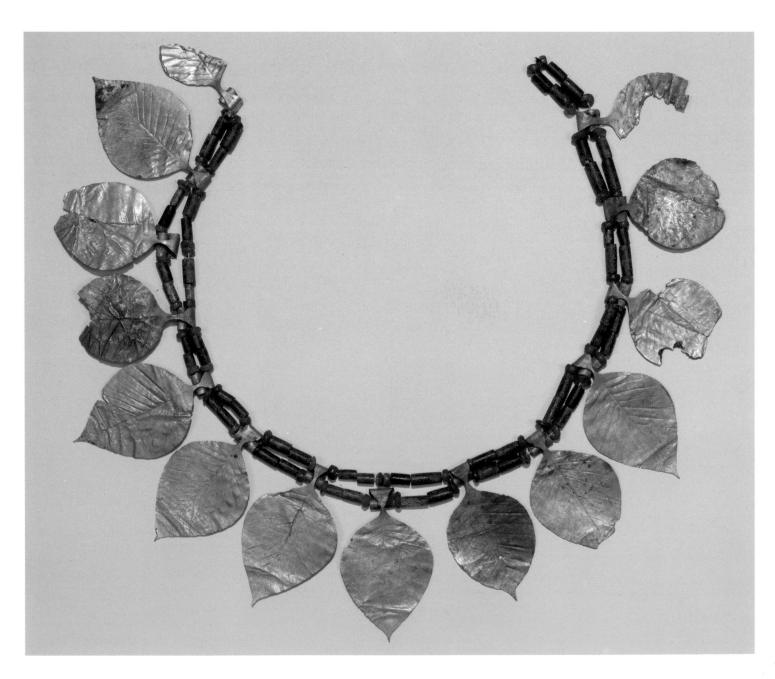

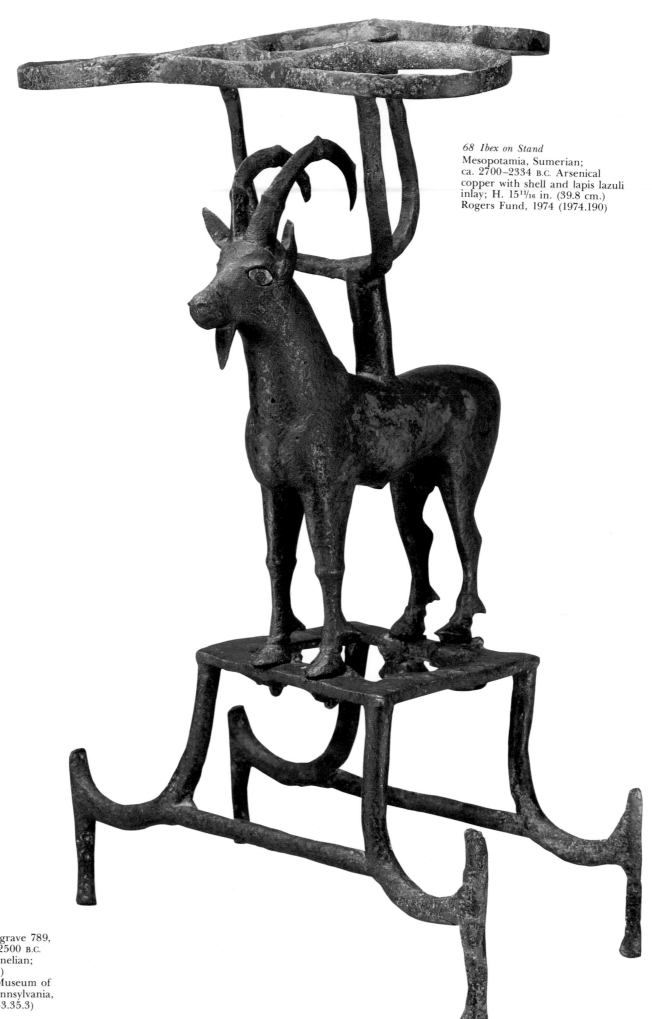

68 Ibex on Stand
Mesopotamia, Sumerian;
ca. 2700–2334 B.C. Arsenical
copper with shell and lapis lazuli
inlay; H. 15¹¹⁄₁₆ in. (39.8 cm.)
Rogers Fund, 1974 (1974.190)

67 Chaplet of Leaves
Mesopotamia,
Ur, Royal Cemetery, grave 789,
Sumerian; ca. 2600–2500 B.C.
Gold, lapis lazuli, carnelian;
L. 15³⁄₁₆ in. (38.5 cm.)
Ex coll.: University Museum of
The University of Pennsylvania,
Dodge Fund, 1933 (33.35.3)

FOUNDATION FIGURE

This bronze figure in the form of a snarling lion probably comes from the northern reaches of the Akkadian Empire. The basis for this assumption is the plate beneath the animal's paws, which is inscribed in the language of the Hurrians with the partially preserved name of Tishatal, King of Urkish. Little is known of the Hurrians, except that they were a non-Indo-European, non-Semitic people who were present in the northern parts of Mesopotamia and Syria in the third millennium B.C. The head and torso of the feline emerge from a tapered peg and its forelegs rest on a metal plate. As early as the fourth millennium B.C., the lion had become a symbol for both secular and divine power. In this case, it was placed in the foundation of a building to ward off evildoers.

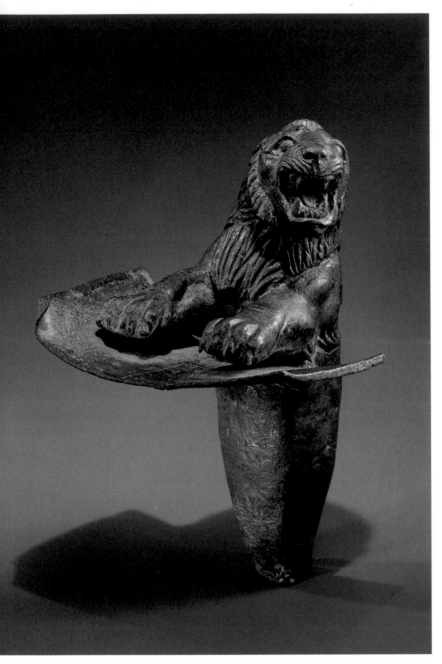

69 Foundation Figure
Northern Mesopotamia or
Syria, Hurrian; ca. 2200 B.C.
Bronze; H. 4⅝ in. (11.7 cm.)
Purchase, Joseph Pulitzer
Bequest, 1948 (48.180)

CYLINDER SEALS

Invented in the mid-fourth millennium B.C., seal stones of cylindrical shape, engraved with figural and geometric designs, served both as a kind of amulet and as a mark of ownership or identification. Seals were either impressed on clay masses that were used to close jars, doors, and baskets, or they were rolled onto inscribed clay tablets that recorded information about commercial or legal transactions.

Cylinder seals are important to the study of ancient Near Eastern art because many examples survive from every period; they serve as a visual chronicle of changes in style and iconography.

The seal illustrated at the top of the page was made during the Akkadian Period (2334–2154 B.C.), a time in which the iconographic repertory of the seal engraver expanded to include a variety of mythological and narrative subjects that were unknown in earlier periods. During the centuries of Sumerian ascendancy in Mesopotamia, Semites migrated to the region from the west and established their principal settlements in Akkad, a region north of Sumer, extending north from Nippur to the environs of the modern city of Baghdad. The Akkadians, as these Semites are called, were unrelated to the Sumerians and spoke a different language. By 2334 B.C., they had established a dynasty that was to rule Mesopotamia for two hundred years.

The seal illustrated at center was produced during the Old Babylonian Period (1850–1800 B.C.) and reflects the air of pious gravity that dominated the art of that time. The seal on the bottom dates from the Middle Assyrian Period (1350–1000 B.C.) and is a fine example of the heightened interest in naturalism and landscape elements that then characterized Mesopotamian glyptic art.

70a Late Akkadian Cylinder Seal
Mesopotamia, late Akkadian;
ca. 2250–2154 B.C.
Chert; H. 1⅛ in. (2.8 cm.)
Bequest of W. Gedney Beatty,
1941 (41.160.192)

70b Old Babylonian Cylinder Seal
Mesopotamia, Old Babylonian;
ca. 1850–1800 B.C.
Hematite; H. 1¹/₁₆ in. (2.6 cm.)
Collection of Mrs. William H.
Moore, Lent by Right Reverend
Paul Moore, Jr., 1955 (L.55.49.26)

70c Middle Assyrian Cylinder Seal
Mesopotamia, Middle Assyrian;
14th-13th c. B.C.
Carnelian; H. 1¼ in. (3.2 cm.)
Collection of Mrs. William H. Moore,
Lent by Right Reverend
Paul Moore, Jr., 1955 (L.55.49.90)

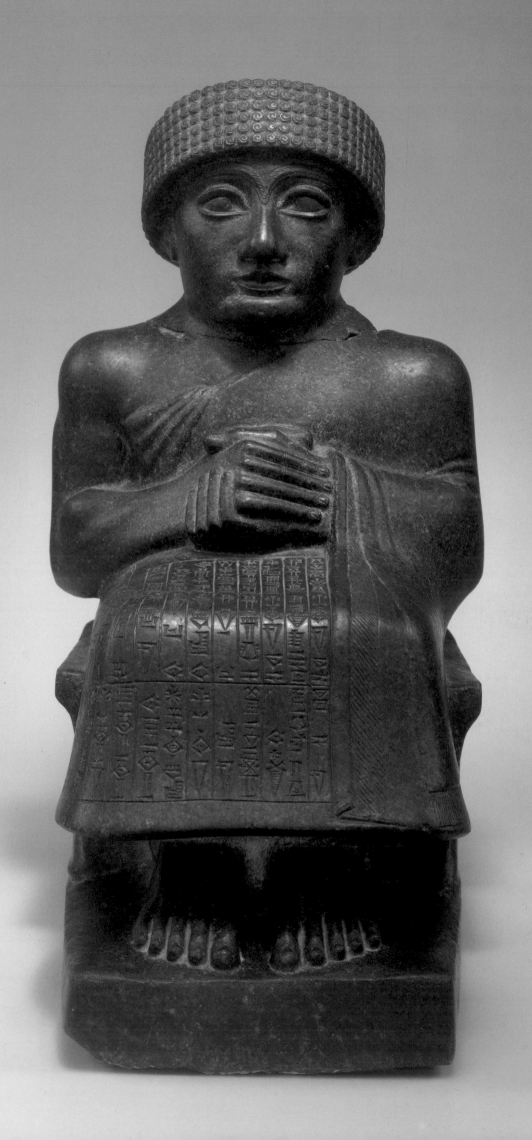

Gudea and Ur-Ningirsu

In the middle of the twenty-second century B.C., the Akkadian Empire fell before hordes of Gutian tribesmen who swarmed down from the Zagros mountains in the east. At the same time, the nomadic Amorites were pressing into Mesopotamia from the western deserts. Only the city-states in the extreme south of Mesopotamia succeeded in escaping Gutian plundering. One such city-state, Lagash, experienced a cultural renaissance under the governorship of the Sumerian leader, Gudea (2144–2124 B.C.), and his son, Ur-Ningirsu (2123–2119 B.C.). During this time, many fine works of art were produced. Unlike the art of the Akkadian Period, which is characterized by dynamic naturalism, the works produced by this Neo-Sumerian culture are pervaded by a sense of pious reserve and calm.

As governor, or *ensi,* Gudea devoted his energies to rebuilding the great temples of Lagash. Numerous statues survive, inscribed with his name and with divine dedications. One such work is the diorite statue of the seated Gudea (Plate 71), which is thought to have been placed in a temple. With hands clasped in front of him, the governor sits on a low chair and gazes with the traditional staring eyes of a supplicant before his god (see Plate 65). Gudea wears the brimmed wool hat of a ruler and a long mantle that exposes his left shoulder. An inscription in cuneiform runs across the front of his robe and identifies him as, "Gudea, the man who built the temple, his life may it make long."

With much the same aspect as his father, Gudea, Ur-Ningirsu (2123–2119 B.C.) (Plate 72) stands at attention, the long fingers of his stylized hands joined in prayer. Like Gudea, he is clothed in a long robe and a brimmed wool cap. The inscription carved on the back dedicates the statue to the god Ninqishzida, and names the statue "I am he who loves his god, may my life be lengthened." The base of the statue is sculpted in low relief with a series of eight figures on bended knee bearing baskets of offerings to Ur-Ningirsu. The men are bearded, their hair is bound in fillets, and they are dressed in knee-length skirts. Though they share a similar pose, each of the men is different, and it is believed that they may have represented leaders of vassal tribes of the kingdom. The inclusion of the secular subject of conquered peoples on an object of the cult, showing Ur-Ningirsu as worshiper, is a new concept in Neo-Sumerian art and recalls the artistic legacy of the Akkadian Period.

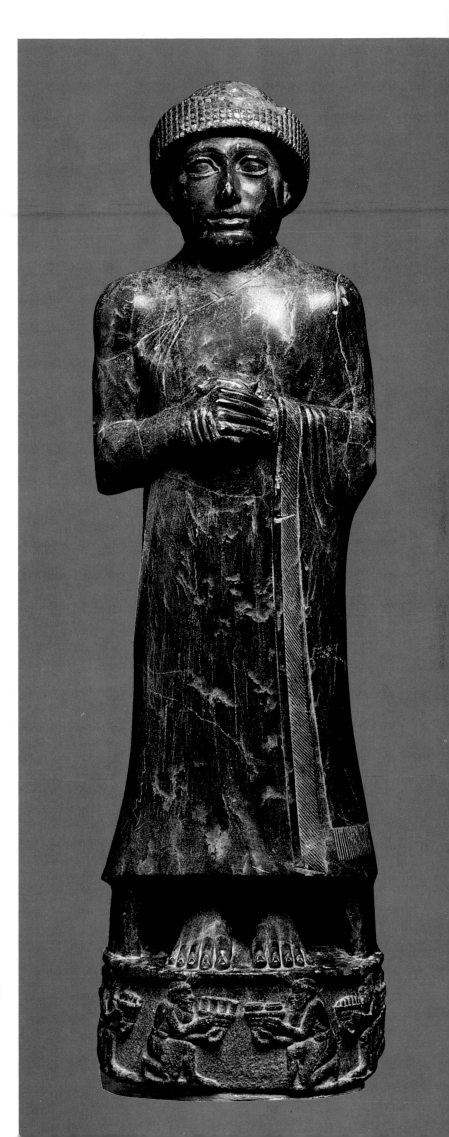

71 Seated Gudea
Mesopotamia, Neo-Sumerian;
ca. 2144–2124 B.C. Diorite;
H. 17⁵⁄₁₆ in. (44 cm.)
Harris Brisbane Dick Fund,
1959 (59.2)

72 Ur-Ningirsu, Son of Gudea
Mesopotamia, Neo-Sumerian;
ca. 2123–2119 B.C. Chlorite;
H. of head 4½ in. (11.4 cm.),
H. of body 18½ in. (46 cm.)
Head: Rogers Fund, 1947; Body
and base lent by the Musée
du Louvre, Département des
Antiquités Orientales
(inv. A.O. 9504)
(47.100.86; L.1984.1)

73 Necklace with Pendants
Mesopotamia; 19th–18th c. B.C.
Gold; L. 16¹⁵/₁₆ in. (43 cm.)
Fletcher Fund, 1947 (47.1a–h)

Opposite: detail

NECKLACE WITH PENDANTS

This elaborate necklace is an example of the very finest craftsmanship in gold from the ancient Near East. It has been known since 1911 and is said to have been found at Dilbat, a modern town near Babylon. The necklace is composed of a double row of beads from which are suspended seven pendants, each in the form of a deity or the symbol of a deity. The two females, wearing horned headdresses and long flounced dresses, probably represent Lama, a protective goddess; the disk with rays emanating from a central boss represents Shamash, the sun god; the crescent stands for Sin, the moon god, and the forked lightning is the symbol for Adad, the storm god. The two disks with granulated rosettes may be the symbol of Ishtar, goddess of love and war. Necklaces with symbols such as these can be found on the figures of royal personages in Assyrian wall reliefs and probably served both as jewelry and talisman.

Though the necklace appears complete, the reconstruction of its more than two hundred pieces is modern, so the original position of each element is uncertain. It is difficult to date the necklace because the technique and the imagery employed were known throughout the first half of the second millennium B.C. However, a date may be suggested by the extensive use of granulation, the form of the beads, and the shape of the divine symbols, which are virtually identical to those of an item of gold jewelry recently found in the excavation of a house at Larsa in southern Mesopotamia. The house had been occupied in the nineteenth to eighteenth century B.C.

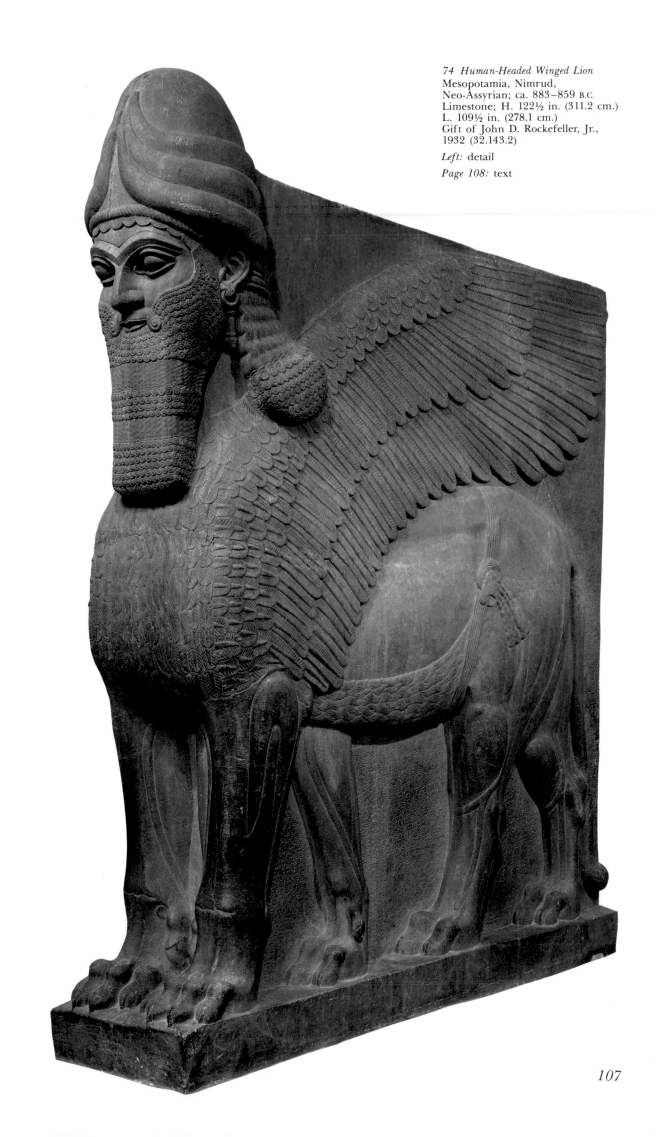

74 *Human-Headed Winged Lion*
Mesopotamia, Nimrud,
Neo-Assyrian; ca. 883–859 B.C.
Limestone; H. 122½ in. (311.2 cm.)
L. 109½ in. (278.1 cm.)
Gift of John D. Rockefeller, Jr.,
1932 (32.143.2)

Left: detail

Page 108: text

RELIEFS FROM THE PALACE OF ASSURNASIRPAL II

From the ninth to the seventh century B.C., the kings of Assyria ruled over a vast empire. Its heart lay in northern Iraq, where the capital cities were located. The first great Assyrian king in this era was Assurnasirpal II, who ruled from 883 to 859 B.C. He moved the capital from Assur to Nimrud (ancient Kalhu), where he undertook a vast building program. The ruins of Nimrud are situated on the east bank of the Tigris River, twenty-two miles south of ancient Nineveh (near modern Mosul). Until it became the capital city under Assurnasirpal, Nimrud had been no more than a provincial town, scarcely noticed by the inhabitants of Assur, the old tribal capital of Assyria, or of Nineveh, another capital of the Neo-Assyrian Empire. Both Assur and Nineveh had been the principal religious and political centers of Assyria since the second millennium B.C. Assurnasirpal probably chose Nimrud both to establish his own identity and to free himself from the political and religious intrigues of the two older centers.

The new capital occupied an area of about nine hundred acres, around which Assurnasirpal constructed a mud brick wall 120 feet thick, 42 feet high, and 5 miles long. In the southwest corner of this enclosure was the acropolis where the temples, palaces, and administrative offices of the empire were located. In 879 B.C., Assurnasirpal held a fete for 69,574 people to celebrate the construction of his new capital, and the event was documented by an inscription that read, ". . . the happy people of all the lands together with the people of Kalhu for ten days I feasted, wined, bathed and honored them and sent them back to their homes in peace and joy."

The palace rooms at Nimrud were decorated in a new fashion with large stone slabs ornamented with low relief carvings and with sculptural figures guarding the doorways. The so-called Standard Inscription that runs across the surface of most of the reliefs describes Assurnasirpal's palace: "I built thereon [a palace with] halls of cedar, cypress, juniper, boxwood, teak, terebinth, and tamarisk[?] as my royal dwelling and for the enduring leisure life of my lordship." He goes on to describe the decoration: "Beasts of the mountains and the seas, which I had fashioned out of white limestone and alabaster, I had set up in its gates. I made it [the palace] fittingly imposing." One such limestone beast is the human-headed winged lion pictured here (Plate 74). The horned cap attests to its divinity and the belt signifies its power. The Neo-Assyrian sculptor gave these guardian figures five legs so that the animal stands firmly in place when viewed from the front, but appears to stride forward when seen sideways.

The wall slabs, always cut in low relief, were decorated primarily with protective figures and with images of the king and his retinue engaging in ritual acts. Only in the throne room were there narrative scenes showing the victories of Assurnasirpal over the various peoples of his empire. The bird-headed divinity (Plate 75) is carved on a slab that originally decorated a doorjamb in the northern part of the palace at Nimrud. This bird-headed creature recalls the *apkallu* of Babylonian ritual texts, which, with a purifier in its right hand and a ritual cup in its left, protected the house from evil spirits.

75 *Winged Bird-Headed Divinity*
Mesopotamia, Nimrud,
Neo-Assyrian; ca. 883–859 B.C.
Limestone; 94 x 66 in.
(238.8 x 167.6 cm.) Gift of
John D. Rockefeller, Jr., 1932
(32.143.7)

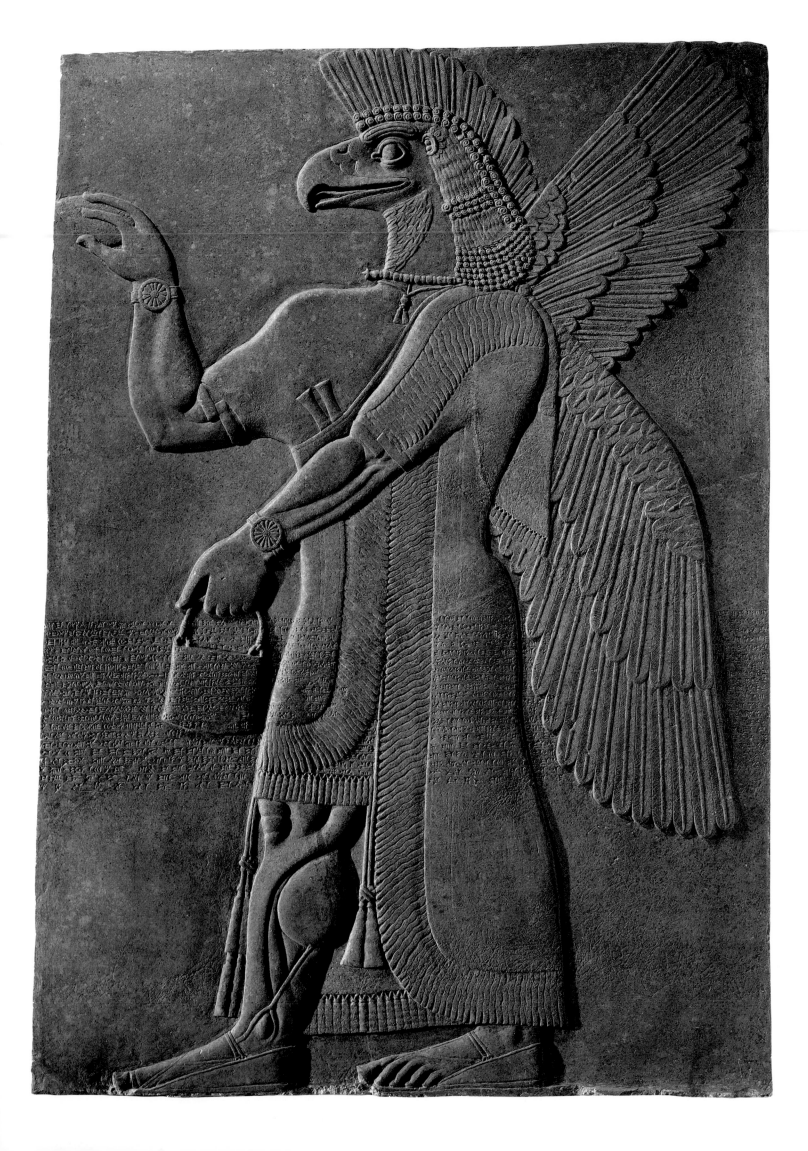

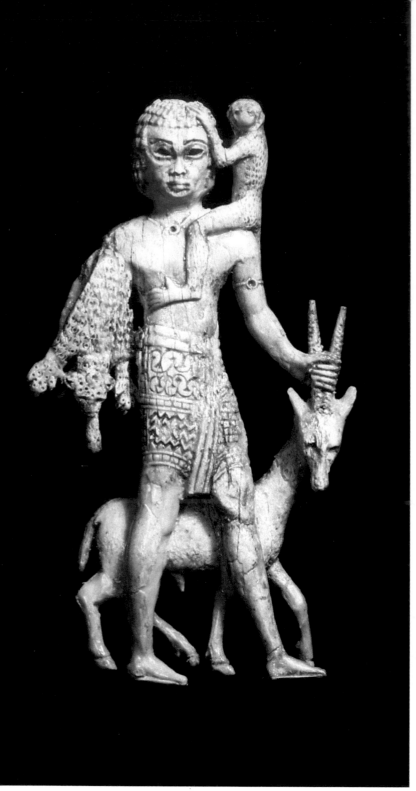

76 *Nubian Tribute Bearer*
Mesopotamia, Nimrud,
Fort Shalmaneser,
Neo-Assyrian; 8th c. B.C.
Ivory; H. 5¹⁵/₁₆ in. (13.5 cm.)
Rogers Fund, 1960 (60.145.11)

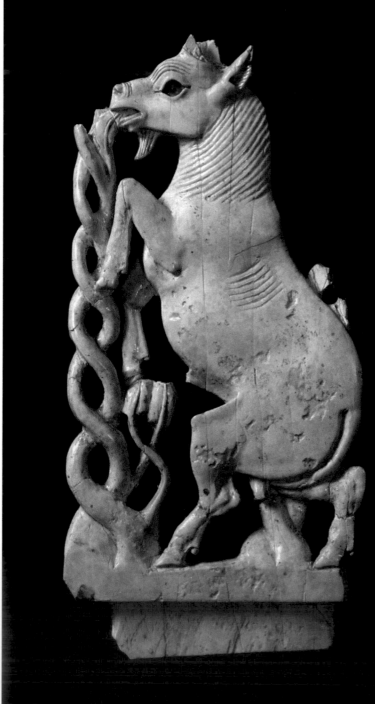

77 *Plaque with Goat*
Mesopotamia,
Nimrud, Neo-Assyrian,
Syrian style; 8th c. B.C.
Ivory; H. 6¹⁵/₁₆ in. (16 cm.)
Rogers Fund, 1961 (61.197.6)

NIMRUD IVORIES

In contrast to the grand, stylized reliefs that flanked the walls of Assurnasirpal's palace at Nimrud are the delicate ornamental ivories that once adorned the royal furniture. Ivory, prized throughout the ancient world, was used extensively at the time of the Assyrian Empire. The material was valued by craftsmen because it could be carved in such detail. Although modern tastes appreciate the beauty of a surface of ivory, these carvings were often covered with gold foil. Many of the ivories found at Nimrud were brought as booty or tribute from the vassal states to the west of Assyria, where elephants were native and ivory carving was a long-established craft. Others were undoubtedly carved in Assyria by craftsmen brought as captives to the capital cities. Contemporary inscriptions record that Assurnasirpal took "couches of ivory overlaid with gold" from a city on the western Tigris and received tribute of "elephant tusks and ivory thrones overlaid with gold and silver." Thousands of ivory fragments were discovered by the British in their exca-

vations of the ruins of Nimrud. Stripped of their gold covering by invading armies, the ivories themselves were discarded as of little worth.

The ivories from Nimrud were carved in several styles that reflect regional differences. The styles of Phoenicia and Syria are the most easily distinguished. The Nubian tribute bearer (Plate 76) has traits of the Phoenician style, characterized by the slender, elongated form of the bearer and his animal gifts, the precision of carving and intricacy of detail, and the distinct Egyptian flavor of both pose and feature. The three-dimensionality, however, is not characteristic of the Phoenician style. The symmetrical ivory fragment, showing a pair of griffins surrounded by lotuses and curving branches (Plate 78), is more clearly created in the Phoenician style. The somewhat heavier image of a goat (Plate 77) is portrayed naturalistically, with less refined detail, and is more typical of the Syrian style of the period. The stylized tree upon which he is feeding was a popular motif.

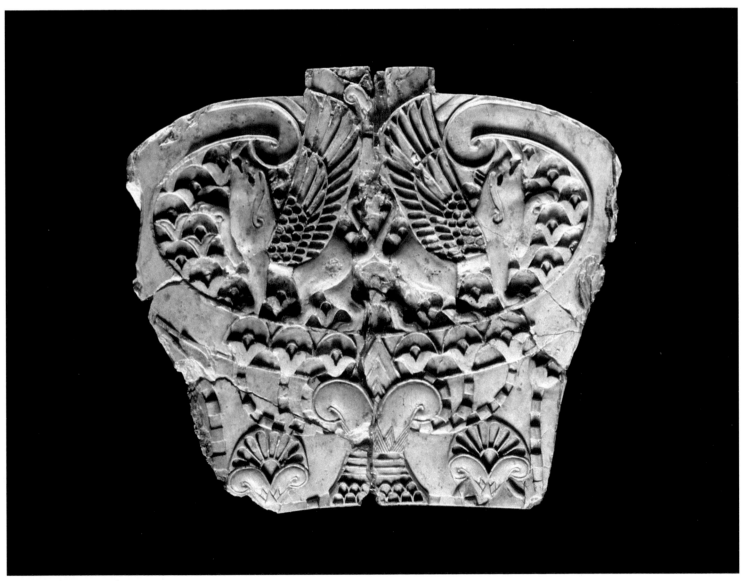

78 Plaque: Concave Cloisonné Design with Two Addorsed Griffins
Mesopotamia, Nimrud, Neo-Assyrian,
Phoenician style; 8th c. B.C.
Ivory; H. 4⅛ in. (10.5 cm.)
Rogers Fund, 1961 (61.197.1)

MAN LEADING HORSES

Divine and fantastic creatures were not the only subjects that engaged Assyrian sculptors; they also depicted the victories of their monarchs in war and in the chase. Full of vitality and extraordinarily detailed, these scenes expressing regal power and triumph are among the masterworks of Assyrian art. This fragment comes from the palace of the Assyrian king, Sargon II (722–705 B.C.), at Khorsabad. It shows a mountaineer, probably from Iran, bringing two richly caparisoned horses as tribute to the king.

79 Man Leading Horses
Mesopotamia, Khorsabad,
Neo-Assyrian; late 8th c. B.C.
Limestone; 20 x 32 in.
(50.8 x 81.3 cm.) Gift of
John D. Rockefeller, Jr.,
1933 (33.16.1)

80 Panel with Striding Lion
Mesopotamia, Babylon,
Neo-Babylonian; ca. 604–562 B.C.
Glazed brick; 38¼ x 89½ in.
(97.2 x 227.3 cm.)
Ex coll.: State Museums, Berlin,
Fletcher Fund, 1931 (31.13.2)

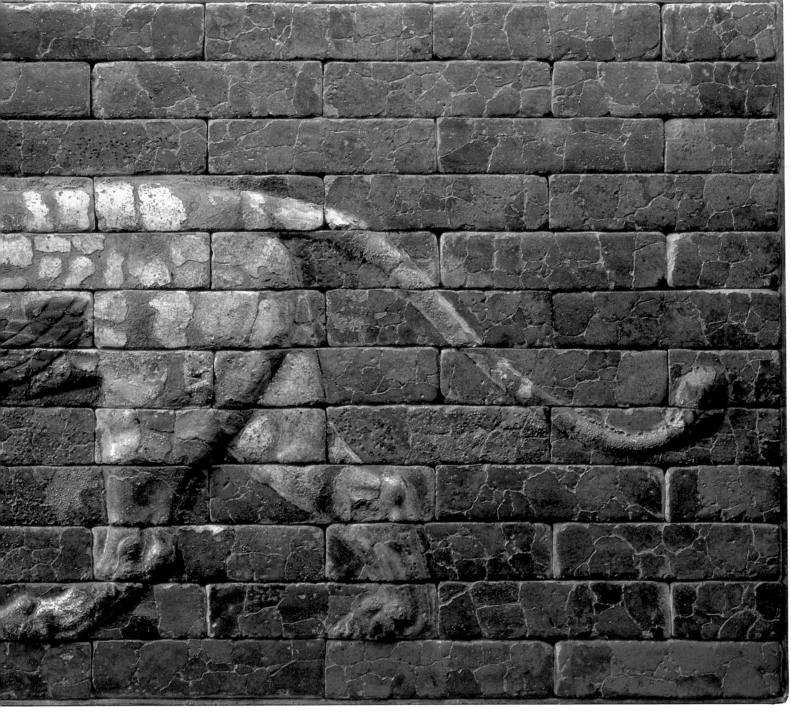
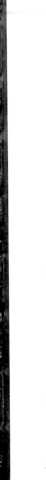

PANEL WITH STRIDING LION

The Assyrian Dynasty fell before the combined onslaughts of the Babylonians, the Scythians, and the Medes in 614 and in 612 B.C. In the final days of the empire, Nabopolassar (625–605 B.C.), who had been in Assyrian service, established a new dynasty with its capital in Babylon. During the reign of his son, Nebuchadnezzar (604–562 B.C.), the Neo-Babylonian Empire reached its peak. This was largely due to Nebuchadnezzar's ability as a statesman and a general. He maintained friendly relations with the Medes in the east while vying successfully with Egypt for the control of trade on the eastern Mediterranean coast. He is well known as the biblical conqueror who deported the Jews to Babylon after the capture of Jerusalem.

During this period a tremendous amount of building took place, and Babylon became the city of splendor described by Herodotus and the Old Testament Book of Daniel. Because stone is rare in southern Mesopotamia, molded glazed bricks were used for building and Babylon became a city of brilliant color. Relief figures in white, black, blue, red, and yellow decorated the gates and buildings of the city.

The most important street in Babylon was the Processional Way, leading from the inner city through the Ishtar Gate to the *Bit Akitu,* or House of the New Year's Festival. This relief of a striding lion is one of many from a double frieze that covered the walls of the Processional Way. The lion, symbol of Ishtar as the goddess of war, served to protect the street; its repeated design served as a guide for the ritual processions from the city to the temple.

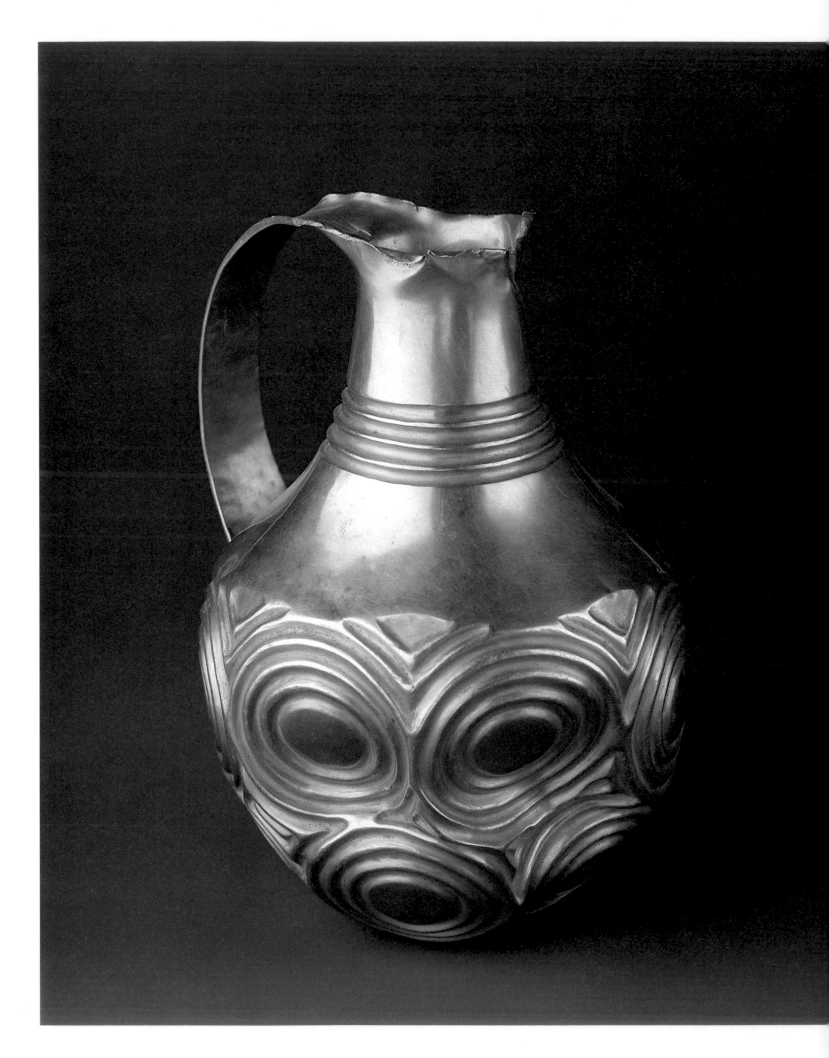

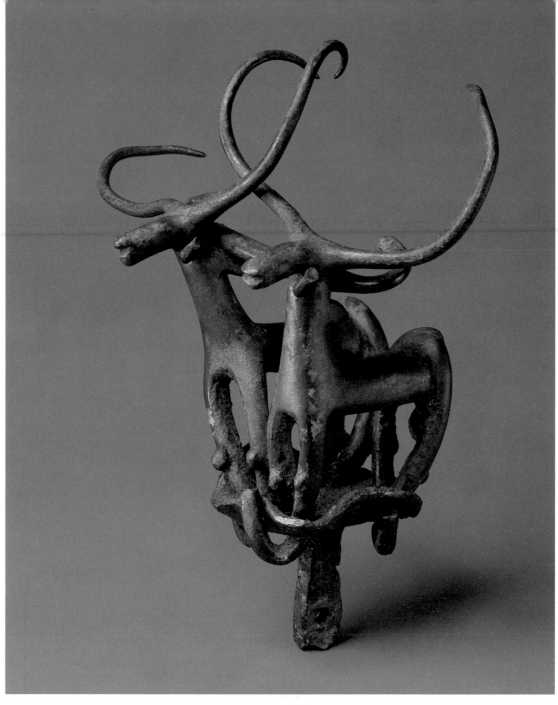

*82 Standard with
Two Long-horned Bulls*
Anatolia, reportedly
from Horoztepe;
ca. 2300–2000 B.C.
Arsenical copper;
H. 6¼ in. (15.9 cm.)
Purchase, Joseph Pulitzer
Bequest, 1955 (55.137.5)

EWER

Before the second millennium B.C., Anatolia was home to
various indigenous peoples whom we know only as prede-
cessors of the Hittites. Material evidence of their flourishing
cultures, scarce until recent excavations, amply illustrates
the skill of the pre-Hittite metalworker. The form of this
gold ewer was achieved by raising—shaping the gold through
hammering; the geometric decoration was made by re-
poussé, also a hammering technique. A long spout would
have projected from the neck of the ewer but has been cut
away in modern times; the vessel's form can be reconstructed
by comparison with similar vessels in pottery and metal. Gold
vessels found in a rich grave at Alaca Höyük have similar geo-
metric decorations.

81 Ewer
Anatolia; late 3rd millennium B.C.
Gold; H. 7 in. (17.8 cm.)
Harris Brisbane Dick Fund,
1957 (57.67)

STANDARD WITH TWO LONG-HORNED BULLS

This pair of long-horned bulls probably served as a symbolic
finial for a religious or ceremonial standard. The bulls were
cast separately. They are held together by extensions of their
front and back legs, bent around the plinth. A pierced tang
at the base suggests that the pair were connected to another
object.

The bulls' elaborate, curving horns are one-and-one-half
times as long as their bodies, and though impossible in na-
ture, this illustrates an effective stylistic convention. The ten-
dency to emphasize important features in the representation
of animals is frequently repeated in ancient Near Eastern art.

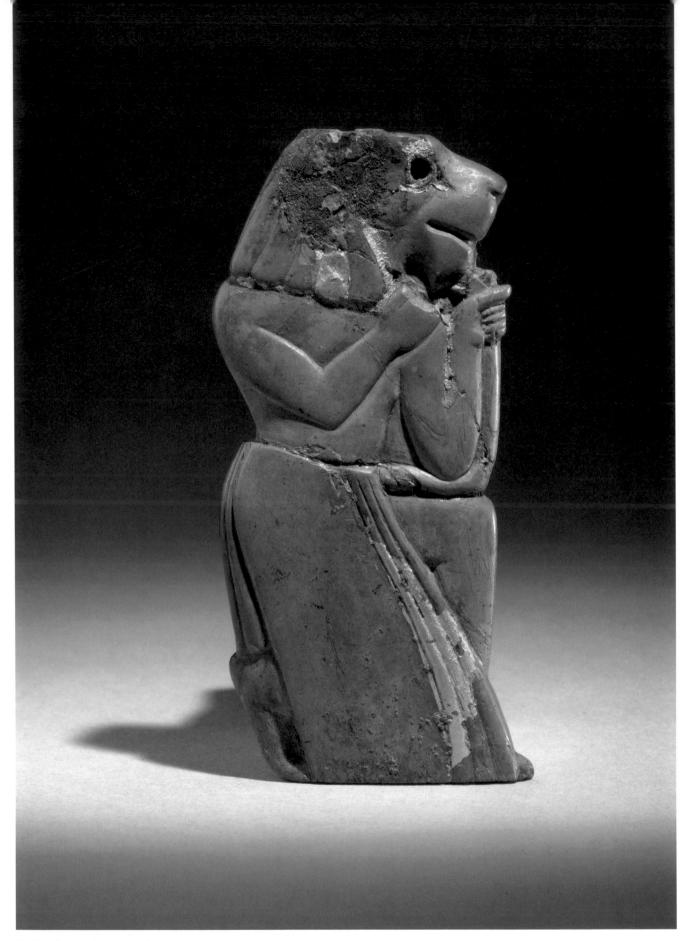

*83 Furniture Ornament in the Form
of a Lion-Headed Man*
Anatolia; 18th c. B.C.
Ivory, with gold leaf; H. 4⅜ in.
(10.9 cm.), W. 2 in. (5 cm.)
Gift of Mrs. George D. Pratt,
in memory of the late George D. Pratt,
1936; Gift of Mrs. George D. Pratt,
in memory of the late George D. Pratt,
1937 (36.70.15; 37.143.3)

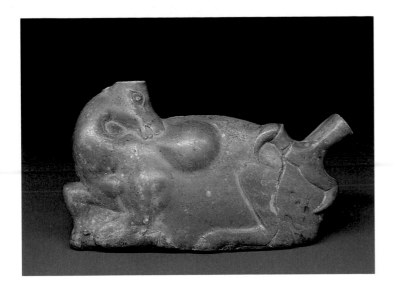

*84 Plaque in the Form of
a Deer Attacked by an Eagle*
Anatolia; 18th c. B.C.
Ivory; H. 1½ in. (3.65 cm.)
Gift of Mrs. George D. Pratt,
in memory of the late
George D. Pratt, 1936 (36.70.4)

85 Female Sphinx
Anatolia; 18th c. B.C.
Ivory; H. 5⅜ in. (13.7 cm.)
Gift of George D. Pratt,
1932 (32.161.46)

ACEMHÖYÜK IVORIES

Around 1900 B.C., traders of the Old Assyrian Period established a *karum,* or merchants' colony at the site of Acemhöyük. Acemhöyük is a large mound located south of Ankara near the Turkish town of Aksaray on the Konya plain. It lay on a route linking Anatolia and the east and seems to have been an important center for the copper trade and industry. In 1965, a Turkish archaeological expedition found sealed bullae, inscribed clay tablets, ivories, and other objects in two burned palaces on the highest part of the mound.

A group of ivories given to The Metropolitan Museum of Art in the 1930s—three of which are pictured here—are thought to have come from Acemhöyük because of the close similarities in style and subject to those known to have been found there. They, too, have been warped and discolored by fire and the conditions of the soil, and they range in color from white to gray-blue and a pinkish orange.

The ivories are carved to represent the fantastic composite creatures that were popular in the ancient Near East. The small female sphinx (Plate 85) is a form borrowed from the Egyptians. Her large almond-shaped eyes and spiral locks ultimately derive from the Egyptian goddess Hathor. Both the lion-headed man (Plate 83) and the deer being attacked by an eagle (Plate 84) are more Anatolian in subject and style. As with the later ones from Nimrud, these ivories were carved as furniture decorations and traces of their original gilding remain. The distinctive form of the upright sphinx recurs later in the art of the Hittite Empire—most notably among the fourteenth-century gate sculptures at Boghazköy. The survival of this image demonstrates a continuity of artistic tradition in Anatolia, from the Assyrian Colony Period to the Hittite Empire.

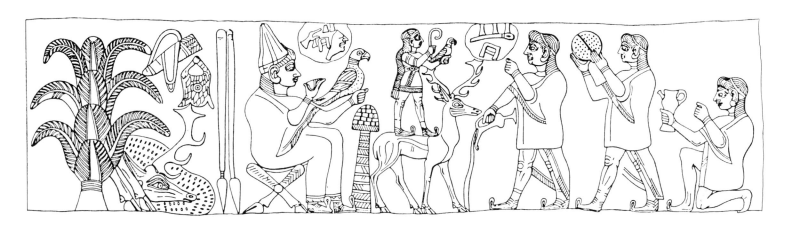

STAG RHYTON

From 1400 to 1200 B.C., the Hittite Empire had its capital at Boghazköy in the center of the Anatolian plateau. During this period, leaders such as Suppiluliuma I (1380–1346 B.C.) held sway, and the arts reached new levels of development and sophistication. Anatolia is rich in metal ore, and the consummate skill of the Hittite metalworkers is amply illustrated by a group of gold and silver objects lent to The Metropolitan Museum of Art by the collector Norbert Schimmel. Three of the objects—a pair of silver rhyta and a gold pendant in the form of a seated goddess—are particularly fine and are thought to be rare examples of art produced by court workshops.

The silver rhyton in the form of a stag shows the front of the recumbent animal with his legs tucked under his body, hooves facing out, and knees projecting slightly forward for balance. The head and upper body are treated with extraordinary naturalism. The oval eyes, once inlaid, are hollow and are connected to prominent tear ducts. The nostrils are in high relief and the small mouth is indicated by an incised line. Veins are shown in relief on the face, and the cheek and jaw are articulated with petallike ridges. The cup and chest section of the vessel was hammered from one piece that was joined to the head by a ring of checkerboard pattern. Both the horns and the handle were attached separately.

A frieze depicting a religious ceremony decorates the rim of the cup section, suggesting the possible uses for which the cup was intended. A prominent figure, thought to be a goddess, sits on a cross-legged stool, holding a bird of prey in her left hand and a small cup in her right. She wears a conical crown and has large ears, typical of Hittite art. A mushroom-shaped incense burner separates her from a male god who stands on the back of a stag. He, too, holds a falcon in his left hand, while with his right he grasps a small curved staff. Three men are shown in profile, moving to the left and facing the deities. Each holds an object of offering that he brings in homage to the divinities. Behind the men is a tree or plant against which rests the collapsed figure of a stag. Above the stag, hanging in space, is a quiver with arrows and an object that appears to be a bag. Two vertical spears complete the frieze and separate the stag from the goddess.

Cult scenes or religious processions are commonly represented in the art of the Hittite Empire, and texts make frequent reference to trees and plants associated with rituals or festivals. The texts also tell us that spears were venerated objects, so that it is possible that the stag killed in hunt, suggested by the quiver and bag, was being dedicated to the stag god. Hittite texts also mention that rhyta, made of gold, silver, stone, and wood, and shaped in the appropriate animal form, were given to the gods for their own use. Though the precise meaning of the frieze on the Schimmel rhyton remains a matter of conjecture, it is possible that the vessel was intended as the personal property of the stag god.

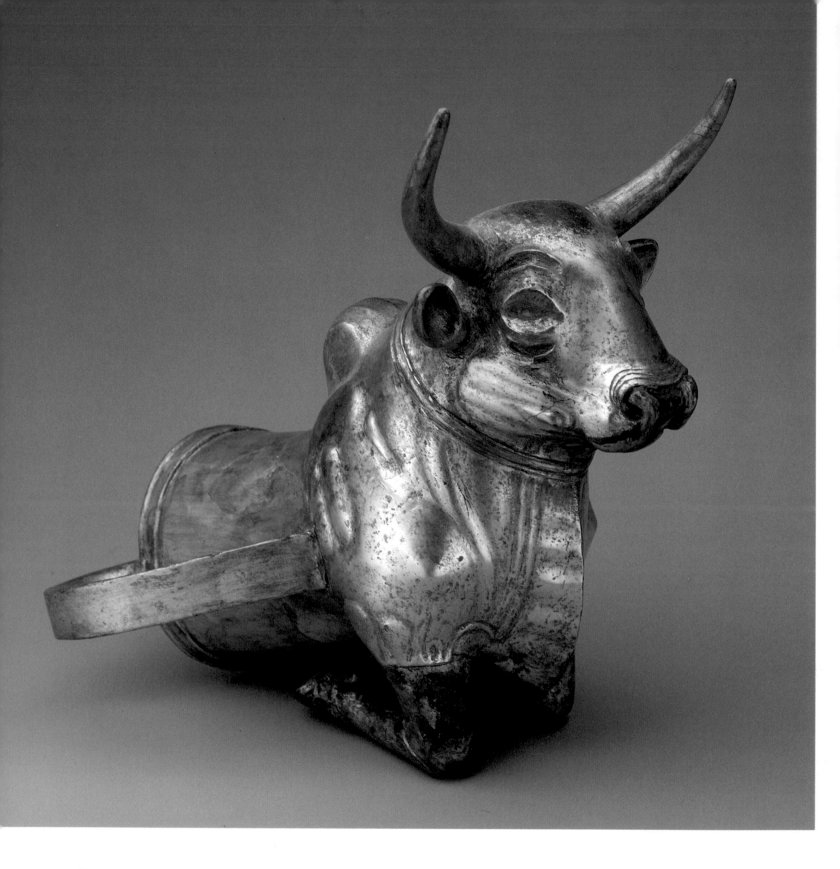

Bull Rhyton

Another silver rhyton in the Schimmel Collection is shaped in the form of a bull. Like the stag, the bull is shown in a kneeling posture and is fashioned from two pieces of silver joined by a grooved collar. The head, with its short neck, is massive and strong; the nose and the oval eyes and brows that once held inlays were all sculpted with a sensitivity comparable to that of the stag rhyton (Plate 86). Also similar to those on the stag are the petallike ridges of cheek and jowl. Repoussé musculature decorates the body above the legs and shoulder, and the chest has a prominent dewlap with horizontal undulations, which suggests folds of skin.

The bull rhyton is larger than the stag rhyton, but the execution, modeling, and use of inlays indicate that the vessels are stylistically related. It is not known whether the bull rhyton originally had a frieze, as that part of the cup has been destroyed. Similar characteristics of modeling and decoration can be seen in representations of other Hittite bulls dating from around 1300 B.C. This rhyton was probably intended as the property of the storm god, Teshub, with whom, according to Hittite texts, the bull was associated.

Pendant of a Seated Goddess
Holding a Child

This tiny pendant was probably intended to be worn round the neck as an amulet. Small gold figures with loops survive from Iran, Mesopotamia, the Levant, and Egypt, attesting to the widespread use of such objects. Similar objects from Hittite culture suggest that these small figures were portable representations of Hittite gods. The figure shown here, cast in gold using the lost-wax process, is of a seated goddess in a long gown, with large oval eyes and a thin mouth with creases at the sides. She is wearing simple, looped earrings and a necklace. Her disklike headdress probably represents the sun, which would lead to the conclusion that this may be the sun goddess, Arinna, a major Hittite divinity. A loop for suspension protrudes from the back of the headdress. On her lap the goddess holds a naked child, cast separately of solid gold and then attached. The chair on which they are seated is backless and has lion paws.

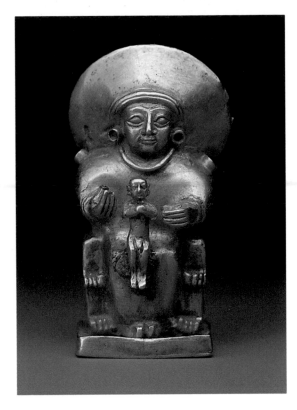

*88 Pendant of Seated Goddess
Holding Child*
Anatolia, Hittite; 15th–13th c. B.C.
Gold; H. 1¹¹⁄₁₆ in. (4.3 cm.)
Lent by Norbert Schimmel
(L.1983.119.3)

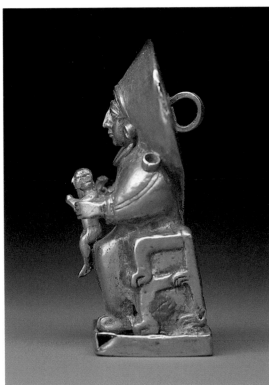

87 Bull Rhyton
Anatolia, Hittite,
Empire Period; 15th–13th c. B.C.
Silver; H. 7⅛ in. (18 cm.)
Lent by Norbert Schimmel
(L.1983.119.2)

THRACIAN SILVER BEAKER

The ancient land of Thrace encompassed a large area now divided into Bulgaria, southern Rumania, eastern Yugoslavia, northeastern Greece, and European Turkey. The first inhabitants of Thrace came from the northern part of Europe and appeared at least as early as the second millennium B.C. Thracian tribes of the mid-first millennium B.C. adopted some of the decorative traditions and nomadic habits of their Scythian neighbors to the east, but they had closer cultural relations with European prehistoric people and preserved many of the traditions of the European Bronze Age. From the mid-first millennium, such objects as ceremonial helmets, armor, drinking cups, and ornamental gear for horses—worked from silver and sometimes gilded—have been discovered in graves and in chance finds that must have been the buried hoards of Thracian princes and chiefs.

This silver beaker is a fine example of fourth-century B.C. Thracian workmanship. It was probably made in the region of present-day Rumania or Bulgaria, as similar beakers have been found in a princely tomb at Agighiol, near the delta of the Danube in eastern Rumania. The beaker is raised from a single piece of silver with a stamped, chased, and repoussé design. The decoration shows a horned bird of prey holding a fish in its beak and clutching what seems to be a hare in its claws. The bird is flanked by one horned and two antlered

89 *Beaker*
Danubian region,
Thracian; 4th c. B.C.
Silver; H. 7⅜ in. (18.7 cm.)
Rogers Fund, 1947 (47.100.88)

Below: three views
Right: detail of base

animals and, facing the large bird, a tiny bird of prey hovers over the horned animal. Almost opposite the large bird is a staglike creature with eight legs. His antlers grow into a border of tines ending in bird heads that circle the upper portion of the cup. Around both the rim and the base of the beaker runs a pattern of overlapping semicircles; below, the pattern is fringed with scrolling that suggests waves. On the bottom of the cup a winged, griffinlike monster chews an animal leg and grasps a small beast in its clawed feet.

Although certain stylistic influences can be seen from contemporary Scythian and Iranian art, the iconography of these scenes is clearly Thracian and probably refers to a native myth or legend. The monstrous bird of prey with land and water creatures in its grasp appears to symbolize dominance over land and water, while the eight-legged stag probably represents a fabulous capacity for speed. Scholars have suggested that its placement on the side of the cup opposite the bird of prey may indicate that the stag is always free from the domination of the bird. Though a precise interpretation of the iconography remains uncertain, scholars have also suggested that these animals were symbols associated with a heroic ruler and served as protective spirits, avatars, and tribal totems.

125

RELIEF WITH A HUNTING SCENE

The powerful empire of the Neo-Assyrian kings (883–612 B.C.) influenced the surrounding region culturally as well as politically. In the west, a number of small but powerful Aramean city-states acted as a barrier between Assyria and the Mediterranean seacoast. These have been called Neo-Hittite city-states although they have no relationship with the preceding culture of the Hittites of Anatolia. To put an end to their continuous interference with trade, these rival states were gradually brought under the control of the Assyrian Empire.

At first, the art of these regions continued to reflect its independent origins, but it was soon influenced by the style and iconography of its powerful neighbor. Stone slabs carved in low relief had traditionally decorated the walls of the Neo-Hittite palaces and temples. The workmanship was often strong if crude—the figures were carved with little descriptive detail engraved on the surface—but it is nevertheless possible to detect, in some of the reliefs, the influence of Assyrian art in the choice of scene, the types of chariots and horse gear, and the galloping posture of the horses.

90 Relief with Hunting Scene
North Syria, Tell Halaf,
Neo-Hittite; 9th c. B.C.
Basalt; 22 x 27 in.
(55.9 x 68.5 cm.)
Rogers Fund, 1943
(43.135.2)

91 Sphinx
North Syria; 9th–8th c. B.C.
Bronze; H. 5¼ in. (13.3 cm.)
Rogers Fund, 1953 (53.120.2)

SPHINX

Hammered from a single sheet of bronze, this plaque depicts the mythical sphinx, a creature with the head of a human and the body of a lion. The figure is one of a pair; its mate faces the opposite way, and their striding pose suggests that they may once have been shown approaching one another. Parallels for the stance and facial features of this fantastic creature can be found in northern Syrian works of art in bronze and ivory from the same period. The flamelike pattern on the hind leg was a common device for representing musculature at this time and appears on ivories from Hama, Nimrud, and Hasanlu. The plaques may have been used as inlays for furniture, or they may have been set into a wall or door. Whatever their use, the plaques are examples of the finest north Syrian bronzes from the first millennium B.C. known to exist.

127

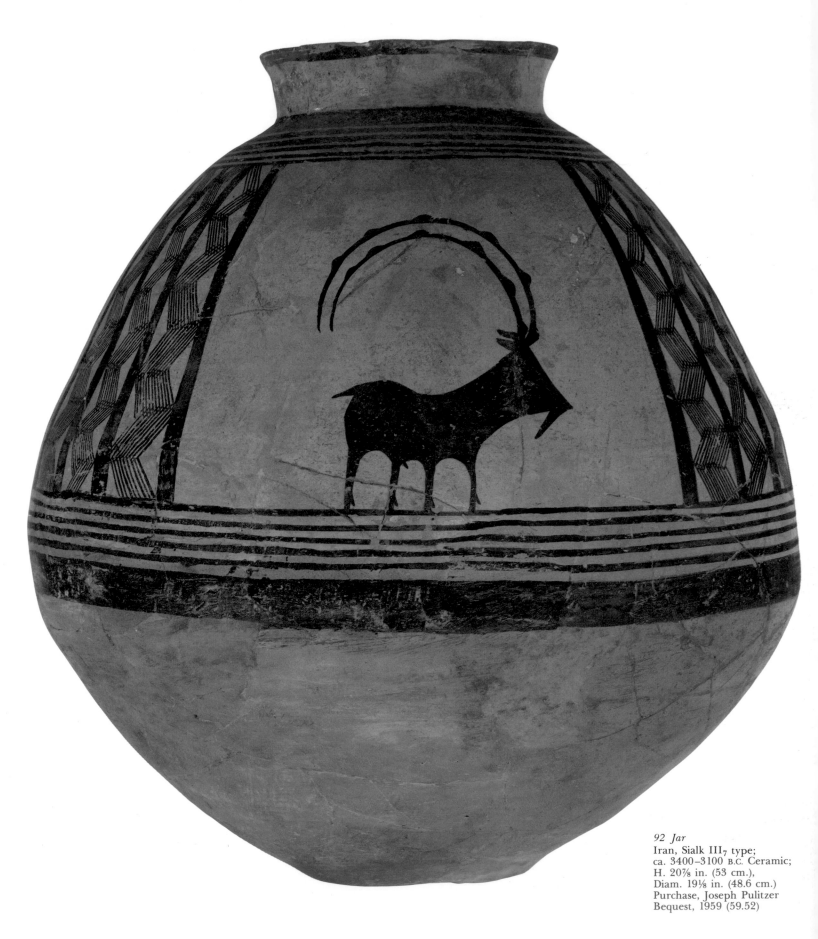

92 Jar
Iran, Sialk III_7 type;
ca. 3400–3100 B.C. Ceramic;
H. 20⅞ in. (53 cm.),
Diam. 19⅛ in. (48.6 cm.)
Purchase, Joseph Pulitzer
Bequest, 1959 (59.52)

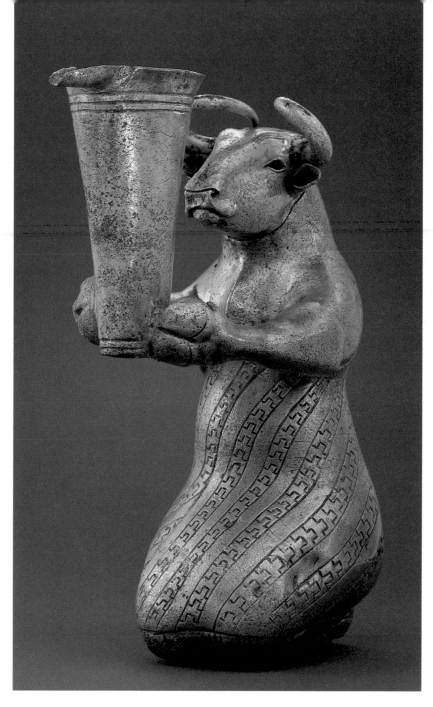

93 *Kneeling Bull Holding a Vase*
Iran, Proto-Elamite; ca. 2900 B.C.
Silver; H. 6⅜ in. (16.2 cm.)
Purchase, Joseph Pulitzer
Bequest, 1966 (66.173)

JAR

The tradition of making painted pottery flourished throughout the Near East in the late Neolithic and Chalcolithic periods of the sixth to early fourth millennium B.C. In Iran, however, the craft took particular hold. Artisans explored its physical and decorative potential, the craft persisted, and it is from Iranian culture that an abundance of fine painted pottery remains. This ovoid storage vessel is a masterpiece of early pottery making. Produced after 3500 B.C. on the Iranian plateau, in a style known from excavations at the site of Sialk, it is a large buff-colored jar painted with dark brown designs. The geometric decoration on the upper portion of the vessel divides it into three panels. In each of these panels is the stylized image of an ibex shown in right profile to highlight the great arch of its exaggerated horns.

KNEELING BULL HOLDING A VASE

This small silver bull, clothed in a robe decorated with a stepped pattern and holding a spouted vessel, shows a curious blend of human and animal traits. The large neck meets distinctly human shoulders, which taper into arms that end in hooves. The figure, from southwestern Iran, is of exceptional technical quality and is composed of many parts carefully fitted together. It is best seen in profile or three-quarter view as, when approached frontally, the face is obscured by the large vessel that the bull is holding out.

Animals in human posture are known in Iranian Proto-Elamite sculpture and can be seen engraved on contemporary cylinder seals. It is interesting that many of the three-dimensional works are meant to be seen from views other than a standard frontal pose. The purpose and meaning of this small masterpiece remain enigmatic, though it is thought that the bull as human is drawn from contemporary religious myth. Traces of cloth that were found affixed to the figure suggest that it was intentionally buried, perhaps as part of a ritual or ceremony.

Head of a Dignitary

This magnificent arsenical copper head is reminiscent of the head of an Akkadian ruler found at Nineveh in northern Mesopotamia. Quite heavy and cast almost solid, it has a dowel at the base with which it was joined to a body or other support.

Because of its unique features, this head has been the subject of scholarly attention. Some have dated it to the second millennium B.C., but most now place it in the late third millennium B.C. on the basis of its close similarity to the magnificent bronze head found at Nineveh. Some scholars even feel that the heavy-lidded eyes, the prominent but unexaggerated nose, the full lips and enlarged ears, all suggest the portrait of a real person. If this is true, the head is unique among Near Eastern artifacts. Its costly material and impressive workmanship suggest that it was intended to represent a king or a nobleman, though this identity is thrown into doubt by the fact that he wears a turban. Regardless of these unsolved mysteries, this head is one of the great works of art preserved from the ancient Near East.

94 Head of a Dignitary
Iran or Mesopotamia; late
3rd millennium B.C. Arsenical
copper; H. 13½ in. (34.3 cm.)
Rogers Fund, 1947 (47.100.80)

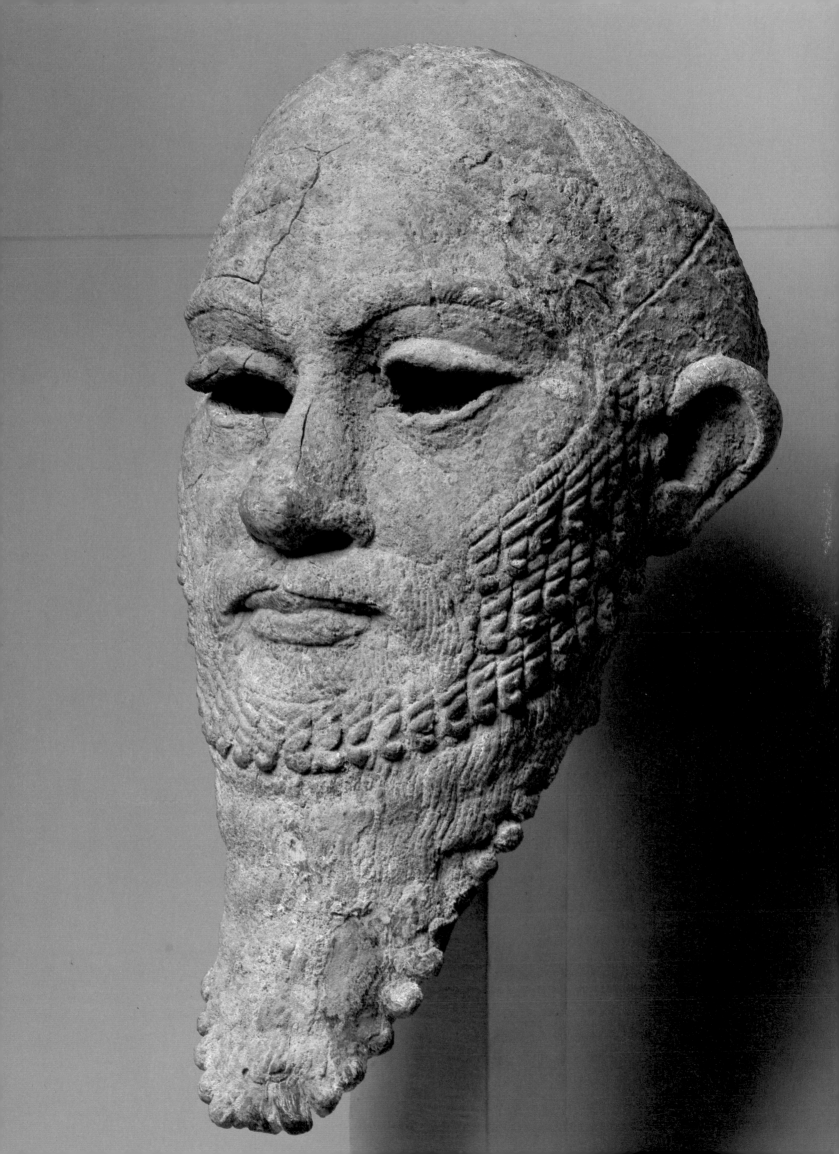

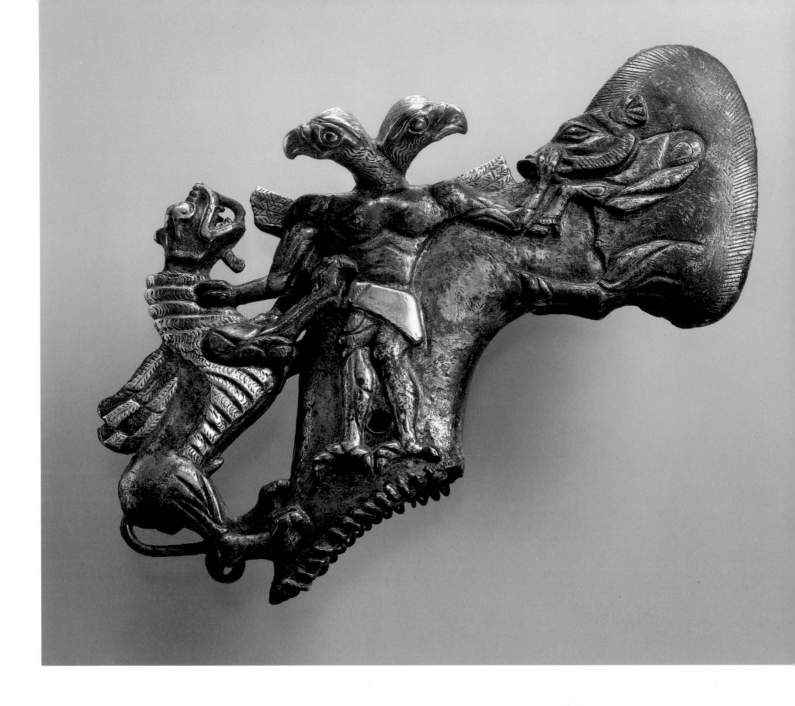

SHAFT-HOLE AXE WITH A BIRD DEMON, BOAR, AND WINGED DRAGON

This silver-gilt shaft-hole axe is a masterpiece of three-dimensional and relief sculpture. Expertly cast and gilded with gold foil, it is decorated with the representation of a lively struggle between a superhuman hero and demonic forces—a scene found elsewhere in the art of western Central Asia during the Bronze Age. On both sides of the axe, a bird-headed hero grapples with a wild boar and a winged dragon. The idea of the heroic bird-headed creature probably originated in mid-third-millennium Iran where it is first documented on an ancient impression of a cylinder seal. The hero's muscular body is human except for the bird talons that replace the hands and feet. He is represented twice, once on each side of the axe, and consequently appears to have two heads. On one side, he grasps the boar by the belly and on the other, by the tusks. The posture of the boar is contorted so that its bristly back forms the shape of the blade. With his other talon, the bird-headed hero

grasps the winged dragon by the neck. This creature is distinguished by folded and staggered wings, a feline body, and the talons of a bird of prey replacing his front paws. It once had a single horn that is now broken and gone. The winged dragon, which is frequently found in the imagery of western Central Asia, served as a symbol of the Iranian Shimashki Dynasty of the late third millennium B.C.

The form of the axe, with its splaying blade and cut-away shaft, as well as the stylistic and iconographic details of the sculptural images, identifies it as a product of the Bronze Age culture of ancient Bactria, which extended over an area that today includes part of northern Afghanistan and southern Turkmenistan. During the late third and early second millennium B.C., a prosperous urban culture flourished in this region, supported in part by a lively trade in both luxury and utilitarian commodities with the civilizations to the west, in Iran, Mesopotamia, and Asia Minor.

CUP DECORATED WITH BIRDS

During antiquity, vessels of precious metal were used in ritual ceremonies and as symbols of status for members of the ruling elite. From the western Caucasus to eastern Afghanistan, several hoards of these vessels in gold and silver have been found and recorded. Such a cup, made of a natural alloy of gold and silver known as electrum, is part of the Norbert Schimmel Collection. Resting on its narrow base, the body of the vessel curves gently inward before flaring out again to a wide mouth. The vessel is decorated at the rim with eight birds of prey incised with patterned lines. They are placed at equal intervals, with wings outspread and heads projecting above the rim of the cup. Each bird is attached with three round-headed gold rivets. Since the placement of the birds makes it awkward to drink from the cup, it is probable that the vessel was intended for some kind of ceremonial libation. The bird of prey is prominent in the iconography of western Central Asia, and in this particular posture—viewed as if from below—it had an extremely long life in the art of Iran.

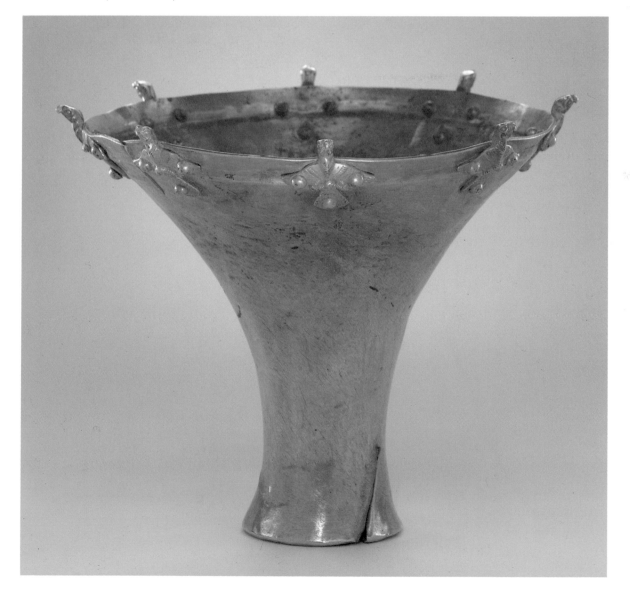

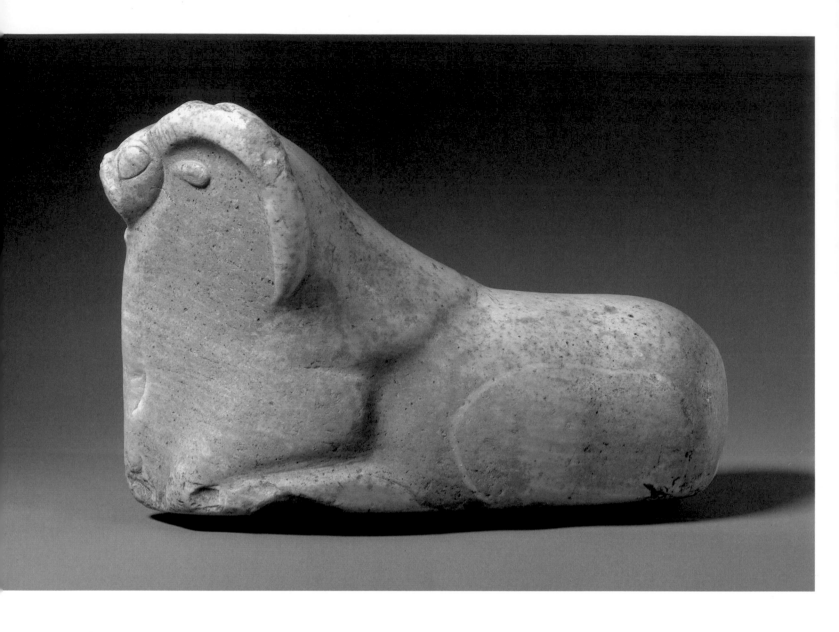

RECUMBENT MOUFLON

This powerful sculpture represents a mouflon, a type of wild sheep native to the highland regions of the Near East. The animal's head, now partially broken away, is held upward and is twisted to the right, creating an impression of alertness. The artist has achieved a realistic rendering of an animal at rest, its weight thrown fully onto its left haunch, and its left hind leg tucked under its body. The bottom of the statue has been worn away, but it is likely that the hidden leg was originally indicated there. The entire body is contained within a single unbroken outline. The horns, ears, tail, and muscles were modeled in relief, although time and secondary use have flattened the contours on the right side. This combination of closed outline with broadly modeled masses and a minimum of incised detail is characteristic of animal sculpture from the Harappan-period levels at the site of Mohenjo Daro in the lower reaches of the Indus River. The function of these animal sculptures is unknown.

97 Recumbent Mouflon
Indus Valley; ca. 2000 B.C.
Marble; L. 11 in. (28 cm.)
Anonymous Gift and
Rogers Fund, 1978 (1978.58)

HELMET

No surviving Elamite or Assyrian monument shows a helmet of precisely this shape or with this decoration. Sturdily made from bronze, and elaborately ornamented with precious material, this helmet was probably worn in battle by a person of high rank. It is more or less hemispherical; the front edge is cut away on the sides where the eyebrows would be. Of the twelve ornamental studs that were once spaced all around the helmet, only nine remain. At the back there is a tapering metal tube for the insertion of a feather or a horsehair plume.

The helmet is ornamented by three divine figures. Each was sculpted from a bitumen core that was overlaid with gold foil and then fastened to a bronze plate riveted to the helmet. The central figure is a bearded god who holds a vase from which streams of water issue. The overlapping semicircles that pattern the god's skirt and the background are a symbol for mountains. This god of the waters was originally a Sumerian·conception, but it was incorporated into the iconography of neighboring regions and endured for a long time. The god is flanked by female divinities whose hands are pressed against their breasts. Their flounced dresses, traditional divine garb in Mesopotamia during the third and second millennia B.C., are also found in other Elamite representations of female divinities. Crowning the helmet and swooping over all three figures is a bird with outstretched wings. Whether the bird represents the divinity of the skies above, complements the power expressed by the figures below, or symbolizes a bird of prey ready to devour the wearer's victims, the impression of strength, even invincibility, is effectively conveyed.

98 Helmet
Iran, Elamite; ca. 1300 B.C.
Bronze with gold foil over
bitumen; H. 6½ in. (16.5 cm.),
W. 8¹¹/₁₆ in. (22.1 cm.)
Fletcher Fund, 1963 (63.74)

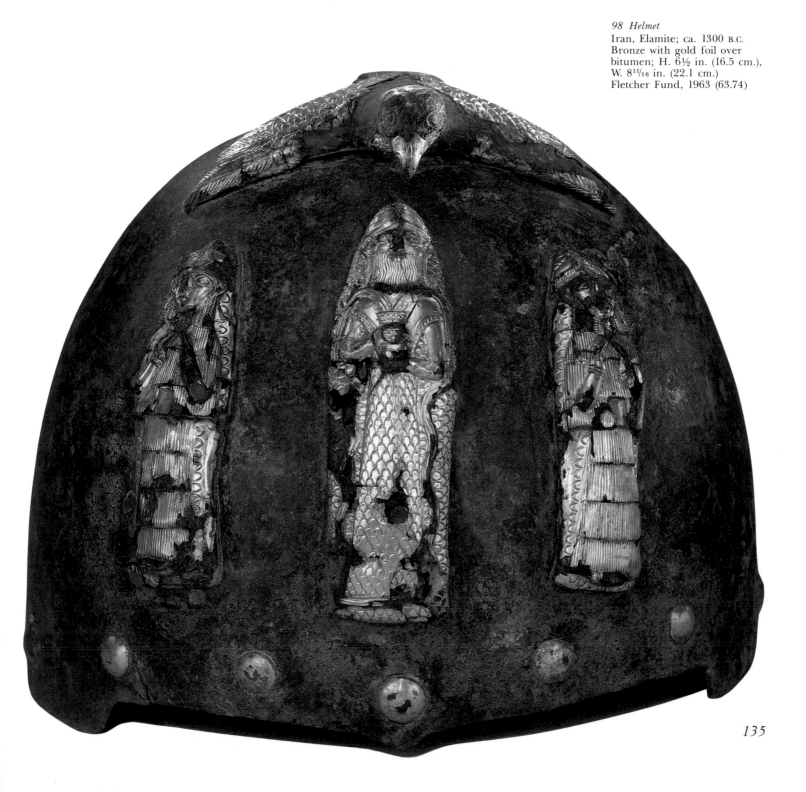

Cup with Four Gazelles

The tradition of making vessels decorated with animals whose turned heads project in three-dimensional relief has a long history in the Near East. A number of cups similar to this one have been found in the excavation of burials at Marlik, a site southwest of the Caspian Sea in northern Iran, and at Susa, in southwestern Iran. This vessel probably comes from the north, in the region of the Elburz mountains. On it, four gazelles, framed horizontally by guilloche bands, walk in procession to the left. Their bodies are rendered in the repoussé technique and are detailed with finely chased lines to indicate body hair and musculature. The projecting heads were made separately, as were the ears and horns, and were fastened invisibly in place by a method much practiced in Iran—colloid hard-soldering, a process involving copper salt and glue. The hooves and eyes are indented, probably to receive inlays.

Vessel in the Shape of an Ibex

This ceramic rhyton in the form of an ibex comes from northwestern Iran where theriomorphic vessels were popular, especially during the later Bronze and Iron ages. This particular vessel is somewhat crude in its workmanship; it is composed of basic geometric forms, cylinders and cones, with a pouring hole fashioned in the center of the breast. The head projects in pyramid form and is more sensitively modeled than the rest of the body, with incised eyes and a triangular beard. In a manner characteristic of the work of Near Eastern artisans, the animal's horns are elongated and emphasized. The legs are unnaturally short—this may have been to insure the stability of the piece or to suit the convenience of the potter.

100 Vessel in the Shape of an Ibex
Iran; ca. 700 B.C. Ceramic;
H. 10¹⁵/₁₆ in. (27.8 cm.),
L. 11⅛ in. (28.3 cm.) Gift of
Mr. and Mrs. E. Safani,
1964 (64.275)

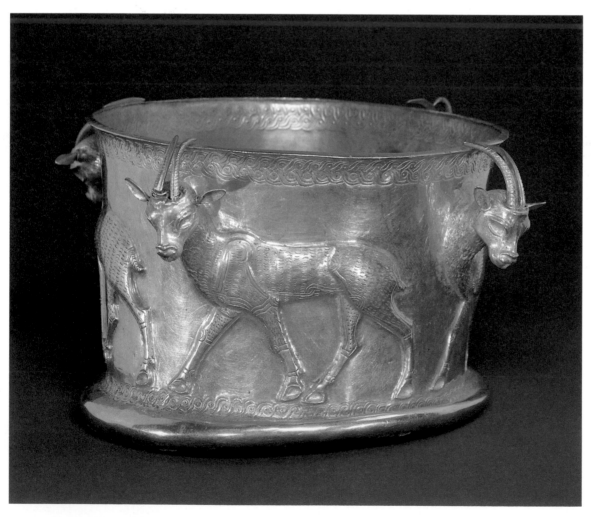

99 Cup with Four Gazelles
Iran; ca. 1000 B.C.
Gold; H. 2½ in. (6.4 cm.)
Rogers Fund, 1962 (62.84)

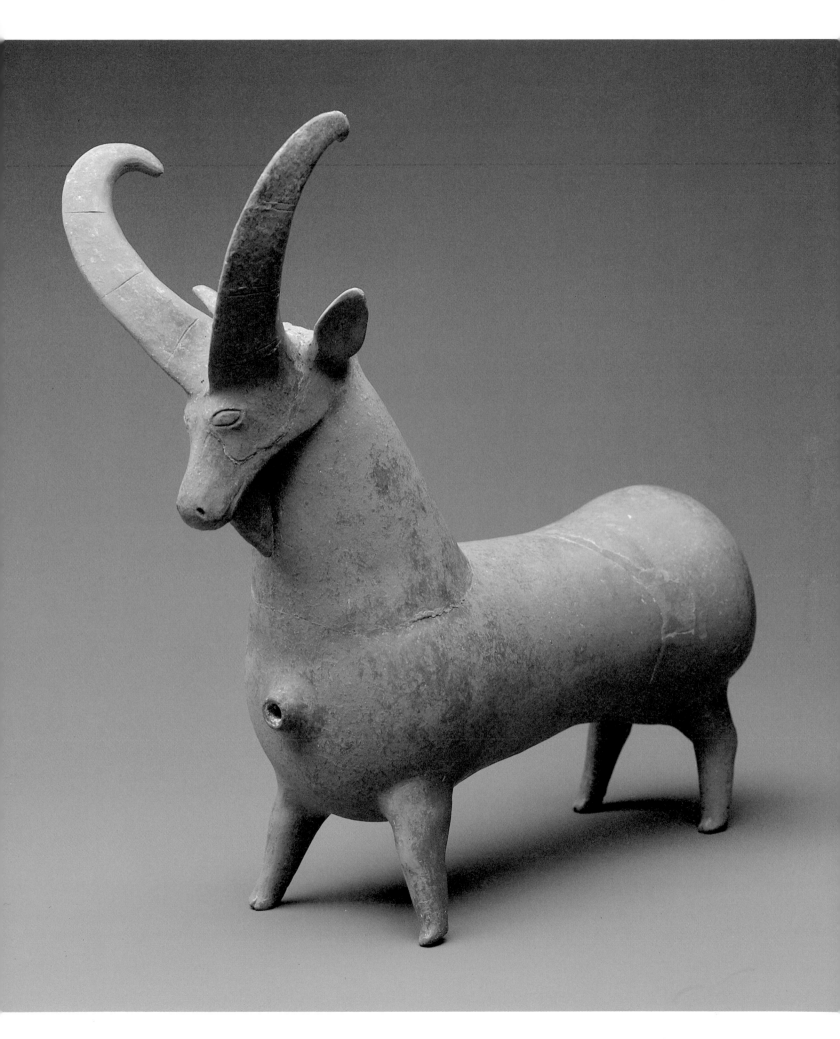

PLAQUE WITH FANTASTIC CREATURES

This gold plaque was allegedly discovered among other treasures in a bronze coffin possibly made for an Assyrian prince. The tub was reportedly found in the ancient mound near the village of Ziwiye in northwestern Iran. Perforated around the edge by small holes, the plaque was perhaps once attached to the garment of a wealthy lord or to the shroud of a prince. Though it was undoubtedly made in Iran, the designs on the plaque show the influence of the Scythians, as well as the Assyrians and the Urartians, who all struggled to dominate the region during the first part of the first millennium B.C. The plaque was originally composed of seven registers decorated in repoussé and chasing; two were separated and are now in the collection of the Archaeological Museum in Tehran. The registers display the familiar composite creatures of the ancient Near East striding in groups of three toward a central motif of the stylized tree of life. The human-headed winged lion, seen in the first and third register, is a creature that also appears as a gate guardian on the doorjambs of Assurnasirpal's palace at Nimrud (Plate 74). A sphinx struts along the second band, followed by winged lions and ibex. The bodies of the fantastic creatures are composed of unusual combinations of animal and bird parts: in the uppermost register, the lions sport ostrich tails, while in the second, their tails are those of scorpions. The trees of life bear pomegranates, pine cones, and lotus flowers. Each scene is framed and separated by a delicate guilloche pattern.

101 Plaque with Fantastic Creatures
Iran, reportedly from Ziwiye;
8th–7th c. B.C. Gold;
8⅜ x 10⅜ in. (21.3 x 27 cm.)
Top fragment: Ann and George
Blumenthal Fund, 1954; Bottom
fragment: Rogers Fund, 1962
(54.3.5; 62.78.1a,b)

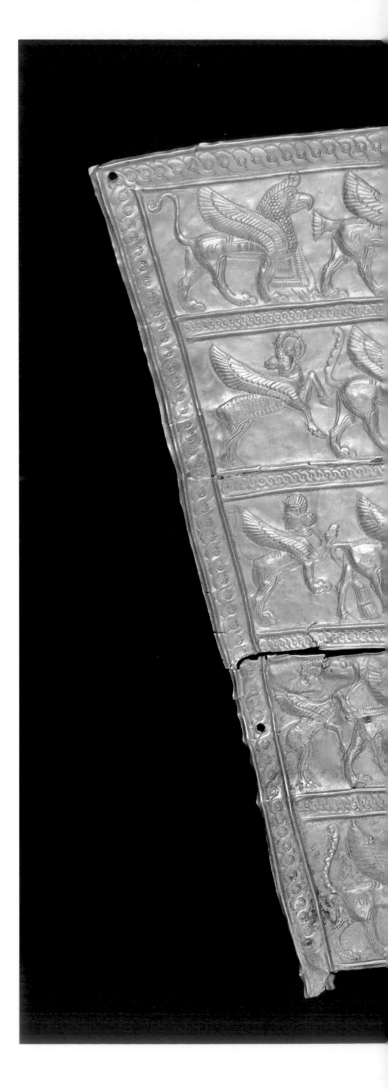

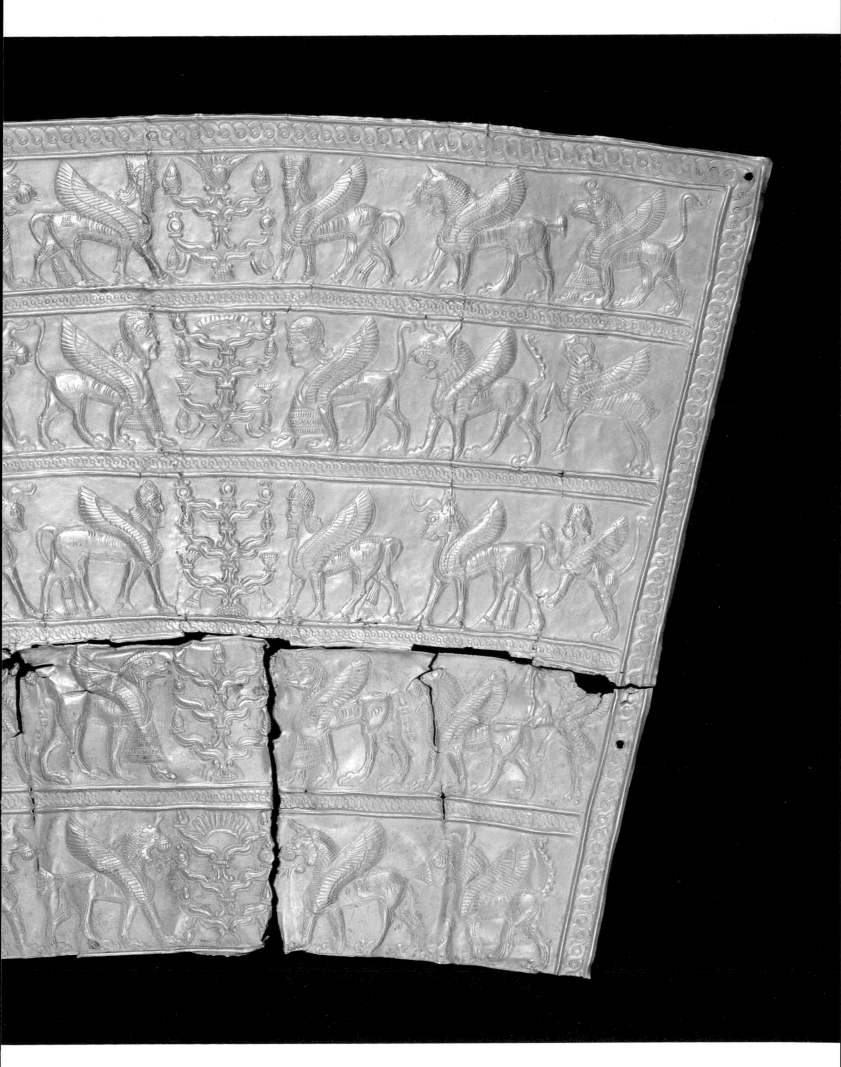

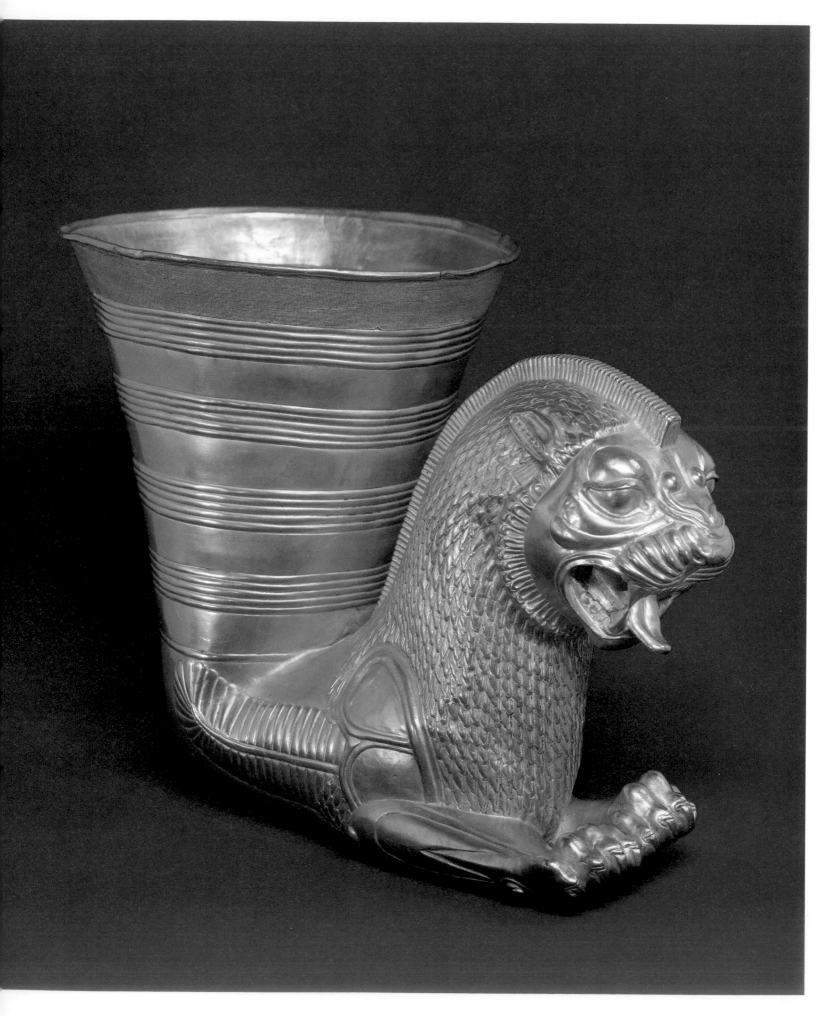

ACHAEMENID GOLD VESSEL

In the sixth century B.C., under the leadership of Cyrus the Great, the Achaemenids overthrew the Medes and established themselves at the head of an empire that would eventually extend from eastern Europe and Egypt to India. The Persian Achaemenid rulers include such famed kings as Cyrus, Darius, and Xerxes. They built palaces and ceremonial centers at Pasargadae, Persepolis, Susa, and Babylon. The Achaemenid Dynasty lasted for two centuries and was ended by the sweeping conquests of Alexander the Great, who destroyed Persepolis in 331 B.C. The Achaemenid Period is well documented by the descriptions of Greek and Old Testament writers and by abundant archaeological remains. The gold object pictured here (Plate 102), and the two on the following page (Plates 103 and 104), are masterpieces of the Achaemenid goldsmith's art.

Horn-shaped vessels ending in an animal's head have a long history in the Near East, as well as in Greece and Italy. Early Iranian examples are straight, with the cup and animal head in the same plane. Later, in the Achaemenid Period, the head or animal protome was often placed at a right angle to the cup, as in this piece. In the manufacture of this gold rhyton, several parts were invisibly joined by brazing, demonstrating superb technical skill. One hundred and thirty-six feet of twisted wire decorate the upper band of the vessel in forty-four even rows, and the roof of the lion's mouth is raised in tiny ribs. Typical of Achaemenid style, the ferocity of the snarling lion has been tempered and restrained by the introduction of decorative convention. The lion has a crest running down his back, his mane has the disciplined appearance of a woven material, and his flanks are covered by an ostrich plume. The inclusion of the plume, a departure from the normal conventions for depicting lions, suggests that this lion is winged and has some supernatural significance.

102 Vessel Ending in the Forepart
of a Lion
Iran, Achaemenid; 5th c. B.C.
Gold; H. 7 in. (17.8 cm.)
Fletcher Fund, 1954 (54.3.3)

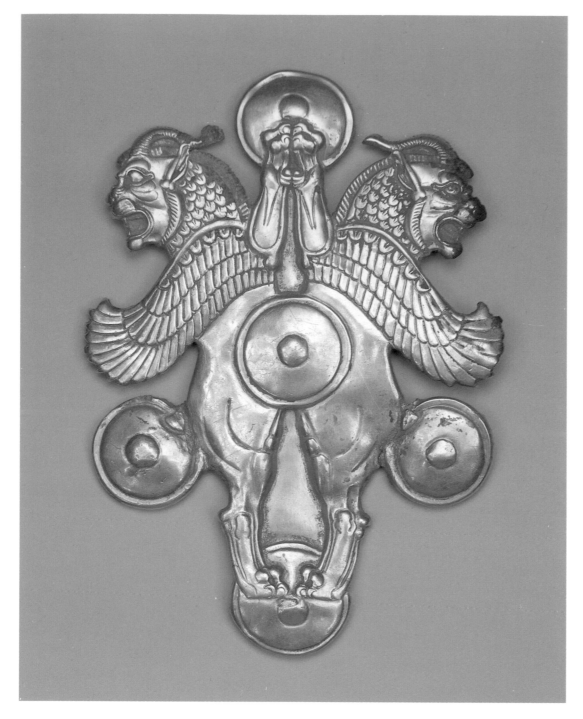

103 Ornament in the Form of Two Lions
Iran, Achaemenid;
6th–5th c. B.C.
Gold; H. 5⅜ in. (13.6 cm.)
Rogers Fund, 1954 (54.3.2)

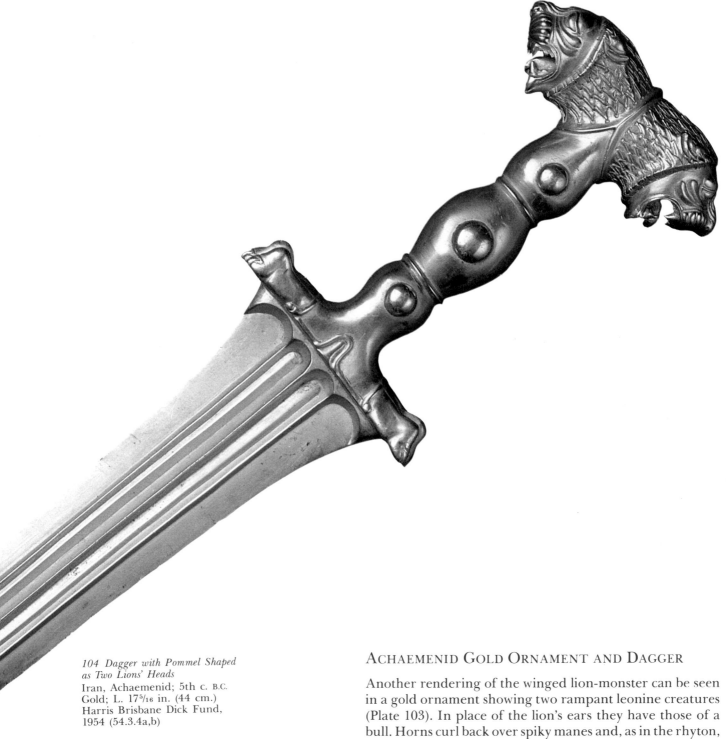

*104 Dagger with Pommel Shaped
as Two Lions' Heads*
Iran, Achaemenid; 5th c. B.C.
Gold; L. 17⁵/₁₆ in. (44 cm.)
Harris Brisbane Dick Fund,
1954 (54.3.4a,b)

ACHAEMENID GOLD ORNAMENT AND DAGGER

Another rendering of the winged lion-monster can be seen in a gold ornament showing two rampant leonine creatures (Plate 103). In place of the lion's ears they have those of a bull. Horns curl back over spiky manes and, as in the rhyton, the lion's neck is covered with a feather pattern. Sharply stylized wings extend over two of the five bosses that serve as decorative balance for the design. Heavy rings attached to the back suggest that the ornament was worn on a leather belt. The similar treatment of the lion motif demonstrates decorative conventions of the period.

A characteristic Assyrian motif of the double lion head embellishes the hilt of the dagger (Plate 104), while the quillon is formed by lion's feet. Though gold is a soft metal, the fact that the blade was strengthened by several longitudinal ridges suggests that it may not have been intended for purely ceremonial use. Nor were gold daggers rare; they are mentioned with surprising frequency in ancient texts as loot from conquered cities or as objects for presentation.

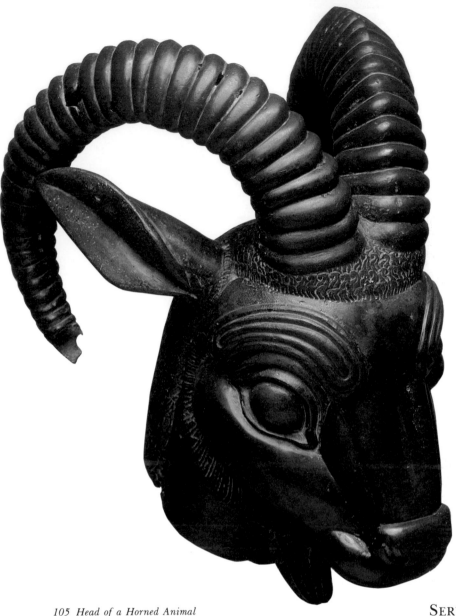

105 *Head of a Horned Animal*
Iran, Achaemenid; 6th–5th c. B.C.
Bronze; H. 13⅜ in. (34 cm.)
Fletcher Fund, 1956 (56.45)

HEAD OF A HORNED ANIMAL

The stylization of all forms—human, plant, and animal—is characteristic of the art of the Achaemenid Period. The abstract patterns for the eyes, brows, horns, beard, and curls, seen in this horned head of an animal, are used again and again. Cast of bronze, using the lost-wax process, this head of a mythical creature, part goat, part sheep, is composed of five separate pieces that were joined by fusion welding. The angle of the tapering neck suggests that the head was not attached to an animal's body but was perhaps joined to a support as an element of architectural decoration.

SERVANTS BEARING A WINESKIN AND A COVERED BOWL

Monumental art and architecture of the Achaemenid Period are best exemplified by the ruins of Persepolis, the large ceremonial capital of the empire originally built by Darius I and expanded by his successors. Persepolis lies thirty miles northwest of Shiraz in the southwest Iranian province of Fars. There, the Hall of One Hundred Columns and the Throne Room of Darius and Xerxes exhibit characteristic features of Achaemenid architecture—large square rooms, the ceilings of which were supported by many columns. Some of the columns in the Throne Room have been reconstructed and stand more than 65 feet high. The column capitals were decorated with the foreparts of bulls, lions, and griffins carved in the round.

Most characteristic of Achaemenid sculpture are the slabs carved in low relief that decorate the various stairways leading to the ceremonial buildings. One such fragment, from a staircase at Persepolis, shows two servants. One carries a wineskin and is clothed as a Persian with a long full-sleeved tunic made from a light textile, the other holds a bowl and is dressed in the Median style with a knee-length tunic and close-fitting trousers of wool or leather, suitable for horse riding. The reliefs are essentially decorative rather than narrative, and while the detail is exquisitely rendered, the forms and composition tend to be formal and abstract.

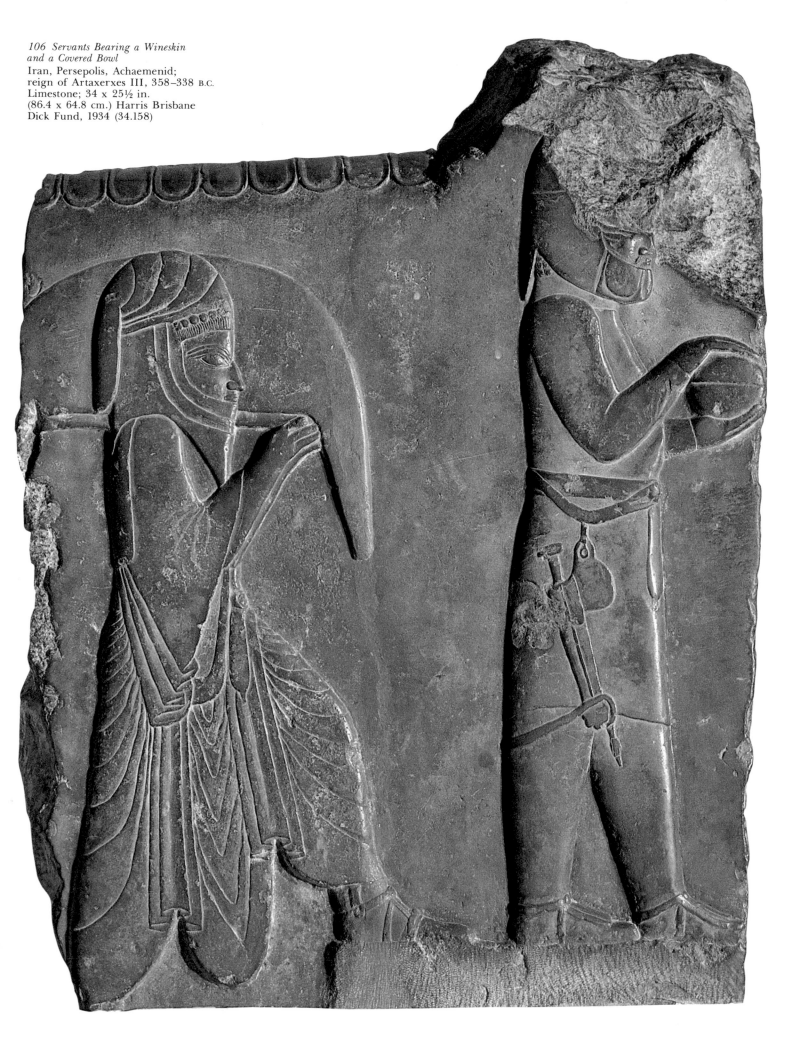

106 Servants Bearing a Wineskin
and a Covered Bowl
Iran, Persepolis, Achaemenid;
reign of Artaxerxes III, 358–338 B.C.
Limestone; 34 x 25½ in.
(86.4 x 64.8 cm.) Harris Brisbane
Dick Fund, 1934 (34.158)

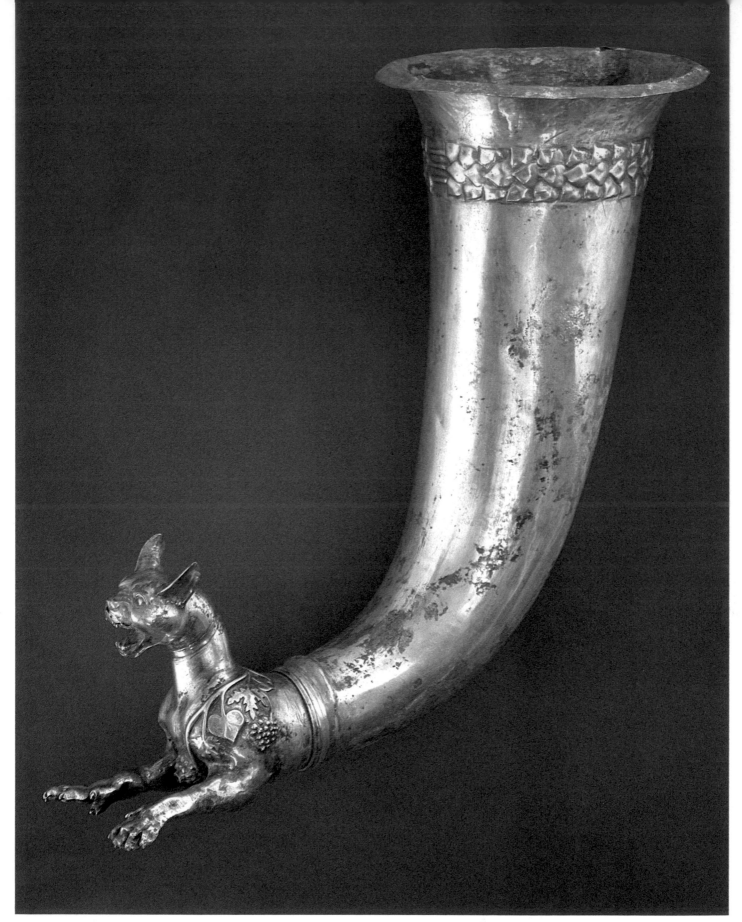

107 Rhyton with the Forepart of a Panther
Iran, Parthian; ca. 1st c. B.C.
Silver with mercury gilding; H. 10⅞ in. (27.5 cm.)
Purchase, Rogers Fund, Enid A. Haupt,
Mrs. Donald M. Oenslager, Mrs. Muriel Palitz,
and Geert C. E. Prins Gifts; Pauline V. Fullerton
Bequest; and Bequests of Mary Cushing Fosburgh,
Edward C. Moore, and Stephen Whitney Phoenix,
by exchange, 1979 (1979.447)

Opposite: detail

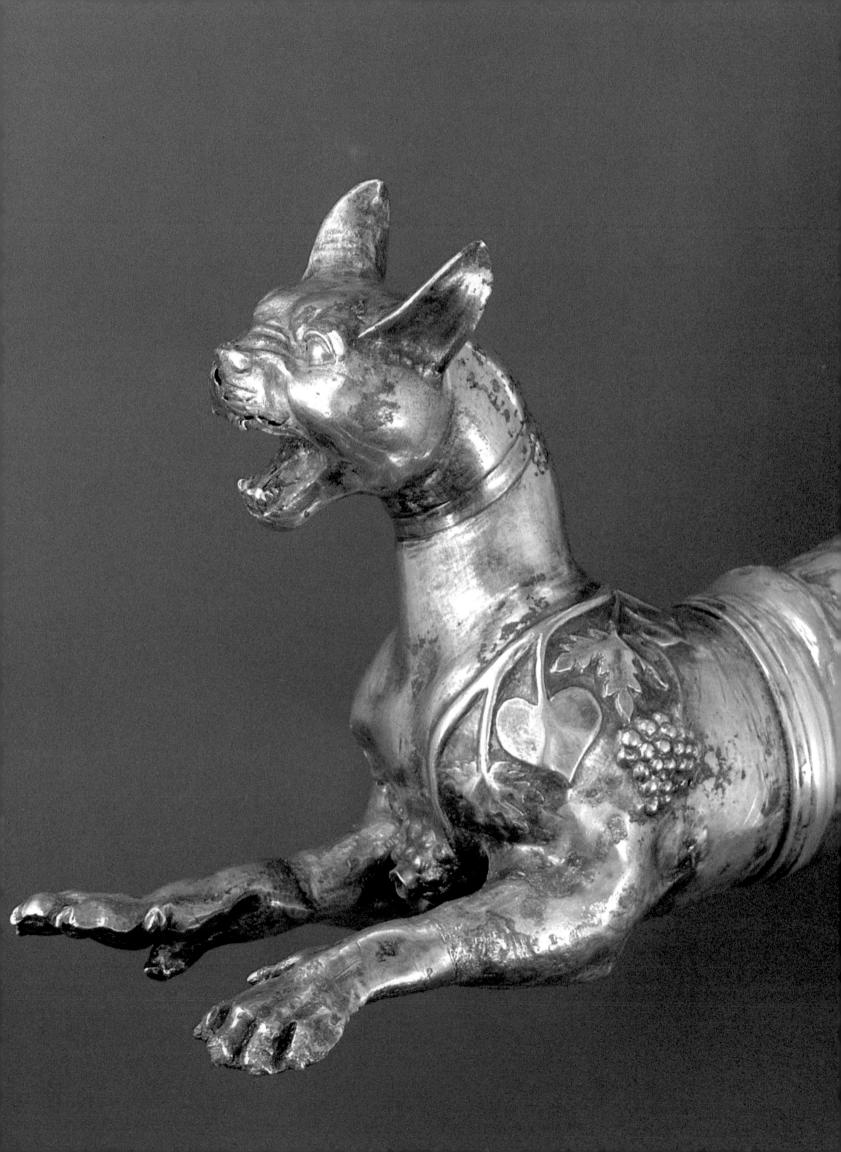

Rhyton with the Forepart of a Panther

(Pages 146–147)

Under Alexander the Great (336–323 B.C.), the Greeks put an end to Achaemenid power and an era of Greek influence in the ancient Near East began. Babylon, Susa, and Persepolis fell to the armies of Alexander in 331 B.C., and his power even reached as far as India. But in 323 B.C., while still a young man, Alexander became ill and died. Deprived of his leadership, the empire that might have become the greatest of the ancient world was split by a struggle for power among his successors, the Seleucid kings.

The Parthians, an Iranian people originally from the north and east of Iran, established supremacy in the Near East in the second century B.C., after the disintegration of Alexander's empire and the collapse of his Seleucid successors. Ctesiphon, the capital, was situated on the bank of the Tigris River opposite the earlier Greek settlement of Seleucia.

This silver rhyton dates from the Parthian Period and is a fine example of the enduring influence of Hellenistic culture, which in itself owes much to the artistic traditions of Achaemenid Iran. The horn-shaped vessel ends in the forepart of a panther; a spout for pouring is in the middle of the chest. The panther wears a gilded fruit-laden grapevine wound around its chest; at the other end of the rhyton, an ivy wreath encircles the rim. These are the symbols of the Greek wine god, Dionysos, whose cult spread eastward with the invasion of Alexander. Dionysiac images—panthers, grapevines, and dancing females—were absorbed by the Parthians and continued to appear in the art of Near Eastern cultures in the Sasanian Period (A.D. 226–651).

Male Head

The ceramic sculpture in the form of a bearded man is a further example of the influence of ancient Greece on Parthian art. Following the Greek conquest, craftsmen and merchants settled in the Near East in considerable numbers. Local architecture soon reflected their presence as Greek capitals, columns, and moldings began to transform the appearance of buildings. The decorative treatment of functional items is exemplified by this object, which may have been a rainspout. The realistic rendering of this male head bespeaks the influence of Hellenism, although the individual features of the man are certainly native. The long, loose locks of hair, the moustache, and the prominent nose are all unmistakable facial characteristics of inhabitants of the Near East.

108 Male Head
Iran, Parthian; 1st–2nd c. A.D.
Ceramic, originally glazed;
H. 8¼ in. (20.9 cm.) Gift of
Walter Hauser, 1956 (56.56)

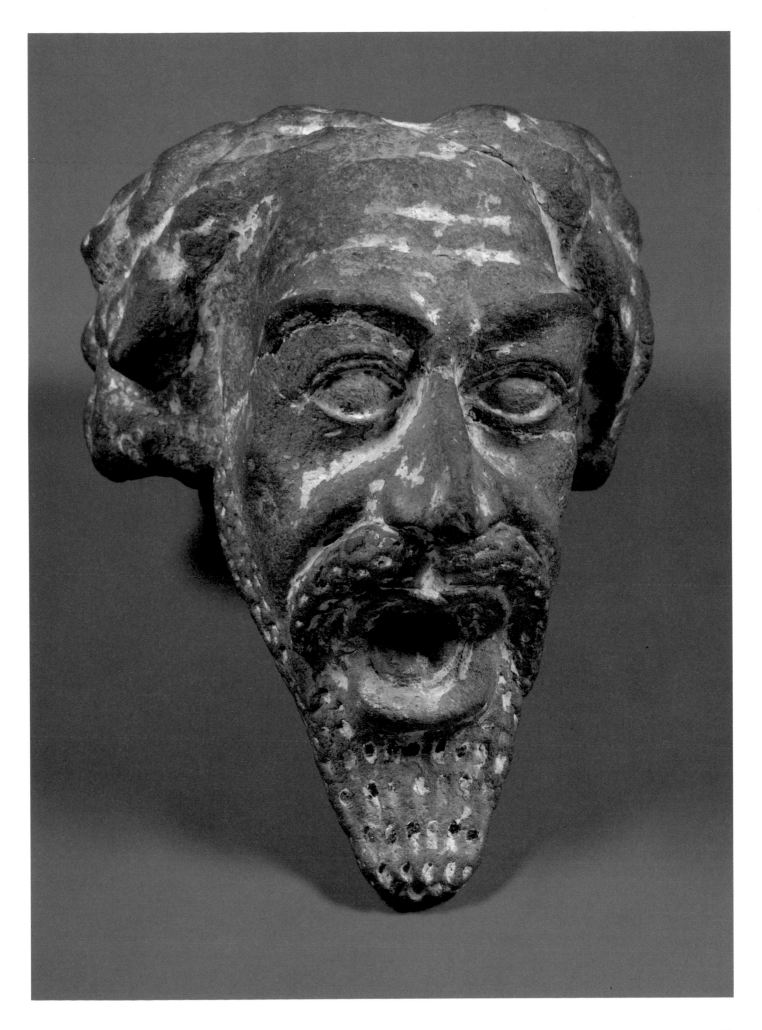

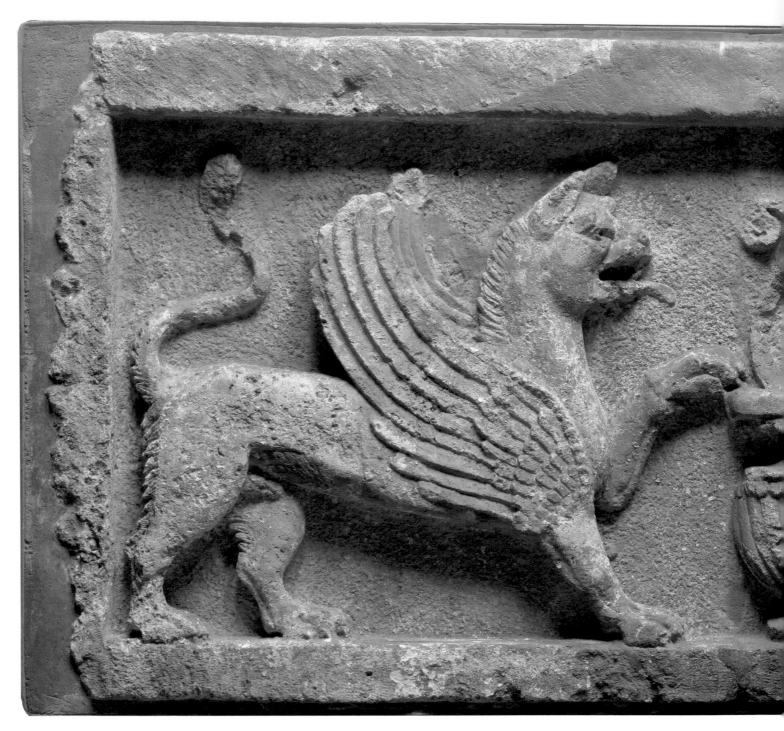

109 Door Lintel
Mesopotamia, Hatra,
Parthian; 2nd–3rd c. A.D.
Limestone; L. 67¾ in. (172.2 cm.)
Purchase, Joseph Pulitzer Bequest,
1932 (32.145a,b)

150

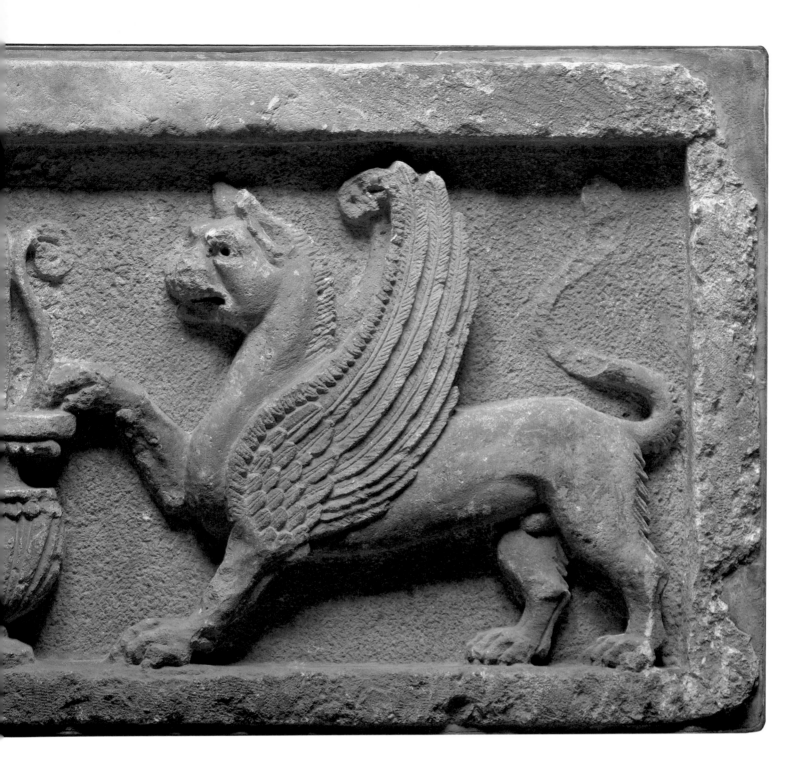

DOOR LINTEL

The borders between the western empire of Rome and the Parthian lands in the east ran between the central and northern Euphrates and Tigris Rivers. Hatra in northern Iraq, southwest of present-day Mosul, was a major trading city heavily fortified against Roman attack and populated by a mixture of peoples, Parthians as well as Arabs and the inhabitants of Syria.

Once part of a decorated doorway in the north hall of the so-called Main Palace at Hatra, this lintel stone was originally positioned so that the carved surface faced the floor.

The two fantastic creatures have feline bodies, long ears, bird's wings, and crest feathers, a combination of animal and bird elements typical of Near Eastern lion-griffins. Between the two figures is a vase containing a stylized lotus leaf and two curling tendrils. The naturalistic modeling of the creatures' bodies and the form of the central vase reflect Roman influence. However, the absolute symmetry of the composition, the pronounced simplification of the plant forms, and the lion-griffin motif are all characteristically Near Eastern features.

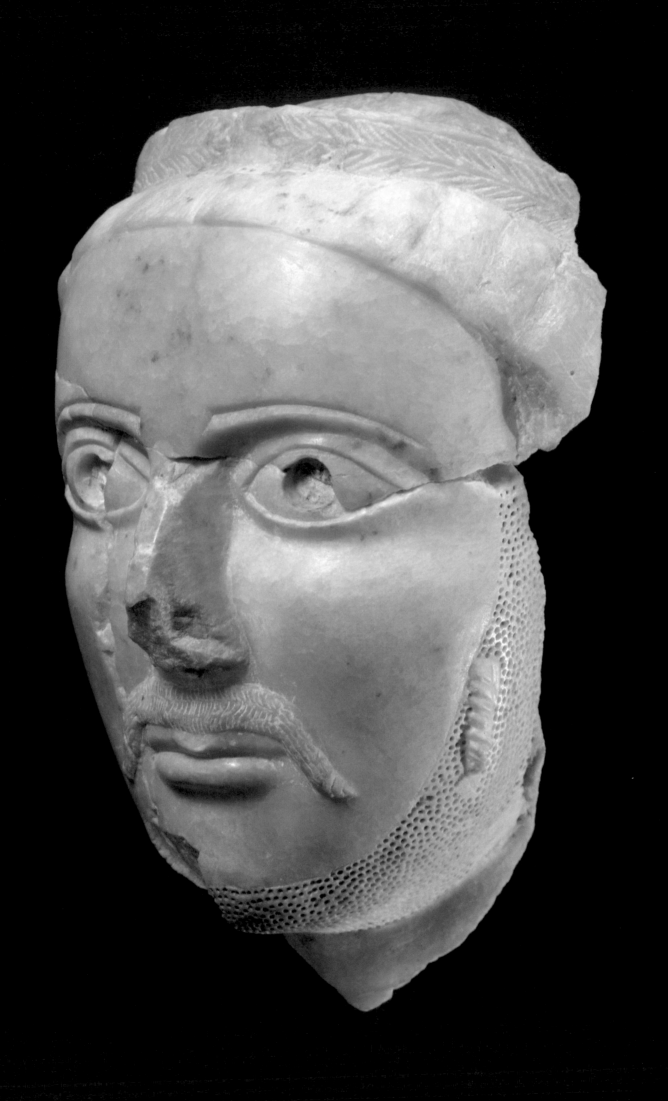

MALE PORTRAIT HEAD

At the beginning of the Christian era, the south Arabian states achieved considerable wealth and power through their control of the trade in incense gums between Arabia and the lands of the Mediterranean seacoast. Frankincense and myrrh, both native to south Arabia, were widely valued in the ancient world for use in religious ceremonies and for the preparation of perfumes and ointments. The kingdoms along the Gulf of Aden were also centers for the importation of objects from abroad—gold, ivory, and precious stones. During the third and fourth centuries A.D., the powerful rulers of Saba and Himyar united the small Arab kingdom and succeeded in governing with considerable authority.

This fine male portrait head is thought to date from the middle of the first millennium A.D. and may have been part of a larger royal sculpture. The figure is wearing a stylized laurel wreath, a symbol of high rank. The use of the laurel wreath to denote status reflects the influence of the Graeco-Roman world and appears in more realistic form on the coins of the kingdom of Himyar from the first centuries B.C. and A.D. A long moustache falls down on either side of the mouth, the chin is bearded, and a single ringlet is carefully carved on the surface of the left cheek. This last detail is undoubtedly significant since it is, to this day, characteristic of the hairstyle of Yemeni Jews. In the fourth century A.D., many of the kings of Himyar were converted to Judaism, so this feature may eventually aid in the identification of the figure. Carved from translucent alabaster with beautifully polished surfaces, the male portrait head is a notable example of the art of ancient Arabia.

110 *Male Portrait Head*
South Arabia; 4th–5th c. A.D.
Alabaster; H. 9⁷/₁₆ in. (24 cm.)
Purchase, Mr. and Mrs. Nathaniel
Spear, Jr., Gift, 1982 (1982.317.1)

OVERLEAF:

PLATE WITH PEROZ OR KAVAD I HUNTING RAMS (Page 154)

Parthian rule came to an end with a revolt in southern Iran near Persepolis. There the Sasanian Ardeshir defeated the last Arsacid Parthian king, Artabanus V, in A.D. 224 and shortly afterward assumed power himself. The Sasanians had long been residents of Iran and considered themselves the rightful successors of the Achaemenids. They inherited a feudal system from the Parthians but effectively bridled the local power of individual lords and instituted a strongly centralized government. For the next four hundred years, the kings of the Sasanian Dynasty controlled an empire that extended at times beyond Iran and Mesopotamia to present-day Afghanistan in the east, and to Armenia, Syria, Yemen, and even Egypt in the west. The vast trade routes that led from China to the Mediterranean served to link distant regions into a closely interconnected world. The prestige of the Sasanian Dynasty was so great that its art was widely imitated in the East and the West.

Many vessels made of silver survive from the Sasanian Empire and attest to the great wealth of the royal court. One of the finest examples is a silver plate in the collection of The Metropolitan Museum (Plate 111, next page), which is alleged to have come from northwestern Iran. It shows a king in full ceremonial dress, mounted on horseback with bow in hand, hunting a pair of rams. He wears the customary regalia: crenellated crown surmounted by a covered globe and fillet. A golden halo—perhaps a symbol of the "royal fortune" of Sasanian kings—surrounds the king's head. The success of the royal archer is implied by a pair of dead rams beneath the horse's hooves. The raised design, which is partially covered with mercury gilding, is made from a number of separate pieces fitted into lips that have been cut up from the background of the plate.

The king as hunter had become the standard royal image on silver plates during the reign of Shapur II (A.D. 310–379). The theme, symbolizing the prowess of Sasanian rulers, was used to decorate these royal plates, which were often sent as gifts to neighboring courts. The identity of the king on this plate is uncertain, but judging from coins of the period, he is either Peroz or Kavad I, both of whom ruled Iran in the second half of the fifth century A.D.

OVERLEAF:

EWER (Page 155)

Late Sasanian silver vessels, particularly bottles and ewers, were often decorated with female figures holding a variety of festal objects. The appearance of these motifs shows the continuing influence of Greek imagery associated with the wine god Dionysos. On this silver-gilt vessel (Plate 112, page 155), floral arches, supported by low pilasters, frame four dancing females. Each of the figures holds a ceremonial object in either hand: grape and leaf branches, a vessel, a heart-shaped flower. Beneath one arcade, birds peck at fruit, and beneath another a tiny panther drinks from a ewer. Both the females and their decorative motifs recall representations of the maenads, attendants of Dionysos. However, it has been suggested that they have been adapted here to the cult of the Iranian goddess Anahita. No specific texts survive to explain the appearance or function of these female figures, but it seems likely that vessels decorated with motifs such as these would have been intended to hold wine for court celebrations or religious festivals.

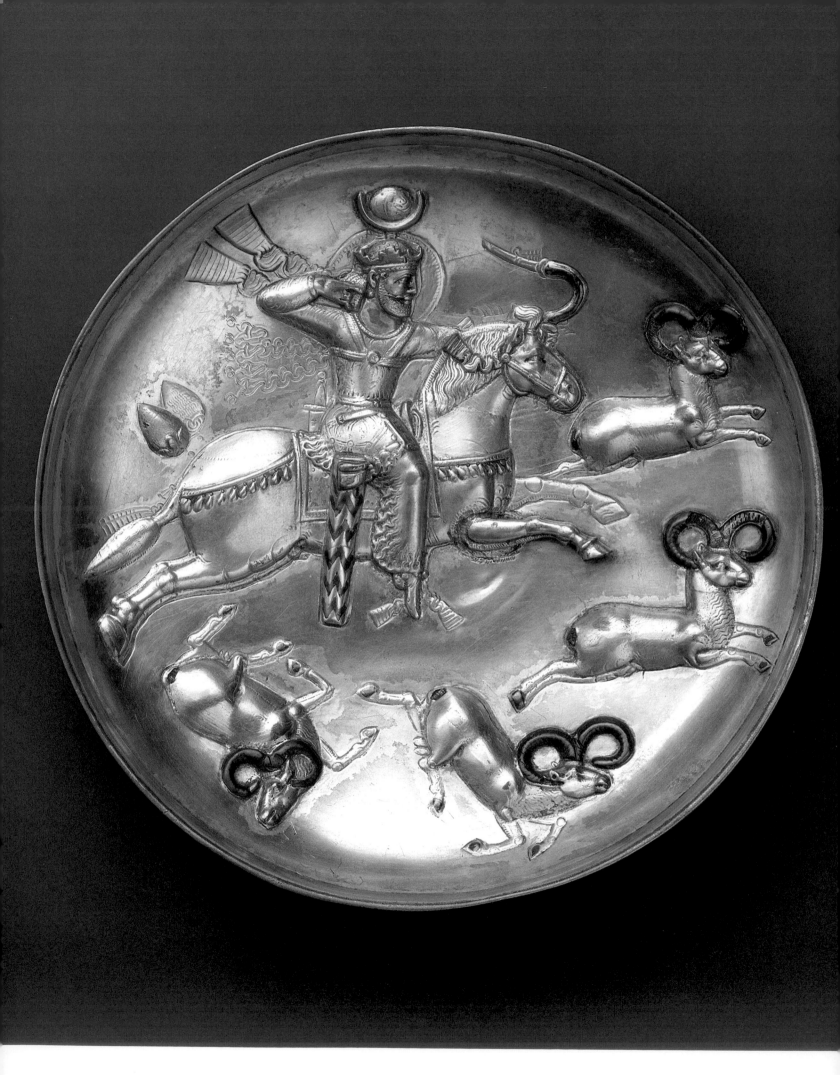

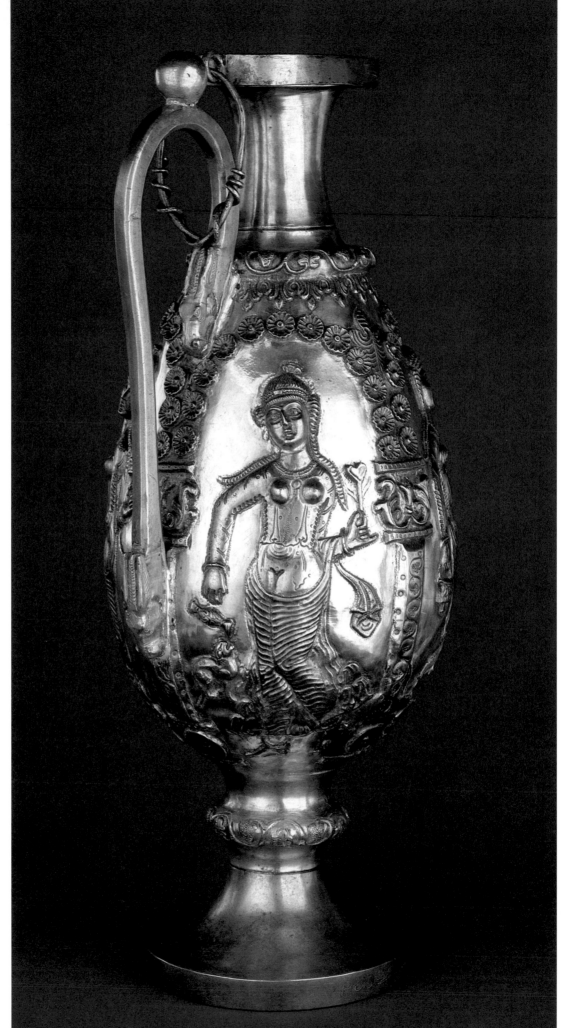

*111 Plate with Peroz or
Kavad I Hunting Rams*
Iran, Sasanian;
late 5th–early 6th c. A.D.
Silver with mercury gilding
and niello; H. 1³/₁₆ in. (4.6 cm.),
Diam. 8⅝ in. (21.9 cm.)
Fletcher Fund, 1934 (34.33)

Page 153: text

112 Ewer
Iran, Sasanian;
ca. 6th–7th c. A.D. Silver
with mercury gilding;
H. 13⁷/₁₆ in. (34.1 cm.)
Purchase, Mr. and Mrs. C.
Douglas Dillon Gift and
Rogers Fund, 1967 (67.10a,b)

Page 153: text

113 Sword and Scabbard
Iran, Sasanian; ca. 7th c. A.D.
Blade: iron; scabbard and hilt:
gold over wood, set with
garnet and glass paste jewels;
guard: gilt bronze and gold foil;
L. 39½ in. (100.3 cm.)
Rogers Fund, 1965 (65.28a,b)

Opposite: detail

SWORD AND SCABBARD

Representations of kings of the Sasanian Period almost always show them with a sword suspended from the belt, a motif appropriate to the image of the Sasanian king as victorious in combat. This iron sword with a gold-covered wooden scabbard is a splendid example of the type adopted by the Sasanians from the Hunnish nomads who roamed Europe and Asia in the sixth and seventh centuries, shortly before the beginning of the Islamic era. It has a long and narrow grip with two finger rests, and the scabbard has a pair of P-shaped projections to which two straps of different lengths were originally attached. The straps held the sword suspended from the warrior's belt in such a way that it could easily be drawn even by a mounted warrior.

The sword itself is inlaid with garnets and glass, and a pattern of overlapping feathers decorates the surface. The fact that a similar pattern can be seen on the helmet of a Sasanian warrior has led scholars to suggest that the pattern may be symbolic of the Zoroastrian god of victory, Verethragna. Several other swords of this type are known—some mounted in gold, some in silver. Stylistically and technically, they are all very similar, although the Museum's sword is by far the most elaborate of the group.

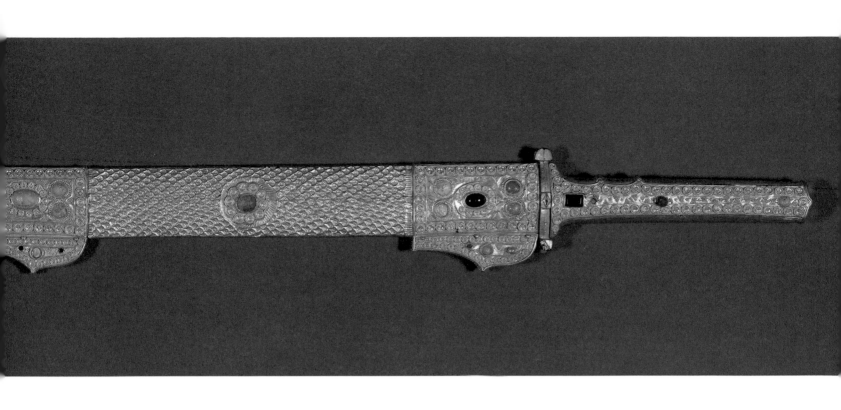

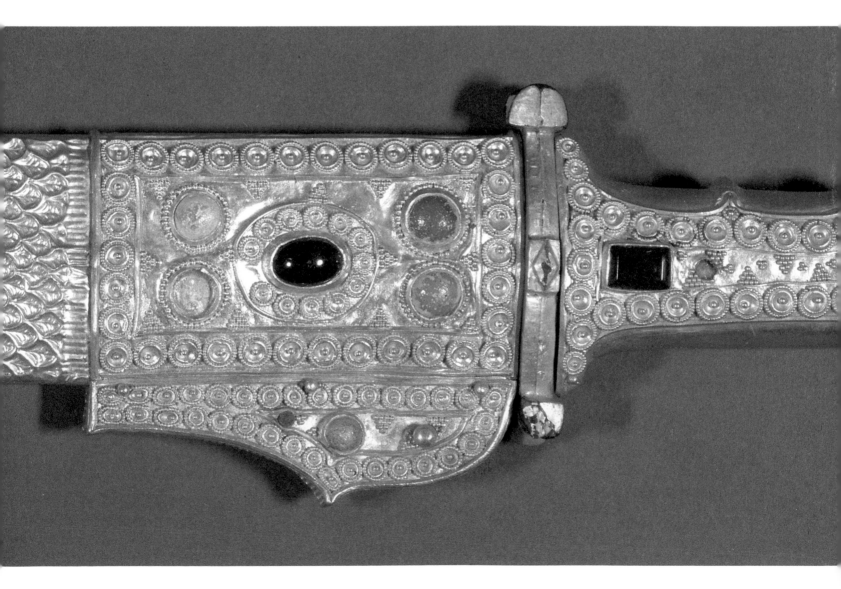

HEAD OF A KING

This silver head of a Sasanian king dates from the fourth century A.D. and is an exquisite example of Sasanian metalwork. The head is raised from a single piece of silver with details chased and in repoussé. The king wears simple ovoid earrings and a beaded necklace typical of Sasanian fashion. The power of his staring eyes and his characteristic arched nose seem to suggest that the artist was attempting to convey a sense of majesty rather than an individual likeness. The identity of the representations of Sasanian kings, in relief or in the round, can often be discovered by a comparison of facial features and details of the crown with those of kings portrayed on coins of the period. In the case of this silver head, however, the crescent that decorates the crenellated crown and the striated orb that rises above the crown have no exact parallel. A combination of stylistic details suggests that it was made sometime in the fourth century, perhaps during the reign of Shapur II. The lower section of this head has been cut away, so there is no way of knowing whether it was originally part of a larger sculpture composed of several pieces or a decorative bust intended to be seen alone.

114 Head of a King
Iran, Sasanian; late 4th c. A.D.
Silver; H. 15¾ in. (40 cm.)
Fletcher Fund, 1965 (65.126)

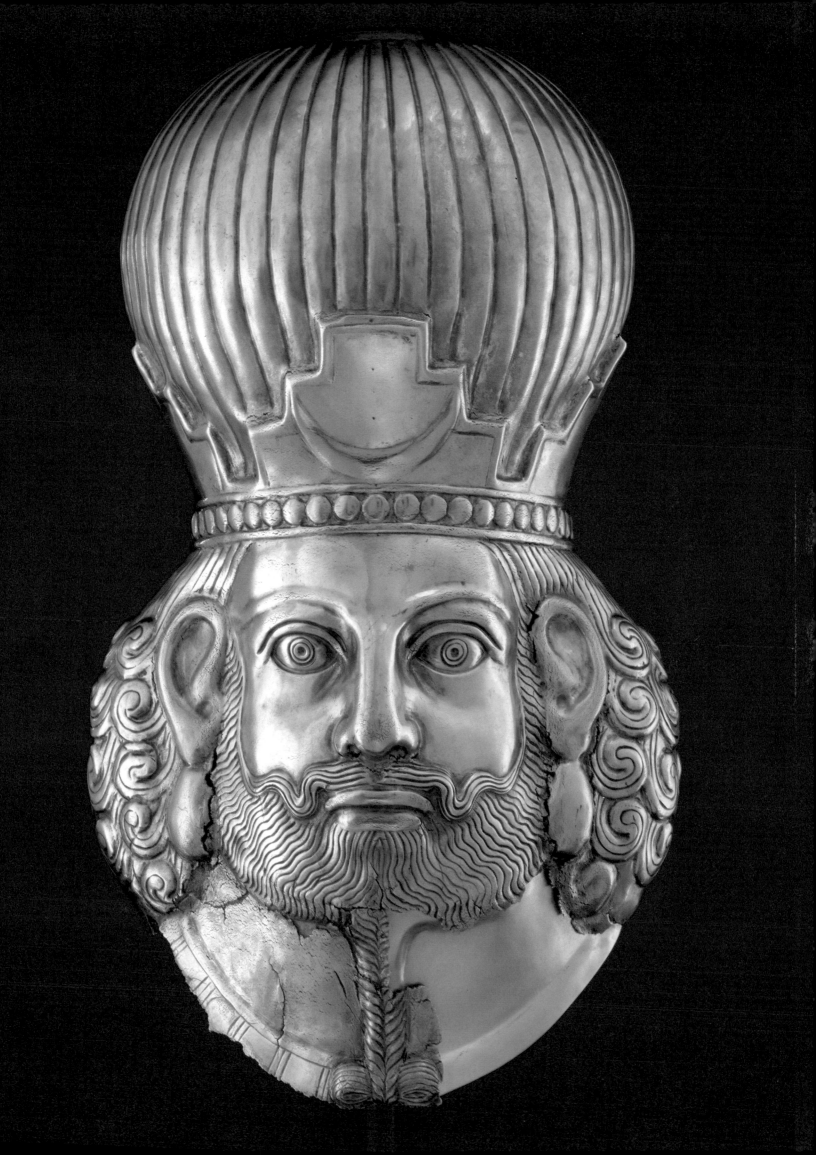

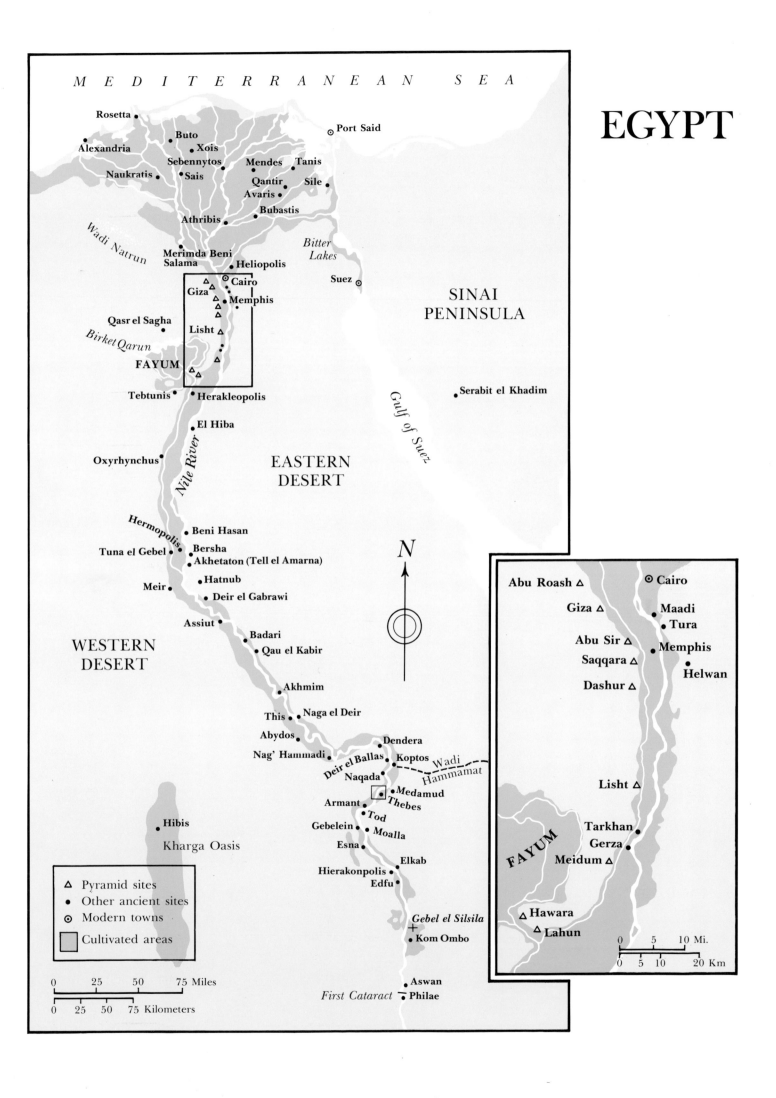

EGYPT

M E D I T E R R A N E A N S E A

Rosetta

Buto

Alexandria

Xois

Sebennytos

Naukratis

Sais

Mendes

Tanis

Qantir

Sile

Avaris

Athribis

Bubastis

Merimda Beni
Salama

Heliopolis

⊙ Cairo

Giza

Memphis

Qasr el Sagha

Lisht

Birket Qarun

FAYUM

Tebtunis

Herakleopolis

El Hiba

Oxyrhynchus

Wadi Natrun

Nile River

Port Said ⊙

*Bitter
Lakes*

Suez ⊙

SINAI
PENINSULA

Serabit el Khadim

Gulf of Suez

EASTERN
DESERT

Hermopolis

Beni Hasan

Tuna el Gebel

Bersha

Akhetaton (Tell el Amarna)

Meir

Hatnub

Deir el Gabrawi

Assiut

WESTERN
DESERT

Badari

Qau el Kabir

Akhmim

This

Naga el Deir

Abydos

Nag' Hammadi

Dendera

Deir el Ballas

Koptos

Wadi
Hammamat

Naqada

Medamud

Armant

Thebes

Tod

Gebelein

Moalla

Esna

Elkab

Hibis

Kharga Oasis

Hierakonpolis

Edfu

N

Gebel el Silsila

Kom Ombo

△ Pyramid sites

● Other ancient sites

⊙ Modern towns

☐ Cultivated areas

0 25 50 75 Miles

0 25 50 75 Kilometers

Aswan

First Cataract — Philae

Inset map

Abu Roash △

⊙ Cairo

Giza △

Maadi

Tura

Abu Sir △

Saqqara △

Memphis

Dashur △

Helwan

Lisht △

Tarkhan

FAYUM

Gerza

Meidum △

Hawara

Lahun

0 5 10 Mi.

0 5 10 20 Km

2300	2100	1900	1700	1500

Kingdom | **2160** First Intermediate Period | **2040** Middle Kingdom | **1786** Second Intermediate Period | **1559** | M

...nasty 5 | **2345** Dynasty 6 | **2181** 7–8 | 9 | Dyn. 10 | **1991** Dynasty 12 | **1668** **1559** Dynasty 15

2133 Dynasty 11

1700 14 Dynasty 16

1786 Dynasty 13 | Dyn. 17 | **1570** Dynasty 18

Plate 12

Plate 15

Plate 20

Plate 38

Plate 82
ANATOLIA

Plate 71
MESOPOTAMIA

Plate 97
INDUS VALLEY

Plate 73
MESOPOTAMIA

Plate 86
ANATOLIA

2300	2100	1900	1700	1500

Old Assyrian Period | **Mitannian Period**

Gudea of Lagash 2144–2124

1894 **Old Babylonian Period** **1595**

Neo-Sumerian Period | **1595** | **Kass**

2017 **Isin-Larsa Period** **1763**

IIb | **Dynasty of Akkad** *2154–2334* | **Third Dyn. of Ur** *2112–2004*

...ze Age | **Middle Bronze Age** | L...

Palace of Elba | *Amorite Invasions* | **Byblos** *Temple of the Obelisks* | *1779–1761 Zimrilim's Palace at Mari* | *Alalakh VII*

a Hoyük | *Royal Tombs* | Horoztepe | *Tombs* | **Assyrian Colony Period** | **Old Hittite Empire** | **Hit**

Yahya IVb | **Yahya IVa** *Shadad Cemetery*

Susa IV | *Akkadian Suzerainty in Susa* | **Old Elamite Period** | **Transitional Period**

Namazga V – VI | Namazga VIa | Namazga VIb

...mazga V
Tepe 3–1

Indus Civilization

	3500 B.C.	3300	3100	2900	2700	2686	2500

EGYPT

3500 B.C.	3300	3100	2900	2700	2500
Gerzean		Archaic Period			Old
	3200 Dynasty 0	Dynasty 1	2890 Dynasty 2	2686 Dyn. 3 / 2613 Dyn. 4	2498 Dy

Plate 1

Plate 4

Plate

EGYPT

ANCIENT NEAR EAST

Plate 92
IRAN

Plate 93
IRAN

Plate 65
MESOPOTAMIA

Plate 67
MESOPOTAMIA

	3500 B.C.	3300	3100	2900	2700	2500
MESOPOTAMIA		Uruk	Jemdet Nasr	Early Dynastic I	II IIIa	I
LEVANT	Chalcolithic Period					Early Bron
	Jericho VIII / Ugarit IIIc		Jericho VII / Ugarit IIIb–a			
ANATOLIA			Troy I (3000–2750)		Troy II	Alac
IRAN WEST EAST	Yahya V		Yahya IVc			
	Proto-Urban Sialk III Susa II		Proto-Elamite Period	Susa III	Sumero-Elamite Period	
WESTERN CENTRAL ASIA			Namazga IV		Na Altyr	
INDUS VALLEY			Early Indus Culture			

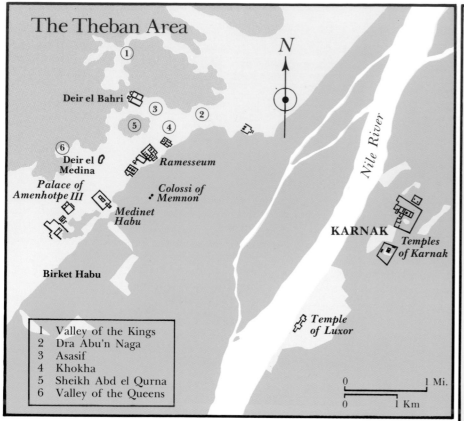

The Theban Area

Deir el Bahri

Deir el Medina

Palace of Amenhotpe III

Medinet Habu

Ramesseum

Colossi of Memnon

Birket Habu

KARNAK

Temples of Karnak

Nile River

Temple of Luxor

1 Valley of the Kings
2 Dra Abu'n Naga
3 Asasif
4 Khokha
5 Sheikh Abd el Qurna
6 Valley of the Queens

0 1 Mi.

0 1 Km

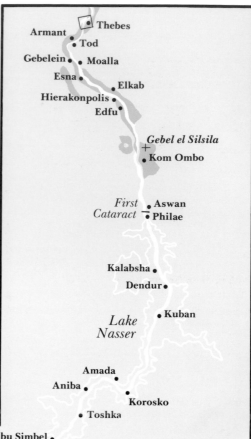

Armant Thebes
Tod
Gebelein Moalla
Esna Elkab
Hierakonpolis
Edfu
Gebel el Silsila
Kom Ombo
First Cataract Aswan
Philae
Kalabsha
Dendur
Lake Nasser Kuban
Amada
Aniba
Korosko
Toshka
Abu Simbel
Faras Qustul
Buhen
Second Cataract
Semna Kumma

MAPS AND TIME CHARTS OF EGYPT AND THE ANCIENT NEAR EAST

On these pages are maps of Egypt and the Near East showing principal ancient sites as well as selected modern cities. Geographical features are identified by their modern names.

On the inside pages is a time chart that places the periods and dynasties of ancient Egypt (along the upper bands) in relation to the cultures of the ancient Near East (along the lower bands); it also includes examples of works of art that are discussed in the text. The chart is divided into 200-year intervals beginning with 3500 B.C.

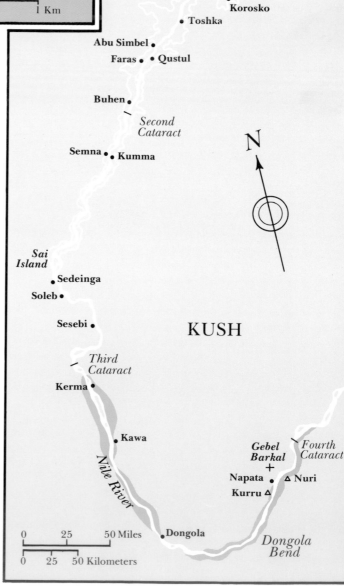

N

Sai Island
Sedeinga
Soleb
Sesebi

KUSH

Third Cataract
Kerma

Kawa

Gebel Barkal
Fourth Cataract
Napata Nuri
Kurru

Nile River

Dongola

Dongola Bend

0 25 50 Miles

0 25 50 Kilometers

ANCIENT NEAR EAST

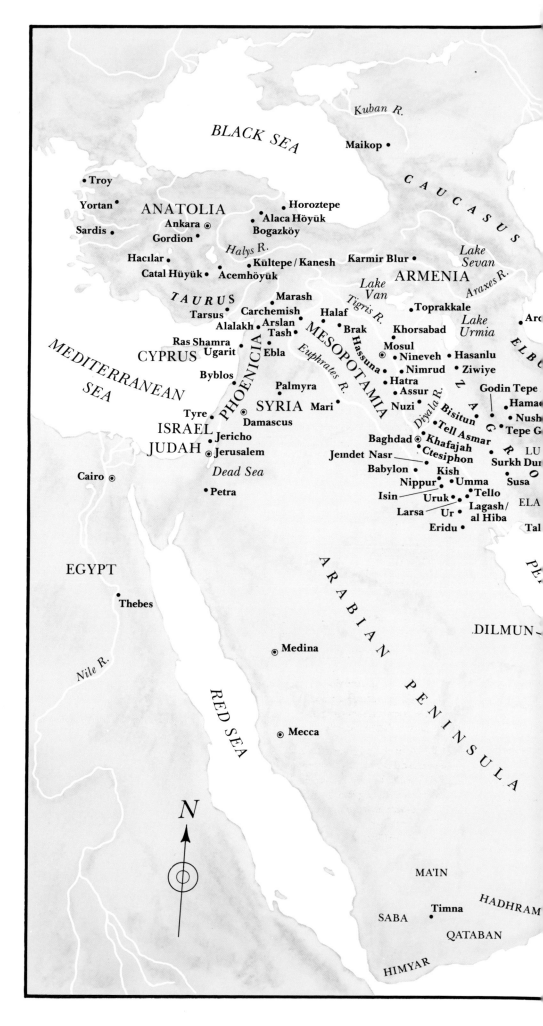

BLACK SEA

Kuban R.

Maikop •

C A U C A S U S

• Troy

Yortan •

ANATOLIA

• Horoztepe

• Alaca Höyük

Sardis •

Ankara ◉

Bogazköy

Gordion •

Halys R.

Lake Sevan

Hacılar •

Kültepe / Kanesh

Karmir Blur •

Araxes R.

Catal Hüyük • Acemhöyük

ARMENIA

Lake Van

T A U R U S

• Marash

• Toprakkale

Lake Urmia

Tarsus •

Carchemish

Halaf •

Tigris R.

Aro

Alalakh •

Arslan Tash •

• Brak

Khorsabad •

E L B U

Ras Shamra

Hassuna

Mosul

• Hasanlu

CYPRUS

Ugarit ◉

• Ebla

◉ • Nineveh

• Ziwiye

Byblos •

Euphrates R.

• Nimrud

MEDITERRANEAN

PHOENICIA

• Palmyra

MESOPOTAMIA

• Hatra

Z

Godin Tepe •

SEA

SYRIA

Mari •

Nuzi •

• Assur

A

Hamae

Diyala R. Bisitun

G

• Nush

Tyre •

Damascus

Bisitun

R

Tepe G

ISRAEL

• Jericho

• Tell Asmar

O

JUDAH

Jerusalem ◉

Baghdad ◉ • Khafajah

S

LU

Jemdet Nasr

• Ctesiphon

Surkh Dur

Cairo ◉

Dead Sea

Babylon • • Kish

Susa

• Petra

Nippur • • Umma

ELA

Isin • Uruk • • Tello

Larsa • Ur • Lagash/ al Hiba

Tal

Eridu •

EGYPT

A R A B I A N

PE

• Thebes

.DILMUN

◉ Medina

P E N I N S U L A

Nile R.

RED SEA

◉ Mecca

N

MA'IN

HADHRAM

SABA

Timna •

QATABAN

HIMYAR

	100 B.C.	100 A.D.	300	500	700

an-Ptolemaic
eriod

30 B.C. Roman Period

A.D. 325 Roman-Byzantine Period

641 Islamic Period

Coptic Culture

Plate 57

Plate 59

Plate 63

Plate 89
RACE

Plate 109
MESOPOTAMIA

Plate 107
IRAN

Plate 110
SOUTH ARABIA

Plate 111
IRAN

	100 B.C.	100 A.D.	300	500	700

Parthian Period **A.D. 224 226** Sasanian Period **651** Islamic Period

of Babylon

**nid and
d Periods** **64 63** Roman Period **A.D. 330** Byzantine Period **635** Islamic Period

of Tyre

63 Roman Period **A.D. 330** Byzantine Period

Parthian Period **A.D. 224 226** Sasanian Period **651** Islamic Period

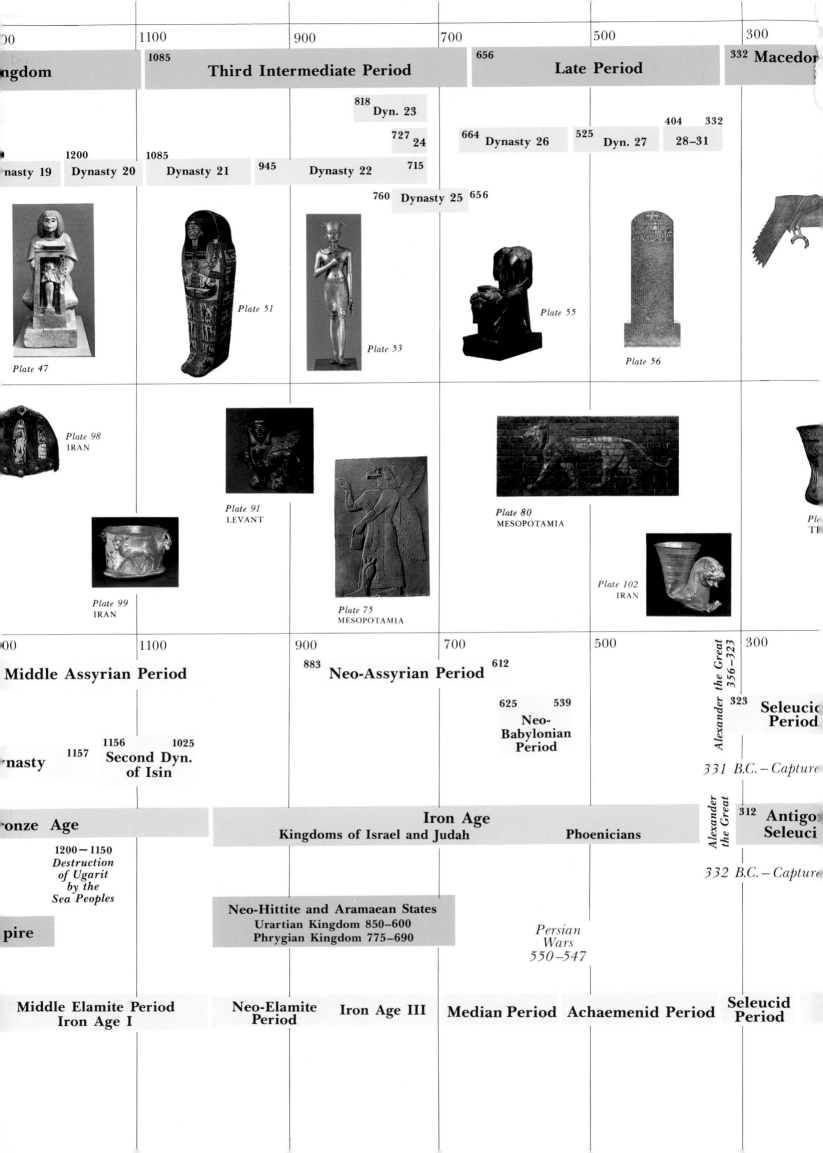

1300	1100	900	700	500	300

...ngdom — 1085 **Third Intermediate Period** — 656 **Late Period** — 332 **Macedon...**

818 **Dyn. 23**

727 **24**

664 **Dynasty 26** — 525 **Dyn. 27** — 404 **28–31** 332

1200 **...nasty 19** — **Dynasty 20** — 1085 **Dynasty 21** — 945 **Dynasty 22** — 715

760 **Dynasty 25** 656

Plate 47

Plate 51

Plate 53

Plate 55

Plate 56

Plate 98
IRAN

Plate 91
LEVANT

Plate 99
IRAN

Plate 75
MESOPOTAMIA

Plate 80
MESOPOTAMIA

Plate 102
IRAN

Pl...
Th...

1300	1100	900	700	500	300

Middle Assyrian Period — 883 **Neo-Assyrian Period** 612

Alexander the Great 356–323 — 323 **Seleucid Period**

625 **Neo-Babylonian Period** 539

1157 1156 **Second Dyn. of Isin** 1025

...nasty

331 B.C. – Capture

...ronze Age — **Iron Age** **Kingdoms of Israel and Judah** — **Phoenicians**

Alexander the Great — 312 **Antigo... Seleuci...**

1200–1150 *Destruction of Ugarit by the Sea Peoples*

332 B.C. – Capture

Neo-Hittite and Aramaean States
Urartian Kingdom 850–600
Phrygian Kingdom 775–690

Persian Wars 550–547

...pire

Middle Elamite Period
Iron Age I — **Neo-Elamite Period** **Iron Age III** — **Median Period** **Achaemenid Period** — **Seleucid Period**

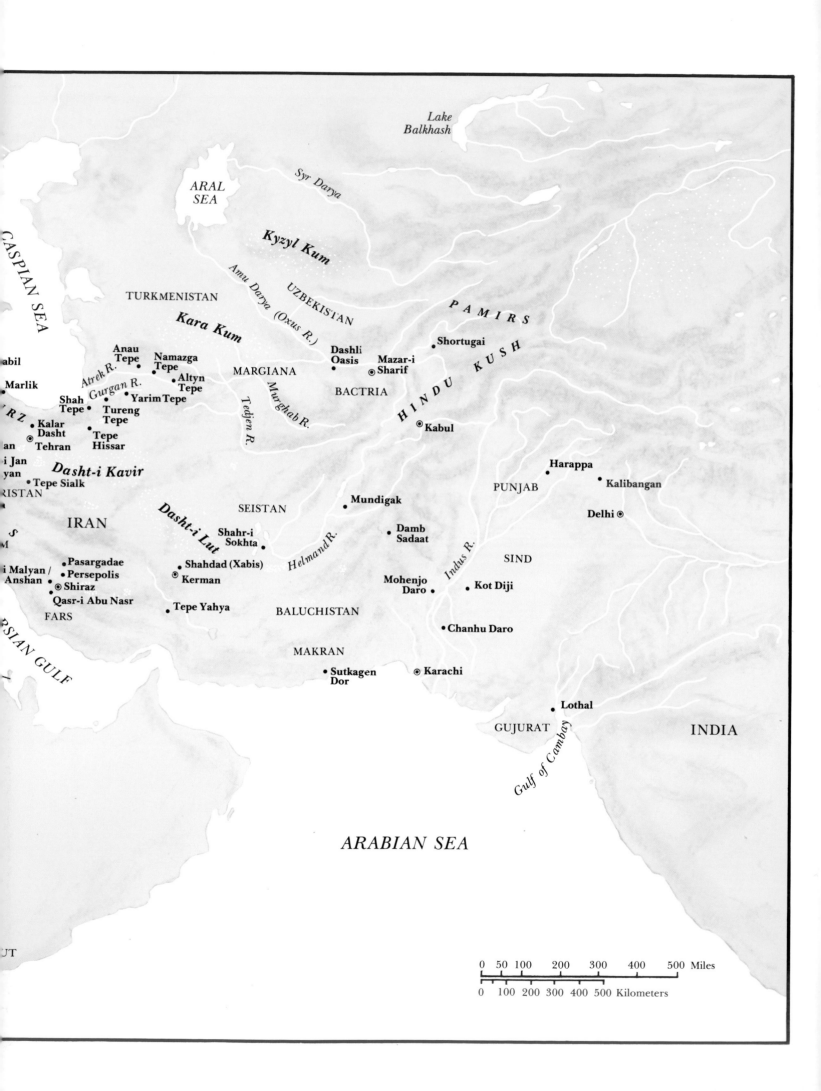

Lake
Balkhash

Syr Darya

ARAL
SEA

Kyzyl Kum

CASPIAN SEA

TURKMENISTAN

Amu Darya (Oxus R.)

UZBEKISTAN

P A M I R S

• Shortugai

Dashli
Oasis

⊙ Mazar-i
Sharif

H I N D U K U S H

Kara Kum

Anau
Tepe

Namazga
Tepe

MARGIANA

Atrek R.

BACTRIA

abil

Marlik

Gurgan R.

Altyn
Tepe

Shah
Tepe

Yarim
Tepe

Tedjen R.

Murghab R.

⊙ Kabul

Tureng
Tepe

Kalar
Dasht

RZ

Tepe
Hissar

an

Tehran

⊙

i Jan
yan

Dasht-i Kavir

• Tepe Sialk

Harappa

• Kalibangan

RISTAN

PUNJAB

IRAN

Delhi ⊙

SEISTAN

• Mundigak

Dasht-i Lut

S

M

i Malyan /
Anshan

Shahr-i
Sokhta

Pasargadae

Persepolis

Shiraz ⊙

Shahdad (Xabis)

⊙ Kerman

Damb
Sadaat

Mohenjo
Daro

SIND

• Kot Diji

Helmand R.

Indus R.

Qasr-i Abu Nasr

FARS

• Tepe Yahya

BALUCHISTAN

• Chanhu Daro

SIAN GULF

MAKRAN

Sutkagen
Dor

⊙ Karachi

Lothal

GUJURAT

Gulf of Cambay

INDIA

UT

ARABIAN SEA

0 50 100 200 300 400 500 Miles

0 100 200 300 400 500 Kilometers